D

Blitz and Blockade

Two sleeping figures

Moore 41

Blitz and Blockade
Henry Moore at the Hermitage

The Henry Moore
Foundation

ГОСУДАРСТВЕННЫЙ
ЭРМИТАЖ
The State Hermitage Museum
20 21

Published with the permission of the Editorial Committee of the State Hermitage Museum

Catalogue for the exhibition *Blitz and Blockade: Henry Moore at the Hermitage*
The State Hermitage Museum, St Petersburg, 6 May–28 August 2011

The catalogue is compiled by the State Hermitage Museum and The Henry Moore Foundation

Catalogue material © 2011 The Henry Moore Foundation and the State Hermitage Museum

Text © 2011 the individual authors

Editors: Frank Althaus, Mark Sutcliffe
Design: John Morgan studio, London

Translation from English: Anna Shevchenko, Irina Nelyubova
Editor of the Russian translation: Dimitri Ozerkov
Editorial assistance: Elena Kulagina
Index: Hilary Bird

Fig. 1, p. 2: *Two Sleeping Figures*, 1941 (HMF 1755)

Printed in St Petersburg by NP-Print
ISBN 978-1-906257-07-1

First published in 2011 by
Fontanka Publications
5a Bloomsbury Square
London WC1A 2TA
www.fontanka.co.uk

Organisation committee
Dr Mikhail Piotrovsky, Director of the State Hermitage Museum, associate member of the Russian Academy of Sciences, acting member of the Russian Academy of Arts, professor of St Petersburg State University

Richard Calvocoressi, Director of The Henry Moore Foundation

Dr Georgy Vilinbakhov, Deputy Director of the State Hermitage Museum for Research, professor of the Stieglitz State Academy of Art and Industry, St Petersburg

Dr Vladimir Matveyev, Deputy Director of the State Hermitage Museum for Exhibitions and Development

Anita Feldman, Exhibition Curator, Head of Collections and Exhibitions, The Henry Moore Foundation

Dr Sergei Androsov, Head of the Western-European Department of the State Hermitage Museum

Dr Dimitri Ozerkov, Head of the Contemporary Art Sector and 'Hermitage 20/21' project of the State Hermitage Museum

Alexei Mitin, researcher of the Western-European Department of the State Hermitage Museum

Geraldine Norman, Chief Executive, London Friends of the Hermitage

Dr Thierry Morel, Director of the Hermitage Foundation UK

Working group 'Hermitage 20/21'
Dimitri Ozerkov, Elena Getmanskaya, Sofia Kudryavtseva, Ekaterina Lopatkina, Kseniya Malich, Darya Gorlenkova

Working group of The Henry Moore Foundation
Suzanne Eustace, Theodora Georgiou, Laura Robinson, James Copper

Exhibition design and installation
Boris Kuzyakin, Vitaly Korolev, Yuri Kolotilov, Boris Stepanov

Packing and transportation
Khepri, St Petersburg

Acknowledgements
The State Hermitage Museum would like to thank The Henry Moore Foundation for the loan of this selection of drawings and sculpture and the ongoing support from their Trustees and Director Richard Calvocoressi; and Geraldine Norman and the Hermitage Foundation UK for their support of this exhibition

Appreciation is also due to the following staff at The Henry Moore Foundation who provided educational research: Martin Davis, Emily Peters, Michael Phipps and Emma Stower

The exhibition *Blitz and Blockade: Henry Moore at the Hermitage* has been sponsored by:

Hermitage Foundation UK and the London Hermitage Council

with additional support from:

we also thank our media partners:

ARTCHRONIKA

L'OFFICIEL

Sculpting the War

My father, Boris Borisovich Piotrovsky, often talked with pleasure of his conversations with Henry Moore. He was delighted to discover that the close links identified by art historians between Moore's works and ancient artistic traditions arose from a position consciously adopted by the artist himself. For both the previous and current director of the Hermitage, Moore represents a bond between human existence throughout the ages. He is truly an eternal artist, for his art combines the aesthetic of nature and the human aesthetic. This is plain to see when you visit his home and studios at Perry Green, which I consider one of the great art installations anywhere in the world. But this artist of the eternal was also someone who expressed entirely concrete emotions in an entirely concrete setting. For during the Second World War Moore was one of those who recorded the horrors of civilian life in the face of war and bombardment.

His Shelter Drawings are wonderful works, combining material anguish with a sense of the eternal. All of Moore's sculptures in some way tell of motherhood, of what gives birth to and nurtures man. In his drawings the Underground is not just a place of suffering, but also a maternal womb, protecting its children. The Underground and its shelterers are thus an echo and an extension of the philosophy expressed by Moore's sculptures before and after the war.

During the war the Hermitage was also a symbol of suffering, misery and the preservation of eternal values – something brought out in this exhibition by drawings from the museum's collection. And this links Moore's art with the Hermitage. It makes this exhibition, which recalls the Hermitage during the Blockade of Leningrad, no mere curatorial contrivance, but an organic cross-pollination. For the Hermitage, Moore is a symbol of the continuity of world culture, of our eternal aesthetic values. He is also a great example of how recognizable reality can be interpreted as part of the immutability of life.

We are delighted to celebrate this year's Victory Day with drawings and sculpture, the two hypostases of this great artist.

Mikhail Piotrovsky
Director
The Hermitage Museum

The last time Henry Moore's work was shown in St Petersburg was twenty years ago, in 1991, the year the city changed its name back from Leningrad. This summer, 2011, sees two historic anniversaries of the Second World War, when Britain and Russia faced the threat of annihilation at the hands of Nazi Germany and survived. In Britain, this May, we mark the seventieth anniversary of the ending of the Blitz, the intensive German bombing of London and other centres of population, which lasted from September 1940 to May 1941. In Russia, the German Blockade of Leningrad began seventy years ago, in September 1941, and lasted for over two years, with appalling loss of life.

During the Blitz Henry Moore depicted in a series of extraordinary sketches and drawings the inhabitants of London as they sheltered from the nightly bombing in the Underground stations – a dimly-lit world of tunnels and draped, sleeping bodies that not only reminded him of his own sculptures but may also have reminded him of his experiences as a young soldier in the trenches in the First World War. These so-called Shelter Drawings have attained an almost mythical status, contributing to Moore's international recognition after the war, when they were widely exhibited (including in Germany itself).

The Henry Moore Foundation is delighted to have been able to react positively and enthusiastically to the invitation from Professor Piotrovsky, via the Friends of the Hermitage in London, to put together an exhibition of the Shelter Drawings and related works. That the basement of the State Hermitage Museum was used as a shelter during the Siege of Leningrad, recorded in drawings by the Soviet architect Alexander Nikolsky, gives this exhibition and catalogue added poignancy.

The exhibition has been selected by Anita Feldman, Head of Collections and Exhibitions at the Foundation. She has been assisted by Suzanne Eustace and Theodora Georgiou, Assistant Curator and Registrar, respectively. Anita Feldman has written an essay for the catalogue that places Moore's wartime drawings in the context of a wider political engagement; while Richard Calvocoressi, Director of The Henry Moore Foundation, contributes a text on the Blitz and how British artists responded to it.

The Henry Moore Foundation owns the largest collection of Moore's work in the world. Its headquarters are at Perry Green, a small village in farming countryside thirty miles north of London. Moore moved there in 1940, when his studio flat in London was damaged in the Blitz, and lived there until his death in 1986. He gradually acquired buildings and land, where he could make and display his increasingly large sculptures. Today, his house and studios, the garden, orchard, parkland and surrounding fields, are open to the public from April to October every year.

Duncan Robinson
Chairman
The Henry Moore Foundation

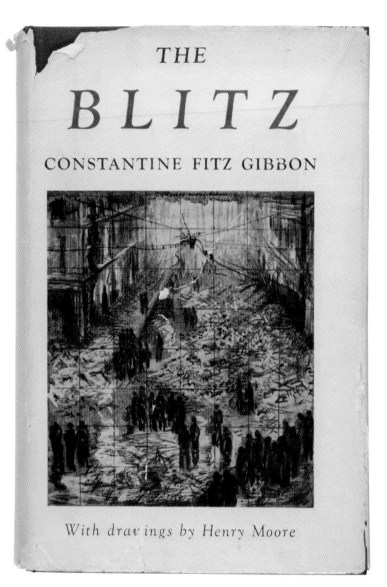

Fig. 2. Constantine Fitz Gibbon, *The Blitz*, 1957,
with Moore's drawing *Morning after the Blitz*,
1940 (HMF 1558), on the cover. The book is
dedicated to Moore's wife Irina and reproduces
seven of the artist's Shelter Drawings

Richard Calvocoressi Recording the Blitz

The Nazis' aerial onslaught on Britain was known as the Blitz, after the German word *Blitzkrieg*, meaning 'lightning war'. It began with two massive air raids on London in the afternoon and evening of 7 September 1940. Escorted by some 600 fighter planes, 348 bombers crossed the English Channel in two waves, dropping incendiary bombs followed by heavy explosives. Although the docks and oil installations of the East End of London were the main targets, neighbouring residential areas suffered badly, with many homes obliterated. Casualties were high: 436 dead and 1,600 seriously injured. For the following fifty-seven nights – and sometimes during the day as well – London was persistently bombed. In November the Germans extended their aerial raids to other industrial centres, beginning with the city of Coventry on the night of 14–15 November, when 568 people were killed and more than twice that number injured, numerous armaments factories were hit, and the medieval cathedral was destroyed. The bombing of British ports, shipbuilding towns and naval bases soon followed, including those on the rivers Mersey (Liverpool) and Clyde (Glasgow), as well as Bristol, Southampton, Portsmouth, Cardiff, Plymouth and Hull.

The final attack on London – the 130th night of raids – took place on 10 May 1941. It was even more punishing than the first, killing 1,436 people, seriously wounding a further 1,800, irreparably damaging 11,000 houses and rendering over 12,000 people homeless. But on 22 May Field Marshal Kesselring transferred his headquarters from the northern French coast to occupied Poland. By early June his Second Air Fleet's squadrons had joined him in the east, amounting to a third of the Luftwaffe's entire strength in planes. On 22 June Hitler invaded the USSR. Operation Barbarossa had begun but Britain could breathe a sigh of relief: the Blitz was over. It had killed over 43,000 civilians, almost half of them in London – more British lives than were lost in the air, on the battlefield and at sea until the autumn of 1941. Homelessness was a serious problem, and not only in London: on Merseyside and Clydebank over 100,000 people lost their homes. In Coventry 60,000 out of a total of 75,000 properties were destroyed or badly damaged. And yet, in spite of widespread hardship and disruption, there is little evidence that the Blitz succeeded in destroying civilian morale, though at times it must have been close to breaking point.

Fig.3. Photographs by Lee Miller from
Grim Glory: Pictures of Britain Under Fire, 1941

70 The rain pours through the shattered roof of University College,
London, reflecting in a contemplative pool the remnants of the dome

71 Revenge on Culture

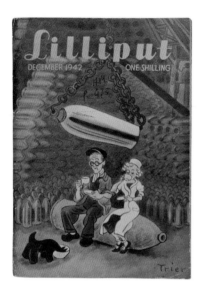

Fig. 4. *Lilliput*, December 1942

Fig. 5. Bill Brandt's photograph of a family
sheltering in the Underground during the Blitz
and (*right*) Moore's drawing *Four Grey Sleepers*,
1941 (HMF 1847); *Lilliput*, December 1942

Artists responded to these eight months of loss, devastation and human resilience
in diverse ways. Many of them were employed by the War Artists' Advisory Committee
(WAAC), formed in 1939 within the British Government's Ministry of Information and
chaired by Sir Kenneth Clark, director of the National Gallery. By 1945 the Committee
had amassed some 6,000 images of the war at home and abroad, in a variety of
idioms, commissioned or bought from more than 400 artists. Familiar names such as
Paul Nash, Graham Sutherland, John Piper, Eric Ravilious, Edward Ardizzone, Anthony
Gross, Edward Bawden and Henry Moore all feature in the collection, but the majority
of works are by artists who are hardly known today. Exhibitions from this growing
resource regularly toured Britain throughout the war, accompanied by free or inexpen-
sive publications, and proved extremely popular.

Moore and Ardizzone were the two principal artists who depicted Londoners
sheltering in the Underground, as well as in the official public shelters – such as the
notoriously overcrowded and insanitary Tilbury shelter in the East End – that pre-
ceded, and co-existed alongside, the Tube shelters. Their approaches were markedly
different. While Moore's imagination transforms the shelter into a modern Hades –
his mass of inert, anonymous bodies would later be compared to the scenes that
greeted the liberators of Belsen and Buchenwald – Ardizzone's slumbering figures
are recognisable, individual characters who seem on the point of bursting into
life. Not surprisingly, Ardizzone's esentially comic vision, in the tradition of English
caricature – he also wrote and illustrated a series of successful children's books –
was judged by the public to be the more appealing of the two; but it is Moore's
tougher drawings that have survived and attained an almost mythical status in their
evocation of human endurance and suffering. Although Moore was not an official
war artist, seventeen of his Shelter Drawings were acquired by the WAAC and later
presented to public museums.

Moore's Shelter Drawings were first published in the magazine *Lilliput* in
December 1942 (fig. 4), juxtaposed with photographs of the Tube shelterers by Bill
Brandt (fig. 5, 6). Brandt later commented that 'apart … from the war-time conditions

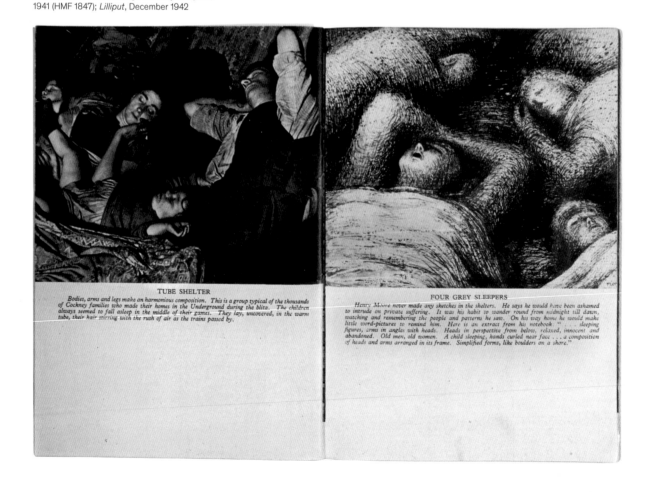

TUBE SHELTER
Bodies, arms and legs make an harmonious composition. This is a group typical of the thousands of Cockney families who made their homes in the Underground during the blitz. The children always seemed to fall asleep in the middle of their games. They lay, uncovered, in the warm tube, their hair stirring with the rush of air as the trains passed by.

FOUR GREY SLEEPERS
Henry Moore never made any sketches in the shelters. He says he would have been ashamed to intrude on private suffering. It was his habit to wander round from midnight till dawn, watching and remembering the people and patterns he saw. On his way home he would make little word-pictures to remind him. Here is an extract from his notebook: " … sleeping figures, arms in angles with heads. Heads in perspective from below, relaxed, innocent and abandoned. Old men, old women. A child sleeping, hands curled near face . . . a composition of heads and arms arranged in its frame. Simplified forms, like boulders on a shore."

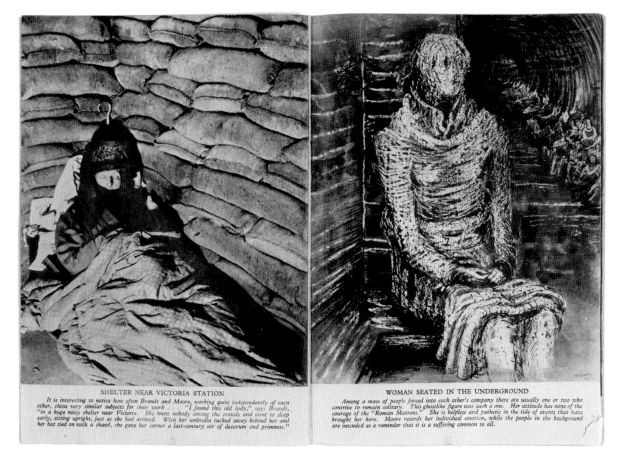

SHELTER NEAR VICTORIA STATION

It is interesting to notice how often Brandt and Moore, working quite independently of each other, chose very similar subjects for their work . . . "I found this old lady," says Brandt, "in a huge noisy shelter near Victoria. She knew nobody among the crowds and went to sleep early, sitting upright, just as she had arrived. With her umbrella tucked away behind her and her hat tied on with a shawl, she gave her corner a last-century air of decorum and primness."

WOMAN SEATED IN THE UNDERGROUND

Among a mass of people forced into each other's company there are usually one or two who contrive to remain solitary. This ghostlike figure was such a one. Her attitude has none of the courage of the "Roman Matrons." She is helpless and pathetic in the tide of events that have brought her here. Moore records her individual emotion, while the people in the background are intended as a reminder that it is a suffering common to all.

Fig. 6. Bill Brandt's photograph of a shelterer near Victoria Station and (*right*) Moore's drawing *Woman Seated in the Underground*, 1941 (HMF 1828; see also fig. 18, p. 23); *Lilliput*, December 1942

in which they were taken, these pictures have a strangely pathetic air – human beings are pathetic when all their defences are broken down in sleep'.[1] Brandt had been commissioned by the Ministry of Information to record the bomb shelters in November 1940. Many of his images of London in the Blitz were published in *Picture Post* (the parent imprint of *Lilliput*) which also employed the photographers Bert Hardy, George Rodger and Humphrey Spender. Cecil Beaton was another photographer commissioned by the Ministry of Information; his famous portrait of a child victim of the Blitz, sitting up in bed clutching her teddy bear, was reproduced on the cover of *Life* magazine for 23 September 1940 as part of a campaign to enlist American sympathy and aid.

The most common Blitz subject was the gutted or destroyed building. Historic structures such as London's Wren churches, the Guildhall and the Houses of Parliament were extensively documented, as was Christopher Wren's St Paul's Cathedral, which survived with relatively minor damage to become a symbol of defiance (fig. 8). Photographers were particularly active in this respect too. Cecil Beaton collaborated with the writer James Pope-Hennessy to produce *History Under Fire*, published in May 1941, just as the Blitz came to an end. The book included fifty-two of Beaton's memorable photographs of London's ruined heritage, from medieval to Georgian architecture, with the largest section devoted to the buildings of Wren. Pope-Hennessy called the destruction 'a by-product of indiscriminate bombing, because we cannot sanely suppose … that enemy bombers single out any specific church or company hall to attack. On the other hand … their [the Nazis'] attitude to the history and the public monuments of Poland and some other of the countries they have conquered shows an inflexible determination to erase the dignified and treasured memorials of a national past.'[2] He also acknowledged that 'the bombing of buildings, however ancient and

This summary has relied heavily on two important recent studies: Brian Foss, *War Paint: Art, War, State and Identity in Britain 1939–1945* (New Haven and London: Yale University Press, 2007); and Juliet Gardiner, *The Blitz: the British Under Attack* (London: Harper Press, 2010). I am also grateful to Roger Tolson of the Imperial War Museum for his advice.

1 Bill Brandt, *Camera in London* (London and New York: The Focal Press, 1948), p.81.
2 Cecil Beaton, with a commentary by James Pope-Hennessy, *History Under Fire: 52 Photographs of Air Raid Damage to London Buildings, 1940–41* (London: Batsford, 1941), p.V.
3 Ibid.
4 Ibid., pp.42, 45.
5 *Grim Glory: Pictures of Britain under Fire*, edited by Ernestine Carter, preface by Edward R. Murrow, photographs by Lee Miller and others (London: Lund Humphries/Scribners, 1941), n.p.
6 Ibid.

magnificent, cannot be considered as criminal as the bombing of living civilians'.[3] Nevertheless, 'the loss of ten Wren churches in one night [29–30 December 1940] is something that made London gasp … the destruction … filled London with anger'.[4]

The word 'anger' is also used to describe the reactions of ordinary Britons in another publication that appeared in May 1941. Edited by Ernestine Carter and with a preface by the veteran CBS broadcaster Ed Murrow, *Grim Glory: Pictures of Britain Under Fire* is more contemporary in feeling than *History under Fire*, with dramatic full-page photographs, cut-outs and pithy captions in large bold type. Some of the most striking photographs in the book are by the *Vogue* photographer Lee Miller, whose Surrealist eye for metamorphic detail was ideal preparation for the incongruous and sometimes gruesome sights she witnessed (fig.3, 7). Miller would later cover the final year of the war for *Vogue* as a combat photographer accredited to the US army in Europe, where she would record even more harrowing scenes, such as the liberation of Buchenwald and Dachau.

Grim Glory, which was reprinted four times in 1941, was aimed at the American market. Both Murrow and Miller were American citizens living in London, while Carter was married to the London director of Scribners, the American publisher which co-published the book. During an air raid on 21 September 1940, Murrow had delivered a broadcast to the USA from the roof of the BBC's headquarters in London. He also visited Coventry the morning after the devastating raid there. In his preface to *Grim Glory* he wrote: 'I would have shown you the open graves of Coventry – broken bodies covered with brown dust, looking like rag dolls cast away by some petulant child, being lifted in tender hands from the basements of homes. This book spares you the more gruesome sights of living and dying in Britain today.'[5] Publications like *Grim Glory*, extolling the 'courage, determination and good humour that sustains the people of this Island',[6] helped to propagate the 'myth of the Blitz' and change US public opinion; though it would be another seven months before Pearl Harbor and the American entry into the war.

Fig.7. Photographs by Lee Miller from
Grim Glory: Pictures of Britain Under Fire, 1941

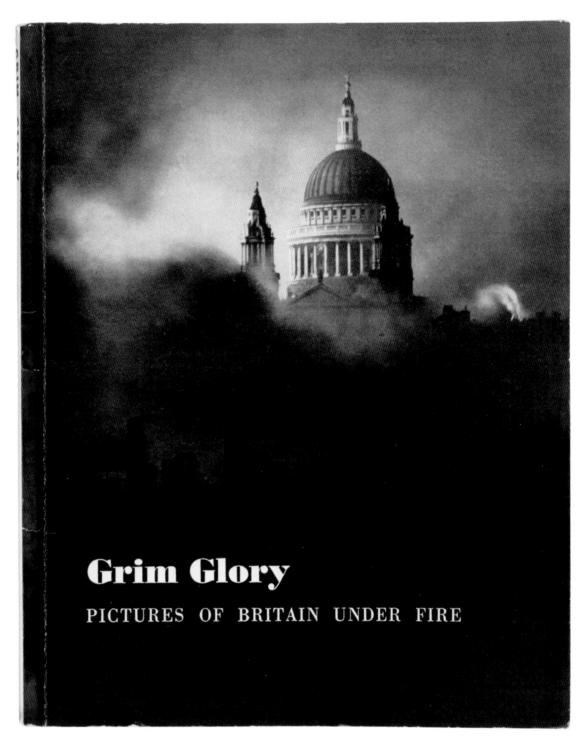

Grim Glory

PICTURES OF BRITAIN UNDER FIRE

Fig. 8. Cover of *Grim Glory: Pictures of Britain
Under Fire*, published in London in 1941 and
reprinted four times that year. The iconic
photograph of St Paul's Cathedral was taken by
Herbert Mason from the roof of the Daily Mail
building on 29 December 1940

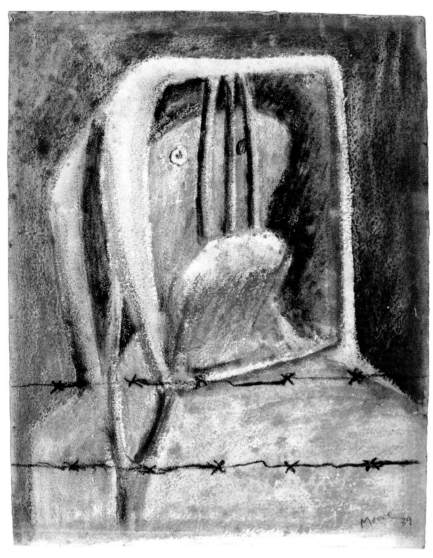

Fig. 9. *Spanish Prisoner*, 1939 (HMF 1464)

Anita Feldman Politics and Invention:
 Moore and the Second World War

We are witnessing in Europe, in Africa, in Asia, three large-scale wars which are being carried on, despite the deeply shocked protests of the whole civilized world, with an inhuman totalitarian ferocity which may well make us despair ... Are we to stand aside while these forces complete the wreck of our civilization?[1]

Henry Moore, 1938

For just a few years during the 1930s London produced one of the most dynamic artistic exchanges in European history. The leafy suburb of Hampstead became a centre for artists, intellectuals, writers and architects from all over Europe, driven there not by a search for inspiration but by the spread of Fascism throughout the continent. Henry Moore's involvement with this group, and his unique contribution to the arts during the war era, reveal him as an artist more socially and politically involved than hitherto acknowledged, and this is supported in his own writing.

From 1934 to 1939, experimentation in the arts was like an electric charge energising all those who came into contact with it. Its two main currents, Surrealism and Abstraction, polarised the artistic community. Moore's career was just beginning; three years after his first solo exhibition at the Warren Gallery in 1928 he was exhibiting sculpture on the rooftop of the newly opened Selfridges department store as part of the London Group. The same year, 1931, he was selected, along with Jacob Epstein and John Skeaping, to represent Britain at the Venice Biennale. Leicester Galleries – the first in Britain to exhibit the work of Matisse and Picasso – began representing Moore. A profile head carved from an ironstone pebble was to be the first of his works sold to a museum. Dr Max Sauerlandt, Director of the Museum für Kunst und Gewerbe in Hamburg, selected the carving along with seven drawings; they have not been seen since. Following Hitler's rise to power in 1933, Sauerlandt was removed from his post, all 'degenerate' works in the museum collection vanished, and within a year Sauerlandt suffered a heart attack and died.

Moore left his teaching post at the Royal College of Art in 1931 to become Head of Chelsea School of Art. He had married Irina Radetzky, a painting student at the Royal College, in 1929, and moved to a flat and studio at 11a Parkhill Road, adjacent to the studios of Barbara Hepworth, John Skeaping and Ben Nicholson (fig.10).[2] Herbert Read joined the neighbourhood shortly afterwards, as did Paul Nash, F.E. McWilliam, Ivon Hitchens and Roland Penrose. Hampstead residents soon included the writers Adrian Stokes and Geoffrey Grigson, editor of *New Verse*, who later introduced Moore to Stephen Spender. The local meeting place, the Isobar, was part of the Isokon Building on Lawn Road, designed by the Canadian architect Wells Coates with crisp, white modern lines and porthole windows. Jack Pritchard, who commissioned the flats, helped many of the leading Bauhaus artists escape Nazi

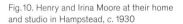

Fig.10. Henry and Irina Moore at their home and studio in Hampstead, *c.* 1930

Germany, including Walter Gropius, Marcel Breuer and László Moholy-Nagy. Other notable neighbours were Naum Gabo, Piet Mondrian and the scientist Julian Huxley. The impact of all these individual thinkers on Moore continued to resonate during and after the war. Gropius later worked with Maxwell Fry on the Impington College project, leading to Moore's first family group maquettes in 1943–44, and on Dartington Hall for which Moore created *Memorial Figure* (1945–46; LH 262) in Hornton stone, in memory of the Socialist reformer Christopher Martin. Breuer would later become the leading architect of the new UNESCO headquarters in Paris, presided over by Huxley, where he commissioned Moore to make a prominent sculpture for the entrance.

Herbert Read famously referred to the conflux of intellectuals in Hampstead as 'a nest of gentle artists',[3] yet the group was notoriously competitive, divisive, determined and politically aware. It resulted in a few intense and dynamic, if short-lived, associations. A group that included Paul Nash, Barbara Hepworth and Ben Nicholson formed in 1933 as Unit One. Their publication edited by Read – *Unit One: The Modern Movement in English Architecture, Painting and Sculpture* – appeared the following year, and included Moore's notes on the observation of natural forms and vitality of expression.[4] *Circle: International Survey of Constructive Art*, edited by Leslie Martin, Nicholson and Gabo, followed in 1937. A manifesto of Constructivism, its contributors included Mondrian, Moholy-Nagy, Read and Gropius, as well as Moore.[5] Moore's treatise on modern form entitled 'Notes on Sculpture' was first published by *The Listener*, also in 1937, as 'The Sculptor Speaks'.[6] Here Moore gives compelling argument for inspiration from forms of nature, from water-worn pebbles with holes through them, to 'universal shapes to which everybody is subconsciously conditioned'.

Rivalries between the artists quickly led to the demise both of Unit One, which enjoyed its first and last exhibition at the Mayor Gallery in 1934, and another group, the Seven and Five Society, in 1935.[7] While Moore was allied with the Constructivist aim to integrate modern art with daily life, at the same time he began experimenting with scale and juxtaposing forms to reveal unexpected relationships. He also worked with found objects, using bones, flints, stones and seashells as starting points for 'transformation drawings', where the forms of nature metamorphose into figures. Ideas of metamorphosis between man and nature, figure and landscape, would continue to inform his work for fifty years. Moore served on the organising committee for the *International Surrealist Exhibition* held in London in 1936 at the New Burlington Galleries, and contributed three drawings and four sculptures.[8] One of these, *Reclining Figure* (1931; fig. 11), reveals a piercing of the body with parallel apertures, anticipating Moore's sculptural use of string.

Fig. 11. *Reclining Figure*, 1931 (LH 101)

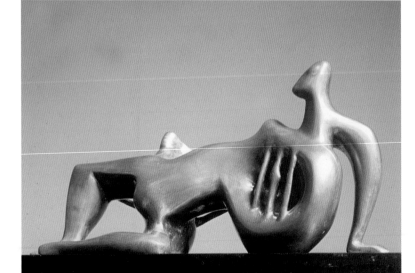

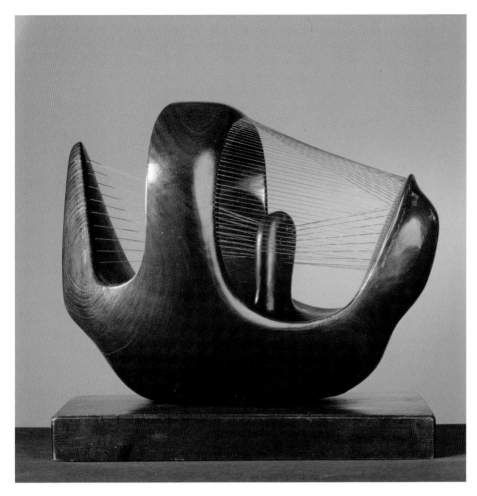

Fig.12. *Bird Basket*, 1939 (LH 205)

Incised lines, strings and flat geometric spatial planes began to appear in Moore's work. Gabo, who immigrated to London in 1935, had been making stringed sculptures with his brother Antoine Pevsner in Paris. Their *Constructivist Manifesto*, issued in Russia a decade previously, was dedicated to the exploration of space through the manipulation of new forms and materials. This corresponded to the utopian Bauhaus philosophy of a classless, machine-age synthesis of all the arts. Miriam Gabo recalled that in the late 1930s, after seeing one of Moore's stringed figure sculptures in his studio, Gabo declared: 'Strings, I'll show them what to do with strings.'[9] Moore's approach was always more organic, however, and intrinsically related to his excavation of internal forms. His awareness of Gabo's work, combined with photographs of similar models by Man Ray reproduced in *Cahiers d'art* in 1936,[10] may have been the impetus that led him to London's Science Museum: 'I was fascinated by the mathematical models I saw there which had been made to illustrate the difference of the form that is halfway between a square and a circle … One end could be twisted to produce forms that would be terribly difficult to draw on a flat surface.'[11] After only three years, however, Moore found the stringed works to be too removed from fundamental human experience to be truly satisfying.

It was during this highly experimental period that Moore began in his drawings to line up both real and imagined sculptures against walls perforated with geometric recesses. These confined scenes yield no clues as to the seemingly arbitrary scale of the imprisoned objects, perhaps reflecting the anxiety of the late 1930s. There is an unsettling quality in objects that are familiar and yet remain unknowable.[12] This is partially the result of altering the scale of existing sculptures and interspersing them with ideas for sculptures that have never been created.

Works such as *Recumbent Figure* (1938; cat.1) and *Bird Basket* (1939; fig.12) reveal how far Moore had moved away from the concept of 'truth to materials' towards a complete opening out of form. Ultimately this direction would lead to his increased use of bronze, which permitted unlimited freedom of form invention. Unlike his earlier carvings, where the form is interconnected with the inherent shape and strength of the block of stone or wood, Moore was now stretching the limitations of the material, opening it out as fully as possible. Carved in fossilized green Hornton stone for the architect Serge Chermayeff's garden, Moore's *Recumbent Figure* further explores the fusion of modern art and landscape.

It is frequently assumed that Moore was apolitical, yet he joined and exhibited with the Artists International Association, a group of artists and intellectuals united against Fascism; much later he was a founding member of the Campaign for Nuclear Disarmament. With Irina and friends Raymond and Gin Coxon, Moore travelled to Spain in the summer of 1934, driving down the coastal road from Pamplona to Santander to the prehistoric caves at Altamira. The trip also took in Madrid, Toledo and Barcelona, including the fourteenth-century paintings and sculptures at Vich, just north of the Catalan capital. The political climate in Spain must have left its mark. Two years later, horrified by the catastrophic events befalling the country, Moore signed the *Surrealist Manifesto* calling for an end to the British policy of non-intervention, as Spain was engulfed in civil war.

In the summer of 1937 Moore accompanied Penrose to Paris, and with Alberto Giacometti, Paul Eluard, André Breton and Max Ernst, visited Picasso in his studio to see *Guernica* in progress. The political and aesthetic impact of *Guernica* was immense, its use of Surrealist imagery capturing the horror of the first-ever bombing raid on civilian targets, carried out by the German Luftwaffe at Franco's request in retaliation for Basque resistance. The subject anticipated the plight that would befall London, and much of Europe, within a few years.[13] Moore's *Three Points* (1939; cat.2), with its sharp protrusions nearly touching, heightening its tension, bears a strong resemblance to the open mouths in *Guernica* that scream in agony with tongues pointed like daggers (fig.13). In a highly worked page from Moore's sketchbook of 1939–40, *Three Points* reappears, is reworked, twisted and elongated to transform into other sculptural ideas (fig.14).

Soon after its completion, *Guernica* toured England, at the same time as Moore was designing the broadsheet for the 1938 Surrealist declaration *We Ask Your Attention* (fig.15). In this work a line emanating from the eye takes on a life of its own in the form of eyeglasses hooked onto an imagined ear, unifying text and image in equal treatment of positive and negative space. The document is a call for action for various parties of the United Front to 'intervene as poets, artists and intellectuals by

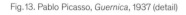
Fig.13. Pablo Picasso, *Guernica*, 1937 (detail)

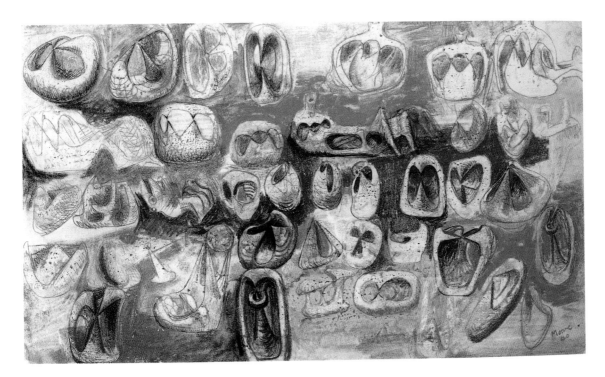

Fig.14. *Pointed Forms*, 1940 (HMF 1496); page from *Ideas for Sculpture Drawing Book*

Fig.15. *We Ask Your Attention*, 1938, broadsheet of the Surrealist declaration designed by Henry Moore

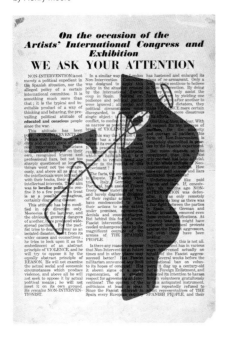

violent or subtle subversion'. Moore attempted to return to Spain that year as part of a delegation of writers and artists opposing Fascism, but was refused permission to travel by the British government.[14] Moore and Read became the primary supporters of the first British Artists' Congress, established to promote art education in Britain as well as artists' trade unions. In the meantime, Moore made a number of drawings with the intention of producing a lithograph to be sold in aid of Republicans who had fled Spain only to be held in French internment camps. The final image is of a single head peering from the bars of a helmet-like enclosure behind barbed wire (fig.9, p.14). Before it could be editioned, however, the printers had been forced to close: war had been declared in England.

Moore was swimming near Dover when news of war with Germany was announced. He captured the moment in his drawing *September 3rd, 1939* (fig.23, p.28) in which bathers are reduced to automata: with helmeted heads and disjointed features they are denied any individuality. Helpless to the unfolding events, the figures are caught unprotected in the sea. The sea port's famed white cliffs form a wall of intense red, a forbidding reminder that invasion would most likely strike this part of the coast. This was the first of Moore's war drawings and the only one of his works to bear an exact date. It would be another year before he began the series of Shelter Drawings.

Having already served in the trenches in the First World War, where he was one of only a few survivors from a regiment of over 400 killed in a gas attack at the Battle of Cambrai, Moore was now uncertain of his wartime role. For the first few months he attempted to continue working as usual and exhibited his recently completed elmwood *Reclining Figure* (1939; LH 210) at the Leicester Galleries in London.[15] But when France fell in June 1940, it became apparent that continuing to sculpt was no longer tenable. Lack of materials and evacuation meant that it was simply not practical to begin time-consuming carving. Initially Moore continued to stay at Burcrott, his cottage in Kent, even though it had become a restricted area. The Chelsea School of Art, where he had been teaching, closed, but its affiliated college, the Chelsea Polytechnic, offered a course in precision tool-making that Moore, together with Graham Sutherland, decided could be the way forward. Moore and Irina left Kent to return to their London flat at 11a Parkhill Road, and to save money they moved shortly afterwards

into the adjacent, smaller flat at 7 Mall Studios. This space had previously been occupied by Hepworth and Nicholson, who fled to Cornwall with their children. Moore wrote: 'We're sorry for your sake you've had to give it up … But I'm glad it's us who are to have it, so that it stays, as it were, in the family.'[16] The Hampstead gathering, so close until this point, rapidly dissolved; several, including Breuer, Chermayeff, Gropius and Mondrian, emigrated to the United States.

The uncertainty of Moore's position is reflected in a letter he wrote to Read: 'I'm a couple of months over the present military age limit. But if the war goes on for long, the limit won't stay at 41, I'm sure. Having been in the trenches in the last war, not for anywhere near as long as you were, but long enough not to want it twice in one lifetime – I hope it won't come to that. But I hate Fascism and Nazism so much that if the war gets closer & more intense & that grows into a main issue, the state of mind to go on quietly working might not be possible to keep up & apart from necessity one might willingly seek some part in it.'[17]

Moore's candid letters to his friend, the poet Arthur Sale, are particularly revealing of his life during the war, and of his political views. The two met in 1936 at the opening of the *International Surrealist Exhibition* in London. A month into the war Moore wrote: 'I can't say with complete certainty that there aren't some things I might find myself ready to fight for, & so I can't call myself a wholly consistent conscientious objector … Although no one can say there's democracy in England in the real sense of the word, & although British Imperialism has a pretty bloody record, I hate Fascism & Nazism, & all its aims & ideology so intensely, that I don't think I could refuse to help in trying to prevent it from being victorious. However when the time comes that I'm asked, or have got to do something in this war, I hope it will be something less destructive than taking part in the actual fighting & killing. There ought to be ways of being used as a sculptor, – in making of splints etc, or jobs connected with plastic surgery, – though the most likely thing I suppose is camouflage work.'[18]

By April 1940 Moore's disillusionment was clear: 'You asked in your last letter if I still feel … pro-war! I hate the war! Apart from its most terrible side of all, the maiming & killing it's going to bring, – it blinds most people to all the real values in life, – holds back the progress of all those activities one most believes worth while, & it encourages & gives opportunities to all the reactionary elements in society. I still think the war could have been avoided if we'd had a government less terrified of socialism & more sympathetic & ready to work with Russia & I still think the Chamberlain government is about the worst we've ever had – it helped rear the Hitler Germany & now this country finds it has to fight Nazi Germany & in doing so will, I agree with you, take over too many of its fascist methods … Its [sic] conceivable, but extremely unlikely, that anti-war movements in England might stop the war from this side, but I should say that the stranglehold which the Nazis have over Germany can never be the slightest bit loosened without some serious setback for them in the war itself, so that if the war stopped now, it would be a virtual victory for Hitler & Mussolini, and a Europe dominated by Fascist ideas –'.[19]

It was during this time that Sir Kenneth Clark, Director of London's National Gallery, led the newly formed War Artists' Advisory Committee (WAAC) and invited Moore to contribute work. Although Moore had experimented with various ideas for war subjects, he hadn't yet found anything substantial enough to develop fully, and he turned the offer down. Some of his initial ideas are worked out in the carefully composed *Eighteen Ideas for War Drawings* (1940; cat.13) with subjects ranging from crashed aircraft to burning cows and 'gun shells bursting like stars'. In another drawing of 1940, *Sheet of Heads Showing Sections* (fig.16), disembodied heads were reworked as helmeted studies of internal and external forms; Moore returned to these ideas in sculptural form immediately after the war (for example, cat.4). But it was not until Moore had spent a night in the Underground shelters in London during a September 1940 bombing raid that he came upon the subject that would be his most significant contribution as a war artist. He immediately noticed how the huddled and sleeping

shelterers resembled his own seated and reclining figures, and how the tunnels evoked his own hollowing out of sculptural form. In a letter to Sale, Moore described the scene he encountered: 'In the daytime in London, I can't believe any bombs can fall, – the streets seem just as full as ever, with people on buses, & in the shops, going along just as usual, until you come across a slice of a house reduced to a mess of plaster, laths and broken glass, and on each side above it film sets of interiors with pictures in position on the walls & a bedroom door flapping on its hinges ... But what doesn't seem like a cinematograph reel to me, are the queues, before four o'clock outside some of the tube stations, of poor looking women & children waiting to be let in to take shelter for the night – & the dirty old bits of blankets & cloths & pillows stretched out on the tube platforms – Its [sic] about the most pathetic, sordid, & disheartening sight I hope to see.'[20]

Clark saw Moore's first Shelter Sketchbook in December 1940, and commissioned four large drawings for the WAAC. By September 1941, the WAAC acquired thirteen more for distribution throughout museums in the UK. Two sketchbooks on the subject remain intact, while at least another four were disbanded.[21] Nearly eighty larger drawings were either scaled up from the sketches or are variations of the ideas worked out in them.

Moore had left London after his flat was damaged in a bombing raid. From 1940 until his death in 1986, Moore lived at Hoglands, in the rural Hertfordshire hamlet of Perry Green thirty miles north of London, where he joined the Home Guard. What began as a temporary retreat became permanent, and ultimately had enormous repercussions on his working methods – particularly sculpting in the open air and on a monumental scale. The old village shop, adjacent to a pair of cottages, was turned into a studio to contain his growing collection of found objects, including the flints and bones that were plentiful in the soil around the old farm.

In his description of the events leading to the move to Hertfordshire, Moore mentions his own experience sheltering in the Underground: 'None of my work was hurt in the damaged studio except a few little clay models were broken & one of the early stone reclining figures was chipped in places in the falling glass. I'm hoping that the large reclining wooden figure (which was the centrepiece in the Leicester Galleries show), which I think is about the best (anyhow it's the biggest & took longest

Fig.16. *Sheet of Heads Showing Sections*, 1940 (HMF 1508)

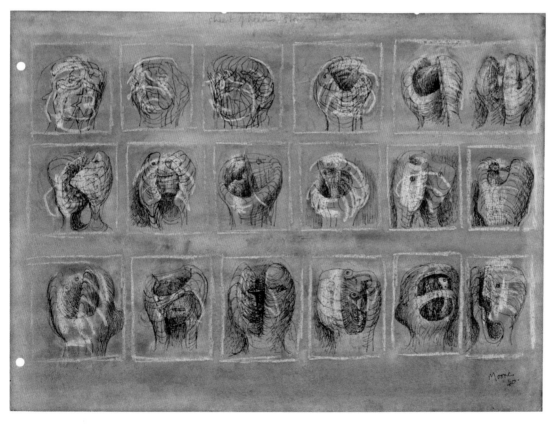

to do) may be going to America,[22] but it will probably be weeks before it goes, in the present disorganised transport conditions due to the bombing of London … But all the other work in the studio I can't attempt to make arrangements for – they'll just have to take their chance. I've had to go several days each week into London, to see about various things, – but here is near enough to London to get back easily each night – We stayed there only one night recently, spending part of the night sheltering from the shrapnel from the barrage guns, in Belsize Park Tube Station, & the remainder of the night in a friend's garden shelter!'[23]

The Chelsea School of Art reopened briefly, enabling Moore to return to teaching. His vivid and poignant observations of London life, simultaneously encapsulating both commonality and alienation, would ultimately become the driving force behind the Shelter Drawings: 'Chelsea School of Art has had a bomb in the middle of it, not a very heavy one, but leaving only half of the school useable – & my particular room, the sculpture room got an incendiary bomb, but that was discovered & put out before it had done more than burn part of the floor. The unreality of it all I think, is because of the complete contrast of everyday normal life, side by side with sudden devastation & danger … The night time in London is like another world – The noise is terrific & everything seems to be going on immediately over one's own little spot – & the unreality is that of exaggeration like in a nightmare … Sudden destruction, earth-quakes & the like, violent death & injury may always come to people however we run the world – But this fear full [sic] & miserable nightly tube life seems scandalous.'[24]

Moore's response was to depict scenes of devastation with a penetrating humanity that captured a more general grim reality; rather than individual portraits, his drawings embody mankind. Alienation, helplessness and despair coexist with enduring human

Fig.17. *Two Sleeping Figures*, 1941 (HMF 1755)

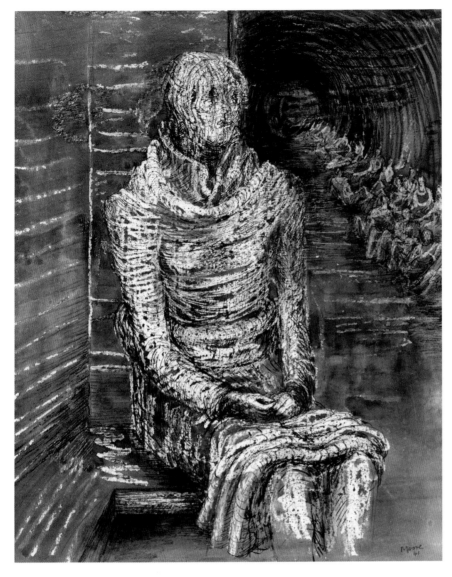

Fig. 18. *Woman Seated in the Underground*,
1941 (HMF 1828)

attributes such as the sharing of blankets with strangers, and mothers protectively holding their children. These are not battle scenes or images of death – those depicted are survivors. The sheer scale and psychological shock of the events in London from 1940 to 1941, as one quarter of the city lay in ruins and 100,000 people each night sought shelter underground, called for a drastic change of approach. The shock here was what Peter Fuller described as 'The Shock of the Old' – the past returning.[25] The conflicts between the Surrealists and the Constructivists now seemed too remote and aloof from the immediate gravity of the situation. For the first time, Moore turned to sources from the Renaissance and antiquity to formulate a particularly humanist and yet modern aesthetic. He found it necessary to rediscover other sources of inspiration, to invent a way of depicting the human condition that transcended any particular event or moment. 'And here, curiously enough', he wrote, 'is where, in looking back, my Italian trip and the Mediterranean tradition came once more to the surface. There was no discarding of those other interests in archaic art and the art of primitive peoples, but rather a clearer tension between this approach and the humanist emphasis.'[26]

Moore had first visited Italy in 1925 on a travel grant from the Royal College of Art. At that time, he filled notebooks with sketches from the works of Masaccio, Mantegna, Parmigianino and Giotto, among others. Now he returned to these ideas, and in the Shelter Drawings we find studies of drapery, intimate portrayals of a mother and child,

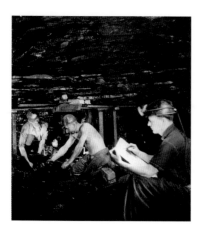

Fig. 19. Moore sketching miners at Wheldale Colliery, Castleford, January 1942

and chiaroscuro effects to depict the subtleties of figures emerging from the darkness. Yet at the same time Moore's drawings are distinctly modern. There is psychological tension in the groupings of alienated figures thrust together by circumstance in a claustrophobic atmosphere. Strong complementary and contrasting colours heighten the psychological tension: purple and yellow, vivid orange and black, pink and green. The sketches also continue his exploration of the reclining figure in innumerable poses, often descending as far as the eye can see into the abyss.

For all their immediacy, none of the Shelter Drawings, apart from seven quick sketches (fig. 17), were made in the Underground itself.[27] Instead, Moore made notes and worked from memory back at Perry Green, as he explained: 'For the drawings of underground shelters, I did no drawing of course in the underground itself. I can't see how anybody could have had the cheek to draw people there. I just wandered about & tried not to show that I was looking at anything, & my drawings were made from general impressions & based on what I remembered when I got home.'[28]

Moore's aides-memoire are found on many of the sketchbook pages, sometimes as lists of subjects or reminders of a scene: '… Remember figures last Wednesday night (Piccadilly Tube) / Two sleeping figures (seen from above) sharing cream coloured / thin blanket (drapery closely stuck to form) / Hands & arms – Try positions oneself …' (cat. 59). Moore would draw from notes and from memory for several days, often relating many experiences in a single composition. Using wax crayon, he drew the basic lines and forms of the composition. A watercolour wash allowed the wax figures to emerge from the darkness. The forms were picked out further in pen and ink and heightened with chalk or gouache. Moore would then often scrape down the surface of the wax with a pallet knife. It was a vigorous, sculptural way of drawing, building up the surface with layers of different media and virtually carving them back.

This technique was carried over into the Coalmining Drawings. Returning to his home town of Castleford in December 1941, Moore ventured into the depths of Wheldale Colliery – the same mine his father had worked. He returned again in January 1942 and spent over a week in the mine (fig. 19). The results are some of the most poignant and subtly personal renderings of the male figure (in itself a rarity) in Moore's œuvre. Largely dismissed by Moore at the time, they have been afforded far less attention than the Shelter Drawings. 'My coalmine drawings will be on show in the War Artists' Exhibition at the National Gallery … I didn't know whether to be pleased or not over them when I handed them over. In retrospect I'm beginning to think that 3 or 4 of them are not too bad.'[29]

Fig. 20. *Coalminers*, 1942 (HMF 1996a)

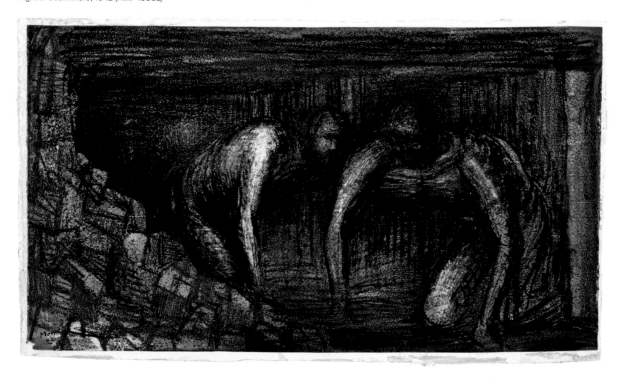

The Coalmining Drawings are acutely modern. With a dark wash the wax figures appear from claustrophobic sections held up by seemingly precarious pit props. Boundaries are tense and uncertain, often indistinguishable in the dark void. The eye needs to adjust to the darkness in order to read the scene, much of which is loosely suggested by streaks of pigment. Unlike the Shelter Drawings, the figures are depicted in relative action, at work rather than in a timeless stasis. Moore made some sketches in situ and also worked from notes, filling four sketchbooks with pencil, wax and black ink washes, from which twenty-eight larger drawings were made (fig. 20; see also cat. 80–87).

Moore's *Madonna and Child* (1943–44; fig. 33, p. 40) for St Matthew's Church, Northampton is one of his very few wartime sculptures.[30] Here, alienation is replaced by a sense of aloofness. Carved in Hornton stone, the weight of the Madonna adds to the real tangibility and permanence of her presence. She is modern and yet reconnects to the Western tradition of ecclesiastical commissions, which for so long had been absent in contemporary art. Moore struggled with the idea of creating a sculpture for a religious setting. 'I believe that art in itself is akin to religion, art is, in fact, another expression of the belief that life is worth living', he wrote.[31] Moore was also approached by Basil Spence to carve eight reliefs for the rebuilt Coventry Cathedral, destroyed in the Blitz, along with Epstein, John Piper and Graham Sutherland, who would produce work for the interior. But Moore resented the role of sculpture as architectural decoration, being far more interested in exploring three-dimensional form, and declined the commission.[32]

At the same time he felt strongly that modern art should have a pivotal role in society, as a focus for the community: schools, cultural centres and the church were a part of that ethos. From 1943 to 1946 Moore even made numerous bold designs for dress and upholstery fabrics, attempting to integrate modern art into daily life (fig. 21). The brilliant colour in these designs looks ahead, away from the drab palette and clothing rations of wartime. The contrast with the Coalmining Drawings which immediately preceded them could not have been more stark. And yet the compositions are drawn in the same technique, with a building up of media, from a wax outline to watercolour wash resist, then highlights in gouache and finally definition of the forms through pen and ink. Brilliant pinks and greens, whimsical blue caterpillars, piano keys and flowers trailing through barbed wire all serve as indicators of having survived into a new era.

With over a million homes in London alone destroyed or damaged, it is difficult to overestimate the impact of the Second World War on the arts in Britain. The traditional war memorial or monument seemed irrelevant to a disillusioned and largely homeless population. Rationing continued well into the following decade, and the unfolding realisation of the atrocities committed in Europe provided an additional shock. Moore's *Family Group* (1948; cat. 3) was neither monument nor memorial, but an affirmation of life itself, a testament to the spirit of survival and renewal. His inspired use of themes such as the family, mother and child, and the reclining figure provided reassurance both in terms of their continuity and their modern treatment. In a climate of post-war social reform, Moore became increasingly active within the art establishment, helping to restart the sculpture department of the Chelsea School of Art, and becoming a member of the Art Panel of the Arts Council of Great Britain, as well as a Trustee of the Tate Gallery and the National Gallery. Despite his acceptance within the establishment, Moore's work continued to be challenging. In 1952 he addressed the role of the artist in a paper entitled 'The Sculptor in Modern Society' at the International Conference of Artists in Venice: 'The evolution of art cannot be forced – nor can it be retarded by an obstinate adherence to outworn conventions … there is no doubt that the public authority that has the vision and the courage to commission forward-looking works of art, the work of art with what might be called prophetic vision, is doing more for art than the public authority that plays for safety and gives the public what the public does not object to.'[33]

Fig. 21. *Barbed Wire* fabric design, c. 1946 (TEX 4.13)

Moore's presence at the 1950 Venice Biennale was signalled with a work at the entrance to the British pavilion. Only two years earlier he had represented Britain with a solo exhibition, taking home the coveted International Sculpture Prize. Now the bone-white, disturbingly alien forms of Moore's *Double Standing Figure* (1950; fig.22) heralded a new generation of British sculptors, including Bernard Meadows, Kenneth Armitage, Lynn Chadwick and Reg Butler, whose work would be characterised by similar tense forms. Read, referring to the group, coined the term 'Geometry of Fear' to characterise their angst-ridden, particularly post-war, aesthetic.

Moore's first and long-awaited retrospective at the Tate Gallery in 1951 was followed only two days later by the opening of the Festival of Britain. The festival enthusiastically embraced the arts and technology, looking towards the future with radiant structures like the 'Skylon' and the 'Dome of Discovery'. Despite being officially requested by the Arts Council to create another family group, Moore felt that the occasion – more of a national celebration – called for something different. He produced one of his boldest works, *Reclining Figure: Festival* (1951; fig.32, p.38; working model, cat.5). It was, he said, the first sculpture of his in which space and form were completely inseparable. In contrast, Moore's warrior figures emerge in this era as poignant embodiments of the plight of mankind (cat.6). They are pared down to the core of their being. Retaining dignity, they are nevertheless not triumphant but truncated, fallen, vulnerable, without weapons to resist their fate. They are what is left of humanity once the deprivations of war have stripped everything else away. Taking inspiration from the Parthenon, and a visit to Greece in 1951, Moore's warriors are similarly conceived from an enduring subject matter and in a material – bronze – that will likewise stand the test of time.

Fig.22. Moore with *Double Standing Figure* (LH 291) in Hoglands garden, Perry Green, 1950

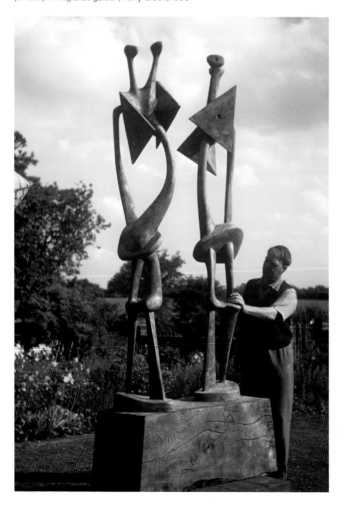

1 Letter from Moore printed in the *Yorkshire Post,* March 1938, in Roger Berthoud, *The Life of Henry Moore* (London: Giles de la Mare, 2002), p.158.

2 Irina Radetzky was born in Kiev in 1907, and spent her childhood in Moscow and St Petersburg. Having fled the revolution of 1917 which claimed her father's life, she lived with her grandmother in the Crimea, and returned to Moscow at the age of eleven following her grandmother's death. Her mother had in the meantime been evacuated to Paris with the assistance of the French military mission and remarried a British Officer. Irina was finally traced at the age of thirteen and discovered to be suffering from malnourishment; she was smuggled out to Paris where she rejoined her mother for two years before she was sent to live with her new stepfather's family in Buckinghamshire.

3 Herbert Read, 'A Nest of Gentle Artists', *Apollo* (September 1962), pp.536–40.

4 Herbert Read (ed.), *Unit One: The Modern Movement in English Architecture, Painting and Sculpture* (London: Cassell, 1934), pp.29–30.

5 J.L. Martin, Ben Nicholson, Naum Gabo (eds.), *Circle: International Survey of Constructive Art* (London: Faber and Faber, 1937), p.118; Moore's contribution is reprinted in Alan Wilkinson (ed.), *Henry Moore: Writings and Conversations* (Aldershot: Lund Humphries, 2002), p.193.

6 Henry Moore, 'The Sculptor Speaks', *The Listener* (18 August 1937). Moore's text was later reprinted in volume 1 of the Lund Humphries catalogue raisonné of Moore's sculpture with the artist's original title.

7 The Seven and Five Society had existed as a union of seven painters and five sculptors from as early as 1920; members included Leon Underwood, Ivon Hitchens and H.S. Williamson (later Principal of Chelsea School of Art). They were founded with a free sort of 'anti-manifesto', declaring their desire to pursue their own calling. Nicholson later shook the group up by insisting that only non-representational art should be condoned, leading to the resignation of several members.

8 Committee members also included Herbert Read, Paul Nash, Hugh Sykes Davies and Humphrey Jennings.

9 Martin Hammer and Christina Lodder, *Constructing Modernity: The Art and Career of Naum Gabo* (New Haven and London: Yale University Press, 2000), p.288.

10 Man Ray photographed mathematical stringed models on exhibition at the Institut Henri Poincaré, Paris, for the Object-Issue of *Cahiers d'art,* XI, nos. 1–2 (1936), pp.7, 9, 11–20; see Christa Lichtenstern, 'Henry Moore and Surrealism', *Burlington Magazine,* vol. CXXIII, no. 944 (November 1981), p.651.

11 John Hedgecoe (ed.), *Henry Spencer Moore* (London: Nelson, 1968), p.105.

12 See Andrew Causey, 'Henry Moore and the Uncanny' in Jane Beckett and Fiona Russell (eds.), *Henry Moore: Critical Essays* (Aldershot: Ashgate, 2003), pp.81–106.

13 A cast of Moore's final work, *Large Figure in a Shelter,* 1985–86 (LH 652c), was created for the Parque de los Pueblos de Europa in Guernica.

14 The delegation also included Stephen Spender, William Hayter and Jacob Epstein.

15 The carving, LH 210, was purchased by Surrealist Gordon Onslow Ford and later acquired by the Detroit Institute of Arts.

16 Letter from Moore to Hepworth in October or early November 1939; quoted in Wilkinson (ed.), *Henry Moore: Writings and Conversations*, p.59, n. 44.

17 Letter from Moore to Herbert and Ludo Read, 9 October 1939; quoted in Wilkinson (ed.), *Henry Moore: Writings and Conversations*, p.60.

18 Letter from Moore to Arthur Sale, 8 October 1939; Imperial War Museum.

19 Letter from Moore to Arthur Sale, 30 April–14 May 1940; Imperial War Museum.

20 Letter from Moore to Arthur Sale, 10 October 1940; Imperial War Museum.

21 Of the two intact sketchbooks, Sir Kenneth Clark's wife Jane left the First Shelter Sketchbook to the British Museum, while the Second Shelter Sketchbook was given to The Henry Moore Foundation by Irina Moore.

22 LH 210; see note 15.

23 Letter from Moore to Arthur Sale, 19 September 1940; Imperial War Museum.

24 Letter from Moore to Arthur Sale, 10 October 1940; Imperial War Museum.

25 Art historian Peter Fuller was writing a critical reappraisal of Moore's work at the time of his tragic death in 1990. His notes were subsequently published in Anthony O'Hear (ed.), *Henry Moore: An interpretation* (London: Methuen, 1993).

26 James Johnson Sweeney, 'Henry Moore', *Partisan Review* (March–April 1947), p. 185.

27 The seven sketches are HMF 1739, 1740, 1755, 1756, 1757, 1758, 1758a.

28 Letter from Moore to Arthur Sale, 22 October 1941; Imperial War Museum.

29 Letter from Moore to Arthur Sale, 5 August 1942; Imperial War Museum.

30 Another *Madonna and Child* was carved from Hornton stone in 1948–49 for the Church of St Peter in Claydon (LH 270).

31 J.P. Hodin, 'Quand les artistes parlent du sacré', *Vingtième Siècle*, Paris (December 1964); quoted in Wilkinson (ed.), *Henry Moore: Writings and Conversations*, p.129.

32 Interviews with Richard Cork, 1 December 1980 and 26 May 1981, in S. Nairne and N. Serota (eds.), *British Sculpture in the Twentieth Century* (London: Whitechapel Art Gallery, 1981), p. 97.

33 UNESCO, International Conference of Artists, Venice 1952; typescript in The Henry Moore Foundation archive.

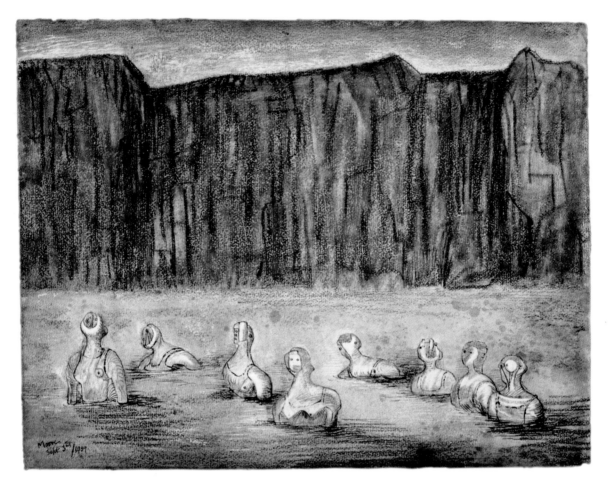

Fig. 23. *September 3rd, 1939*, 1939
(HMF 1551)

Alexei Mitin The Shelter Drawings

Henry Moore created his Shelter Drawings during the Blitz – the devastating aerial assault on Great Britain by Nazi Germany which lasted from 7 September 1940 to 10 May 1941. The Blitz began with the bombing of London, but many other major military and industrial centres, such as Belfast, Bristol, Coventry, Liverpool and Manchester, were also subjected to heavy air attack. Hitler's aim was to demoralise and destroy the civilian population. By the end of May 1941 more than 43,000 innocent civilians had been killed by the bombardments and more than a million houses destroyed or damaged.

On Sunday 3 September 1939, in response to the German invasion of Poland, Great Britain declared war on Germany. Henry Moore was on holiday in Dover, where he heard British Prime Minister Neville Chamberlain's radio broadcast that the country was now at war. At forty-one, the artist was too old to be called up. The only question facing him was how long he would be able to continue teaching at Chelsea School of Art. With his assistant, Bernard Meadows, Moore went down to the beach where he made a small drawing of swimmers against the backdrop of the forbidding cliffs; he titled it 'September 3rd, 1939' (fig.23). The bathers, instead of being shown alive and animated in the water, are depicted as if frozen to the spot. They are looking towards the enemy continent, apparently transfixed by the threat emanating from its shores. The drama of the scene is accentuated still further by the high cliffs rising up in the background. The faces of the swimmers are like puppets or theatrical masks. By introducing this Surrealist touch to an ordinary, everyday subject, Moore has created a strange, ambiguous image. This small drawing, in which realism merges with fantasy, and artistic expressiveness with the passivity of the figures, was the forerunner of the unique series known as the Shelter Drawings that was to bring the sculptor international acclaim.[1]

Early in the summer of 1940 the War Artists' Advisory Committee (WAAC) suggested that Moore do a series of drawings on the theme of the war, and his friend Sir Kenneth Clark, director of the National Gallery and a collector of Moore's works, recommended him for the position of 'official war artist'. For several weeks Moore could not decide how to respond: seeing himself principally as a Surrealist artist, he felt that his work was unsuited to depicting the war. He was determined, however, to continue working, and so it was inevitable that he would have to consider his role within the context of war. In the summer of 1940 Moore made his first sketches

Fig.24. *Group of Shelterers during an Air Raid*, 1941 (HMF 1808)

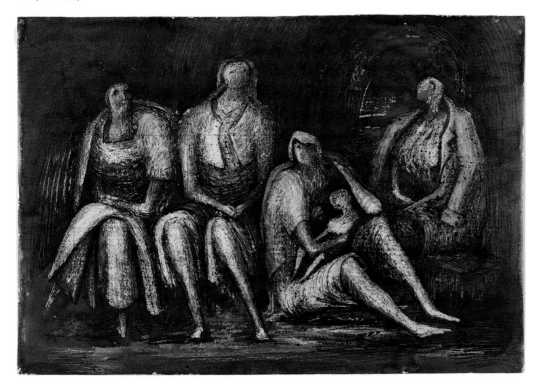

Fig.25. *War Drawing: Aeroplanes*, 1940
(HMF 1552)

showing its effects: ruined buildings, a shot-down German plane, victims of the night-time air raids lying in the rubble (fig.25; see also cat.13). The artist's attitude to the beginning of the war is clearly revealed in his correspondence of the time. In a letter to Clark on 1 October 1939, Moore wrote: 'For I hate intensely all that Fascism and Nazism stands for, & if it should win it might be the end in Europe of all the painting, sculpture, music, architecture, literature which we all believe in.'[2] Writing later to Arthur Sale, he added, 'I still think the war could have been avoided if we'd had a government less terrified of socialism & more sympathetic & ready to work with Russia & I still think the Chamberlain government is about the worst we've ever had – it helped rear the Hitler Germany.'[3] In September 1940 Henry Moore finally accepted Clark's proposal to undertake a commission for the WAAC.

The ferocity of the German bombardments increased with every night. Since the official bomb shelters provided insufficient space, Londoners found their own solution, one that caused the authorities a certain amount of consternation: they took shelter from the nightly air raids in the impenetrable labyrinthine depths of the city's Underground. Here, cut off from life on the outside, tormented by the worry of what might be happening to their homes, they would try to find a place to sleep on the platforms, in the stifling, unventilated atmosphere where there was little if any privacy. The people who shared this refuge became a unique fraternity, a living embodiment of the city's spirit of community. That such an enormous group could survive in these most challenging of conditions was testament to traditional British qualities: a belief in fair play, rational behaviour, sang-froid and a sense of humour.

The government, however, opposed this unauthorised use of the Underground. It had earmarked the stations for official usage and for the movement of troops. The condition of the subterranean population was also a matter of concern for the authorities. 'We ought not to encourage a permanent day and night population deep underground', declared the Minister for Home Security, Herbert Morrison. 'If that spirit gets abroad we are defeated.'[4] Those who remained above ground were also nervous of these underground dwellers, as if resurrecting old superstitious fears of miners being the spawn of darkness. The real issue for the authorities, however, was not defeatism but the fear that this experience of underground life might encourage subversive and egalitarian tendencies. One of the leaflets distributed underground accused the war-time government of 'indifference verging on obduracy, criminal negligence, and heartless disregard for the most elementary of human needs and dignity'.[5]

In these Londoners, Moore said, 'he was surprised to see hundreds of Henry Moore Reclining Figures'.[6] The idea of the Shelter Drawings came to him as he was heading home on the Northern Line on the night of 11 September 1940, the fourth night of the Blitz. Moore and his wife had been dining with friends, and on the way back to Belsize Park they saw hundreds of people on the platforms – families with bags and blankets, waiting for the air raid to pass. The sight was all the more unexpected as they had only decided to go by Underground, rather than car, at the last minute. At Belsize Park they were not allowed to exit 'because of the fierceness of the barrage'.[7] Here again Moore saw a large number of people lying on the platforms. He likened the train tunnels to the organic holes in his earlier Surrealist sculpture. The trains roared past, only yards from children lying fast asleep. Strangers formed into intimate groups. People from all walks of life were gathered in one place by the whim of fate. Moore took this prolonged underground journey to heart. He felt that only now had he seen things which would shake him out of his insular way of life. He later recalled, 'Without the war ... I think I would have been a far less sensitive and responsible person – if I had ignored all that and went on working just as before. The war brought out and encouraged the humanist side in one's work.'[8]

In his novel *Nineteen Eighty-Four*, published soon after the war in 1948, George Orwell describes a wartime Underground station: '... one of [Winston's] early memories was of an air raid which appeared to take everyone by surprise ... He did not remember the raid itself, but he did remember his father's hand clutching his own as they hurried down, down, down into some deep place in the earth, round and round

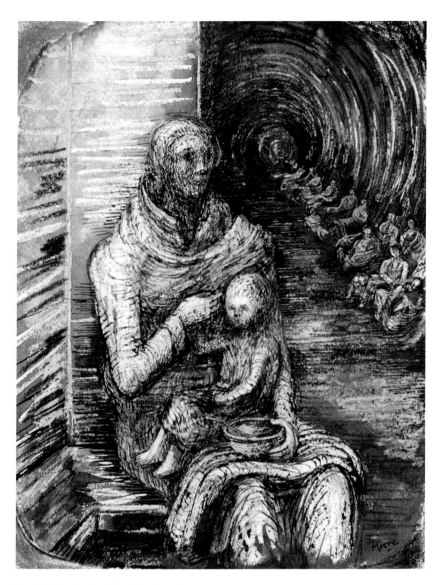

Fig. 26. *Shelter Drawing: Seated Mother and Child*, c. 1942 (HMF 1861a)

a spiral staircase which rang under his feet … His mother, in her slow, dreamy way, was following a long way behind them. She was carrying his baby sister – or perhaps it was only a bundle of blankets she was carrying: he was not certain his sister had been born then. Finally they had emerged into a noisy, crowded place which he had realised to be a Tube station. There were people sitting all over the stone-flagged floor, and other people, packed tightly together, were sitting on metal bunks, one above the other.'[9]

Rumours about the subterranean world beneath London have always abounded – stories of underground tunnels having their own energy and power, their own permanent inhabitants. In his *London at War* the historian Philip Ziegler wrote that 'in February 1918 a third of a million Londoners went underground'.[10] Fellow historian Peter Ackroyd continues the theme: 'In autumn 1940 Londoners once again burrowed underground. They stretched out in subterranean shelters and church crypts, and some started to live a truly underground existence, spending less time in the open air than miners.'[11] Moore's wartime experience seems also to have drawn him to such urban mythology. In several works he heightens the sense of alarm, of hopelessness and despair: at any moment the other side of the subterranean space is poised to come lethally close to the figures in the drawings – to swallow up and bury all these underground dwellers.

Having a WAAC commission, Moore was given a pass which allowed him access to the entire Underground. On one occasion he arrived in Cricklewood intending to visit the vast shelter situated in the basement of a warehouse in Tilbury. What he saw there reminded him of 'the hold of a slave ship'.[12] Moore would often spend all night underground, returning to his workshop at dawn. He drew from memory, explaining the drawings with short notes, thus making them historical documents of the era. Moore recalled: 'I began filling a notebook with drawings – ideas based on London's shelter life. Naturally I could not draw in the shelter itself. I drew from memory on my return home. But the scenes of the shelter world, static figures (asleep) – "reclining figures" – remained vivid in my mind, I felt somehow drawn to it all. Here was something I couldn't help doing… I was absorbed in the work for a whole year; I did nothing else.'[13] The artist's own words provide the best commentary to the Shelter Drawings. The 'hundreds of reclining figures' on the platforms became the central theme of his work, and this modernist artist, whose portrayals of the human figure had hitherto been so experimental, was now driven by simple human compassion.

When they resurfaced, Londoners could scarcely recognise their city: everything was reduced to piles of rubble, and only the remains of some large building, church-tower or town hall would reveal where they were. Drawings from Moore's First Shelter Sketchbook, such as *Devastated Buildings and Underground Platform Scene* (cat.12) and *London Skyline* (cat.14), document the city's destruction, imparting the sense of desolation not just of the artist but of all Londoners.

In his essay, 'The English', George Orwell wrote that 'During the bad period of 1940 it became clear that in Britain national solidarity is stronger than class antagonism. If it were really true that "the proletarian has no country", 1940 was the time for him to show it. It was exactly then, however, that class feeling slipped into the background, only reappearing when the immediate danger had passed.'[14] Shared danger engendered

Fig.27. *In a Large Public Shelter*, 1940–41
(HMF 1592)

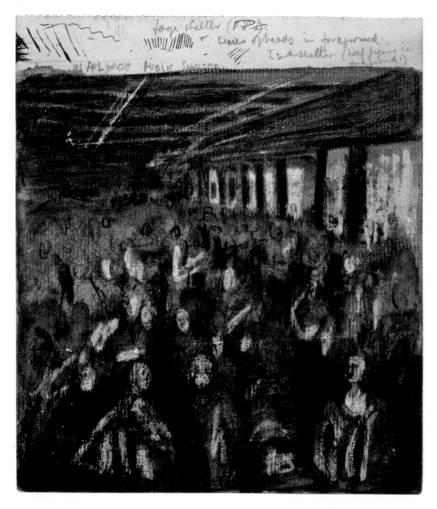

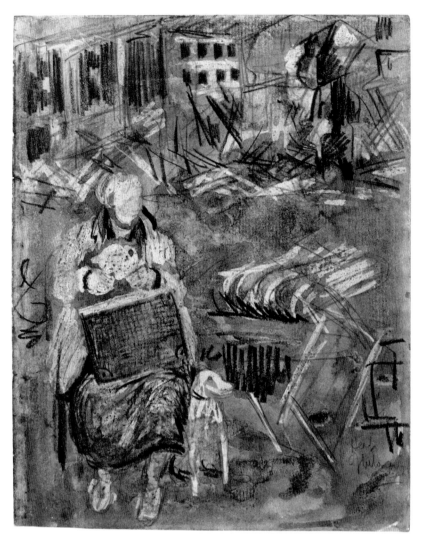

Fig.28. *Woman with Dog*, 1940–41 (HMF 1743)

mutual compassion and even brought closer people who had never before exhibited much warmth or kindness. In this extreme situation the British discovered themselves.

In order to help memorise what he saw, Moore often made brief notes on the pages of his sketchbook: 'Dramatic, dismal lit, masses of reclining figures fading to perspective / point … Chains hanging from / old crane … Muck & rubbish & chaotic untidiness around' (cat.24); 'Remember figures last Wednesday night (Piccadilly Tube) / Two sleeping figures (seen from above) sharing cream coloured / thin blanket (drapery closely stuck to form) / Hands & arms – Try positions oneself' (cat.59); '3 or 4 people under one blanket – uncomfortable positions, distorted / twistings … Group of people sleeping, disorganised angles of arms & legs covered / here & there with blankets' (HMF 1632).

The Shelter Drawings can be seen as a reflection of Moore's aesthetic development as an artist. Initially they depict only the results of the German air raids: violence, death, ruined houses on the horizon, people's suffering. Gradually the artistic variety increases, and he seeks to convey the social reality. Other motifs are added to his repertoire: tunnels, clothing, people embracing in sleep. In form the figures owe much to classical and Renaissance prototypes: images appear in the drawings that have their antecedents in the Early Renaissance, in the frescoes of Giotto and Michelangelo. Many of the drawings are complex compositions, the figures seem to hover somewhere between life and death. In some they look as though they are just asleep, in others like survivors from a disaster, or as if lying in silent graves. They all seem to inhabit a

world midway between reality and dream, simultaneously alive and dead. At the same time the drawings noticeably echo his earlier work: the new figures thus become part of the Surrealist world Moore had created before the war. Such familiar sculptural themes as seated and reclining female figures, the mother and child theme, and individual standing figures are reflected in new artistic form in the Shelter Drawings. *Sea of Sleepers* (cat.50) is particularly dynamic: a sleeping mass, wrapped up in blankets, moves and breathes in the shelter like a fantastical underground sea. In the bottom half of the drawing Moore interprets the same theme in a different way: the blankets roll like waves, as people's heads become the silver surf.

All the Shelter Drawings show Moore's characteristic interest in the human figure and his preoccupation with imparting a sense of volume. He used mixed media, as he often did for his drawings. First he would make a sketch using a wax crayon, usually white, more rarely coloured, over which he would lay a watercolour wash. Then he gave the figures more definition and added in details, going over the drawing in Indian ink and coloured pencil, sometimes pastel. This complex technique helped him to impart a three-dimensional quality to these line-drawn figures. It also intensifies the emotional impact of the drawings: these sleeping creatures are as if entombed in an endless tunnel; Moore, the son of a coal-miner, has created a tragic and convincing vision of being buried alive.

This was a period when it was almost impossible to produce large sculptures, owing to the lack of available materials. Instead, he succeeded in creating images that went far beyond what Kenneth Clark had suggested: everyday wartime life is presented as the background rather than the primary subject of the works.[15]

Moore's Shelter Drawings were not only a watershed in his creative journey; they remain an eloquent document of a period to which Moore, together with all the Londoners who lived in the shelters, bore witness. After being shown in London, the works were exhibited in New York in 1942. The exhibition's aim was entirely political: to show the Americans the dire situation facing the British and thereby hasten American involvement in opening up a second front. The exhibition certainly contributed to Moore's rise to fame after the war. A facsimile notebook with reproductions of many of the drawings was published by Poetry London in 1945 to great acclaim.

The Shelter Drawings played a significant role in the development of Moore's career. While perpetuating his pre-war interest in colour and the seated and recumbent pose, they also allowed the artist to explore the entirely new themes of solidarity and togetherness; the significance of these themes for post-war Western-European art cannot be overestimated.

1 The historical circumstances of the drawings Moore made during the Blitz were first documented in detail by Julian Andrews, and following him there have been several other studies, for example David Alan Mellor, 'And oh! The Stench: Spain, The Blitz, Abjection and the Shelter Drawings', in Chris Stephens (ed.), *Henry Moore* (London: Tate, 2010), pp.52–63. *See also* in this volume Selected Publications, p.139.

2 Letter to Kenneth Clark dated 1 October 1939, cited in Julian Andrews, *The Shelter Drawings of Henry Moore* (Aldershot: Lund Humphries, 2002), p.18.

3 Letter from Moore to Arthur Sale, 30 April–14 May 1940; Imperial War Museum.

4 Cited in Philip Ziegler, *London at War 1939–1945* (London: Sinclair-Stevenson, 1995), p.300.

5 Peter Ackroyd, *London: The Biography* (Moscow: 2007), p.642.

6 Carlton Lake, 'Henry Moore's World', *Atlantic Monthly* (January 1962), p.40.

7 *Henry Moore: A Shelter Sketchbook* (London: British Museum, 1988), p.9.

8 Alan G. Wilkinson, *The Drawings of Henry Moore* (London: Tate Gallery; Toronto: Art Gallery of Ontario, 1977), p.36.

9 George Orwell, *Nineteen Eighty-Four* (London: Secker & Warburg, 1955), p.36.

10 Ziegler, *London at* War, p.10.

11 Ackroyd, *London: The Biography*, p.641.

12 Andrews, *The Shelter Drawings of Henry Moore*, p.40. Also, Henry Moore, *Shelter-Sketchbook*, Marlborough Fine Art, London, 1967.

13 James Johnson Sweeney, 'Henry Moore', *Partisan Review*, vol. XIV, no. 2 (March–April 1947), p.184.

14 George Orwell, 'The English People', in Sonia Orwell and Ian Angus (eds.), *The Collected Essays, Journalism and Letters of George Orwell*, vol. 3 (London: Secker & Warburg, 1969), p.6.

15 Moore was not the only artist working in London in the war years: the photographer Bill Brandt was authorised by the Ministry of Information to document the Underground that same year, 1940, as were a number of other artists and photographers, including Edward Ardizzone and Joseph Bato (see Richard Calvocoressi in this volume, pp.10–12).

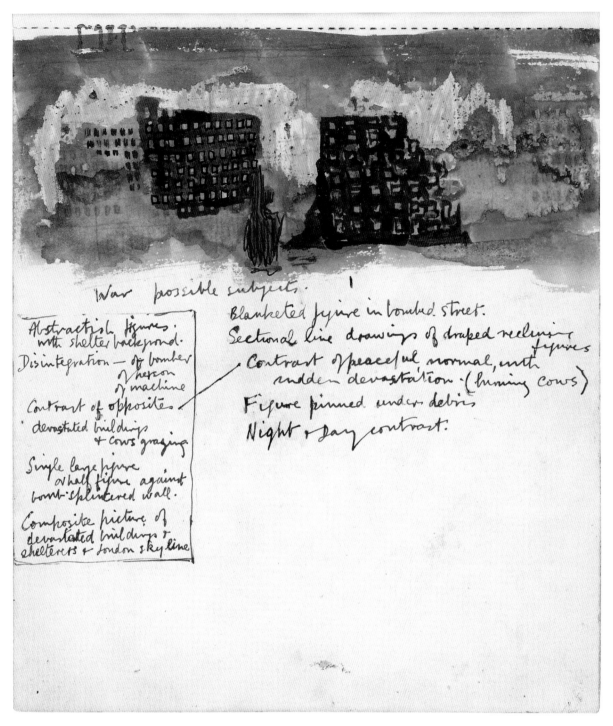

Fig.29. *War: Possible Subjects*, 1940–41
(HMF 1603)

Fig. 30. Henry Moore in his studio, Hampstead,
London c. 1930

Sergei Androsov Henry Moore's Sculpture

Henry Moore continued to work as a sculptor and draughtsman deep into old age. He was born in Castleford in Yorkshire in 1898, and died in the village of Perry Green in 1986 at the age of eighty-eight. His creative output can thus be said to have spanned almost the entire twentieth century, and he is unarguably one of the greatest sculptors of the last one hundred years. Although his artistic journey was far from straightforward, throughout his career he remained consistent and independent in his art; and unlike many of the great artistic innovators, his work achieved recognition during his own lifetime. He was born into a simple mining family, and it seems likely that he owed his strong and calm character to this background. His early interest in sculpture meant that he did not continue his academic education beyond school – perhaps to the benefit of his subsequent career. He was just old enough to fight in the last year of the First World War, before studying at the Leeds School of Art and then spending three years at the Royal College of Art in London.

Art critics have identified various strands of influence on Moore: the primitive art of African and American peoples, the plastic arts of Ancient Egypt and the sculpture of the Italian Proto-Renaissance. His early work bears comparison with that of other twentieth-century masters – Pablo Picasso, Hans Arp and Henri Gaudier-Brzeska – and it is certainly true that his first sculptures in the 1920s reveal none of the individual understanding of the plastic arts which was later to make him stand out so much from his contemporaries. The works of Gaudier-Brzeska, with their large-scale, deliberately simplified and coarsened forms, must have had a particular impact on the young Moore. The influence of the French artist can be seen, for example, in Moore's statuette *Maternity* (1924; LH 22): although small-scale (23 cm high), in photographs the stone statuette's lapidary forms create the impression of a large, weighty piece. Essentially a half-portrait of a female figure, whose disproportionately large palms support the heavy body of the child clinging to her, the immediate impression is of a full-length female figure squatting down or with her legs tucked up under her; when viewed from the front or from either side, the figure reveals a striving towards a spherical form.

Fig. 31. *Reclining Figure*, 1930 (LH 85)

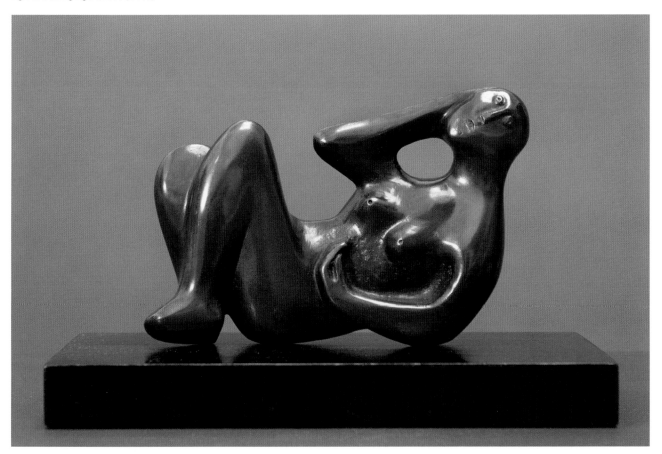

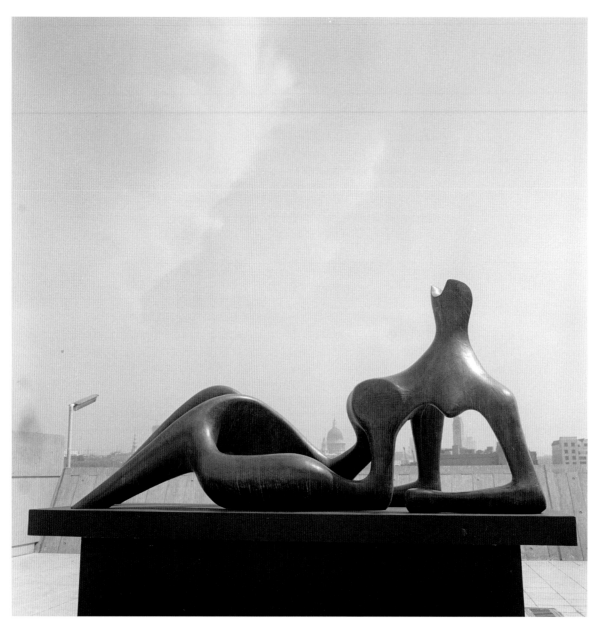

Fig. 32. *Reclining Figure: Festival*, 1951
(LH 293), at the Hayward Gallery, London, 1969

In the late 1920s Moore's drawings and sculptural compositions began to introduce the themes that would later bring him world renown. These were principally his reclining and recumbent figures, in which the human body was subjected to certain preconceived deformations. Generally small in scale, these works were markedly experimental. Moore later recreated some of them in monumental form, including, for example, the bronze *Reclining Figure* (1930; fig. 31). Here the artist deliberately schematises and simplifies the head and body, but it remains clear that the statuette is based on a portrayal of a naked woman. A year later, however, he made a lead cast of an entirely different *Reclining Figure* (1931; fig. 11, p. 16), in which the body is subjected to such deformation that it is difficult to say with any certainty whether it is male or female. The small head is undefined, and the subjectively treated arm on which the figure is leaning is contrasted with the exaggeratedly wide and circular ribcage, which is as if dissected. Commentators have discerned humorous elements in this sculpture, but it is also right to note the explicitly experimental nature of the young artist's work.

Less experimental is the *Recumbent Figure* he created a few years later (1938; cat.1). Its soft, malleable forms are undoubtedly based on the proportions of the human body. Furthermore, like many of Moore's works, it creates vague associations with the plastic arts of antiquity: while not necessarily showing a clear analogy with their sculptural forebears, Moore's sculptures are still enriched by the associations they evoke with the works of the classical masters.

Working Model for Reclining Figure: Festival (1950; cat.5, see also fig.32) is to some extent a return to his earlier works. This monumental sculpture was created for the Festival of Britain which opened in London and other major cities across the United Kingdom in 1951. The festival marked the hundredth anniversary of the original Great Exhibition of 1851, and aimed to promote better-quality design in the rebuilding of British towns and cities following the Second World War. While most of the works displayed at the 1951 exhibition were traditional in style, Moore's statue provided a strong contrast. In his sculpture the breaking down of the parts of the human body is taken almost to extremes. The arms, legs and head are treated in an entirely subjective manner, and in the middle of the torso the artist has left an empty space. In this way the statuette becomes a kind of rebus that has to be solved by the viewer, bringing to mind some of Picasso's pictures.

Moore's early works also reveal a tendency towards abstract forms. Such pieces are reminiscent of works by Hans Arp, and are highly expressive through their experimentation with form and material. They include *Three Points* (1939–40; cat.2), in which the original geometric body conceived by the author bears no relation to the human figure. *Helmet Head No. 1* (1950; cat.4) is similar in conception: it appears that beneath the helmet, intimidating in its plasticity, there should be a human head behind a lowered visor and large eye-slits; in fact the viewer sees only empty space. Thus a frightening form becomes merely an intricate play of volumes and space. And although there are also associations here with the recently ended war, they are far from overt: the sculptural form of the work itself is more important than any allusions.

Moore's early work therefore seems to combine two trends: the first being the study of the human body and its breakdown into constituent parts; the second connected with a more abstract pursuit of expressiveness of form and volume. It could also be argued that a decisive role in resolving the conflict between these two themes was played by the drawings Moore made in the bomb shelters of the London Underground. Aside from their obvious anti-war resonance, the hypnotic spectacle of hundreds of human bodies, lying or sitting in various poses, undoubtedly influenced Moore the sculptor. The majority of the drawings are not like sketches from life, but rather appear as entirely finished and deeply thought-through compositions, executed in the artist's own individual creative style. At the same time, they can be viewed as sketches for future sculptural works by an artist inspired by the plastic form of the human body, and its wholeness and expressiveness, even when encased in the material world. For it was this successful combination of the abstract and the real that marked Moore out from the many other sculptors of his time, and determined his widespread success in the 1950s. The majority of his sculptural compositions can be viewed as free fantasies based on the forms of the human body, rather than on geometric figures. When he was creating the statues of his mature period, Moore sometimes moved closer to nature, sometimes more towards pure abstraction, but three-dimensional reality always remained the basic impulse behind his compositions. The artist himself formulated this with simple clarity: 'The human figure is what interests me most deeply'.[1]

Among the simplest and most eloquent of Moore's works is the *Madonna and Child* group (fig. 33), created for the parish church of St Matthew in Northampton in 1943–44. At first glance it may appear that the artist has returned to the less elaborate motifs of his youth, and the stocky figure of the Virgin, sitting on a low bench, certainly shows similarities with the works of the 1920s. The defining feature of the composition, however, is the overall solemnity of the figure, which makes it clear that this is not just any mother and child, but the Mother of God; and in its primordial simplicity the work is reminiscent of the images of Giotto and Arnolfo di Cambio.

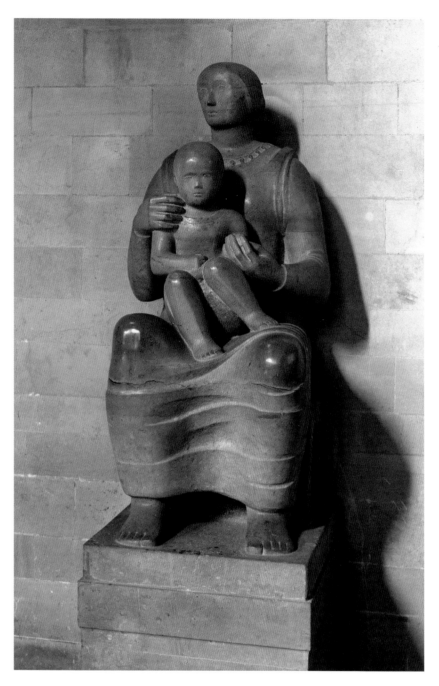

Fig. 33. *Madonna and Child*, 1943–44 (LH 226)

The large scale of the Christ-child, reminiscent of Hercules-like representations of the infant Christ in Italian paintings of the quattrocento, is also significant here. By creating a work for a church, but at the same time aimed at an uninitiated public rather than a narrow circle of connoisseurs, Moore again proved the breadth of his vision and his technical mastery.

A more generalised treatment of a similar theme can be seen in *Family Group* (1945; cat. 3), which comprises two seated figures holding a child in their arms. Moore succeeds in creating an extremely expressive group, where the arms of the parents form a central knot around which the rest of the composition is built. At the same time, as if deliberately trying to avoid accusations of excessive seriousness, he gives the figures small, formless heads with barely any direct allusion to the human face.

Fig. 34. *King and Queen*, 1952 (LH 350), in the grounds at Perry Green

A little later, at the beginning of the 1950s, Moore created a series of works dedicated to the theme of the falling or fallen warrior. Although it may be assumed that the subject was connected with recent world events, it is futile to seek in these statuettes even the slightest reference to contemporaneity. The artist is interested above all in the plasticity of the body caught at the moment of falling, before it becomes motionless – the fixing of a momentary position. In *Falling Warrior* (1956–57; cat. 6), the body of the warrior is shown at this precise moment. He is held up by his heel, his right hand and the shield touching his head. The treatment of the sculptural form of the human body is quite detailed, although some elements are deliberately schematized. It may seem surprising that so characteristic a work should arouse such varied associations: we are reminded, for example, of the figures of dead warriors on the pediments of Greek temples, or wooden images of the Deposition of Christ from the Middle Ages.

One of Moore's most celebrated works, and one equally varied in its resonance, is the monumental group *King and Queen* (1952–53; fig. 34), of which a number of versions exists. The idea behind the work came from the fairy tales that the sculptor read to his daughter, or possibly from the death of King George VI in 1952; the title of the work may have emerged later. The majestic outline of the two seated figures makes them appear, if not divine, then certainly elevated above the common man. This effect is created by the frontal nature of the outline, the precision of the lines and the simplicity of the pose, which sit comfortably alongside the naturalistic treatment of the feet and hands. Only on a second look is the viewer struck by the strange heads of both figures, their mask-like visages reminiscent of animal heads.

Henry Moore's international renown was confirmed in the late 1940s and early 1950s. He had a one-man exhibition at the Venice Biennale in 1948, after which he was awarded the International Sculpture Prize. Moore then held his first retrospective exhibition at the Tate Gallery in London in 1951. In 1957 his monumental *Reclining Figure* (LH 416) was erected in front of the UNESCO building in Paris. The sculptor was invited onto the jury of various competitions, and his advice and views were sought all over the world. He was awarded numerous commissions, among them many for monumental works; this gave him the opportunity – rare in the modern age – to execute large-scale versions of his models and sketches, often dating from earlier periods. Moore's mature works are notable for their particularly free approach to large masses, which he often juxtaposes and contraposes together. At the same time these sculptures take on a more strongly developed sense of place and space: they can be

1 'Henry Moore' in Herbert Read (ed.), *Unit One: The Modern Movement in English Architecture, Painting and Sculpture* (London: Cassell, 1934), p.29.

approached from several view-points rather than just one. Such works are particularly well suited to a natural setting, creating associations with horticultural and topiary forms, for example his *Large Four Piece Reclining Figure* (1972–73; cat.7).

Moore also continued to return to his favourite images of reclining figures. The group *Draped Reclining Mother and Baby* (1983; fig.35, cat.9) represents another variation on the theme. Here the idea of the indissoluble link between mother and baby is given an almost literal treatment: the mother's chest is opened out, creating something akin to the pouch of a kangaroo, and the baby nestles calmly within. At the same time the drapery, in places fluttering, in places enveloping the woman's figure, is reminiscent of Moore's shelter drawings. Thus the master returns once more to the plastic motifs that attracted him so many years earlier, something that re-emphasises the significance of the works on display at the Hermitage.

In Russia Henry Moore's works were generally received negatively by official critics, while arousing intense interest from artists and ordinary art lovers. It was not until 1991 that a major retrospective of his works took place in Russia (at the Benois Museum in Peterhof and the Pushkin Museum of Fine Arts in Moscow). Over the years the Hermitage has displayed a few selected works by Moore, such as in the exhibition *Sculpture as a Living Language* in 1998. This exhibition, while it makes no claims to being comprehensive, will nevertheless bring to a Russian audience the unique world of this remarkable English sculptor.

Fig.35. *Draped Reclining Mother and Baby*, 1983
(LH 822)

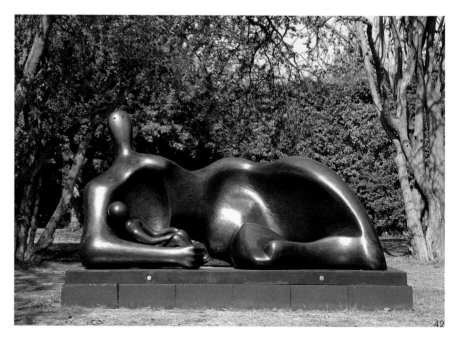

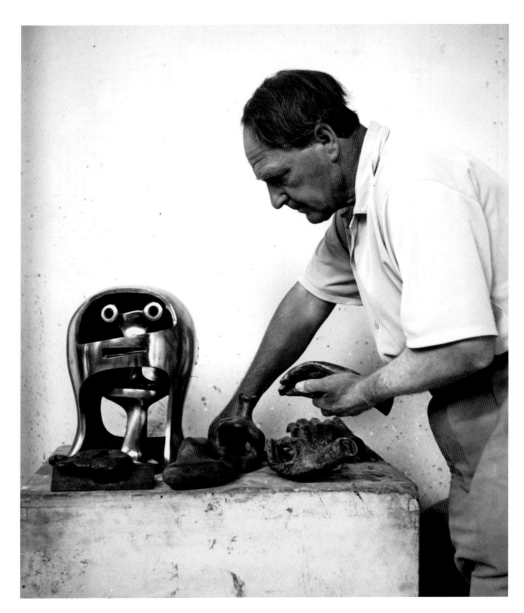

Fig. 36. Moore in his studio at Perry Green with
Helmet Head No. 2, (1950; LH 281)

Catalogue of Sculptures and Drawings

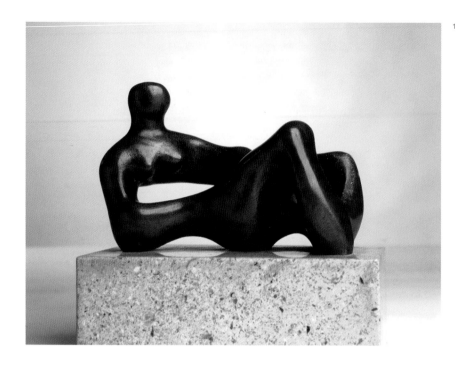

1
Recumbent Figure
1938

LH 184
Bronze edition of [10] + [1]
Length 13cm

The Henry Moore Foundation: acquired
in memory of Margaret McLeod OBE 2007

2
Three Points
1939–40

LH 211
Cast iron, unique
Length 20cm

The Henry Moore Foundation: gift of Irina Moore 1977

3
Family Group
1945

LH 259
Bronze edition of 9
Cast: The Art Bronze Foundry, London
Height 24.1cm

The Henry Moore Foundation: acquired
by exchange with the British Council 1991

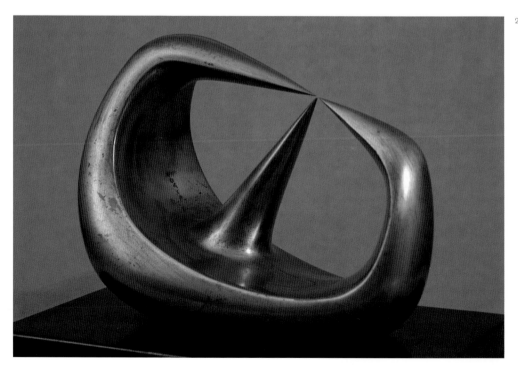

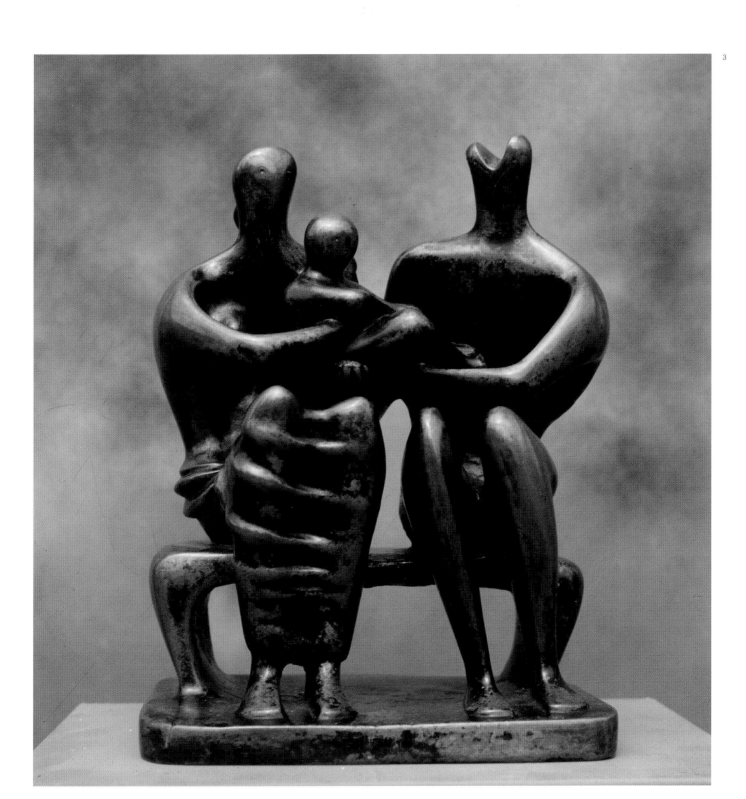

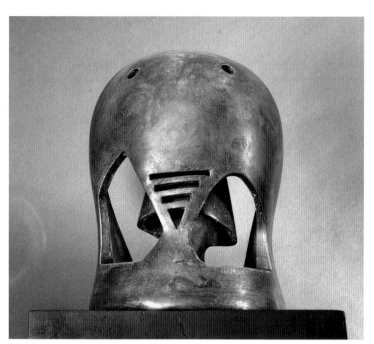

4
Helmet Head No.1
1950

LH 279
Lead
Height 34cm

The Henry Moore Foundation: gift of Irina Moore 1977

5
Working Model for Reclining Figure: Festival
1950

LH 292
Bronze edition of 7 + 1
Length 43cm
Signature: stamped *Moore*

The Henry Moore Foundation: gift of the artist 1977

6
Falling Warrior
1956–57

LH 405
Bronze
Length 147.5cm

Huddersfield Art Gallery

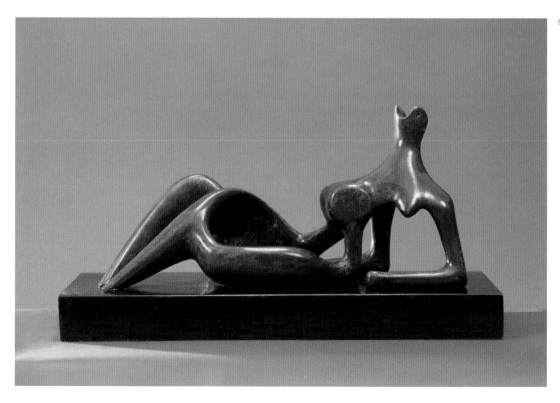

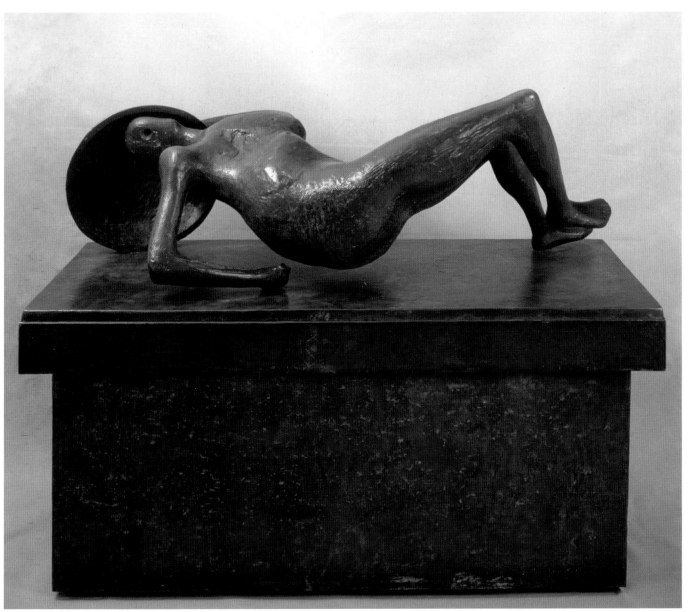

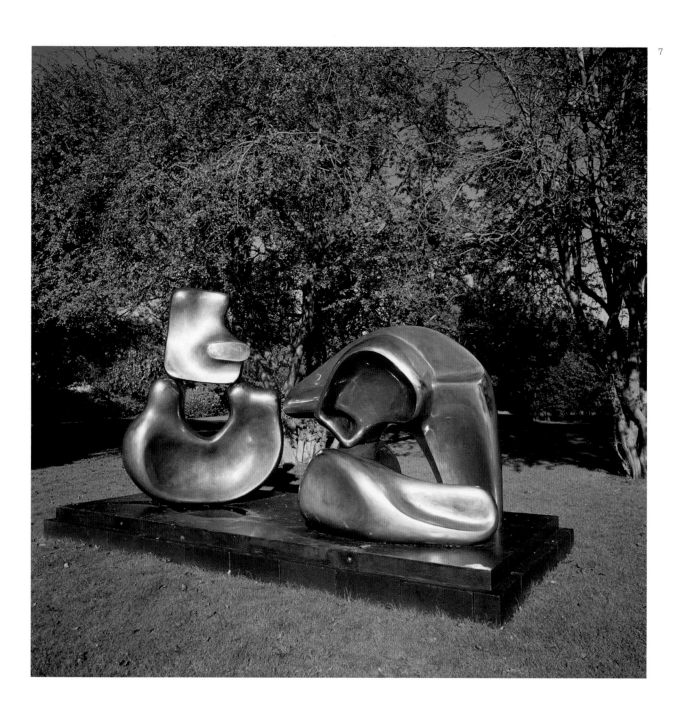

7
Large Four Piece Reclining Figure
1972–73

LH 629
Bronze edition of 7 + 1
Cast: Hermann Noack, Berlin
Length 402cm
Signature: stamped *Moore, 0/7*

The Henry Moore Foundation: acquired 1987

8
Reclining Figure: Hand
1979

LH 709
Bronze edition of 9 + 1
Cast: Hermann Noack, Berlin
Length 221cm
Signature: stamped *Moore, 0/9*

The Henry Moore Foundation: acquired 1986

9
Draped Reclining Mother and Baby
1983

LH 822
Bronze edition of 9 + 1
Cast: Morris Singer, Basingstoke
Length 265.5cm
Signature: stamped *Moore, 0/9*

The Henry Moore Foundation: acquired 1986

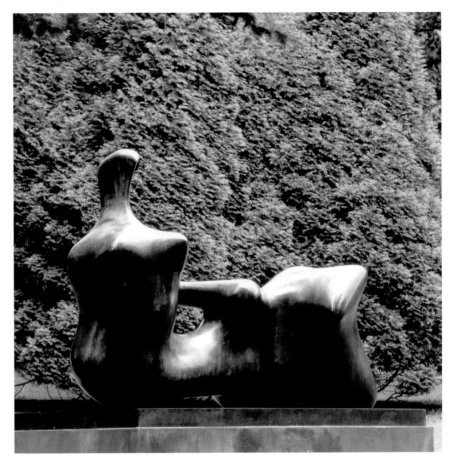

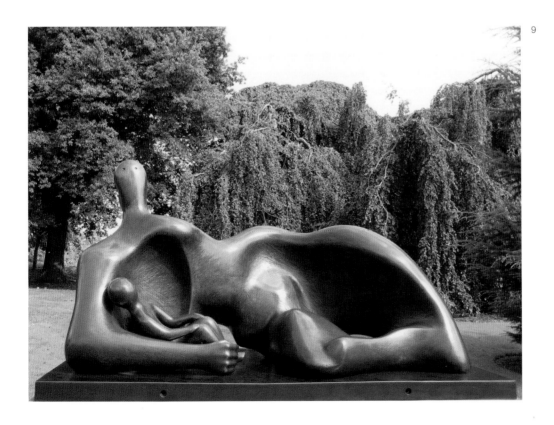

9

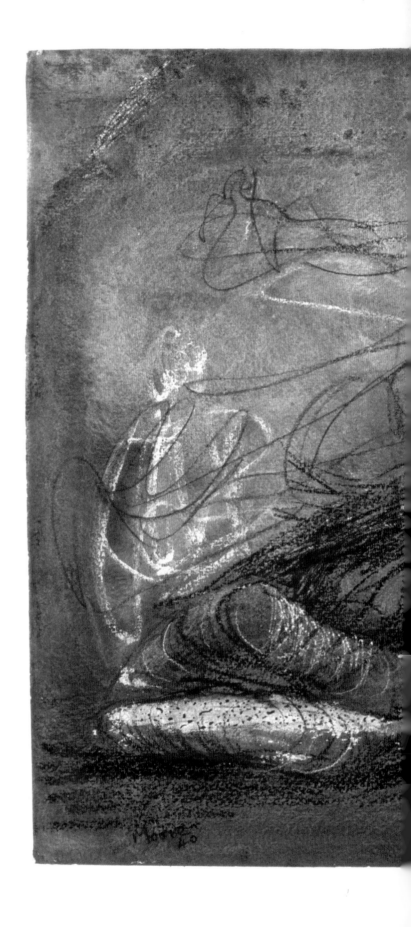

10
Studies of Reclining Figures
1940

HMF 1478
Pencil, wax crayon, coloured crayon, pastel,
watercolour wash, conté crayon, gouache, pen and
ink on cream heavyweight wove
380 × 560mm
Signature: wax crayon l.l. *Moore / 40*

The Henry Moore Foundation: acquired 1984

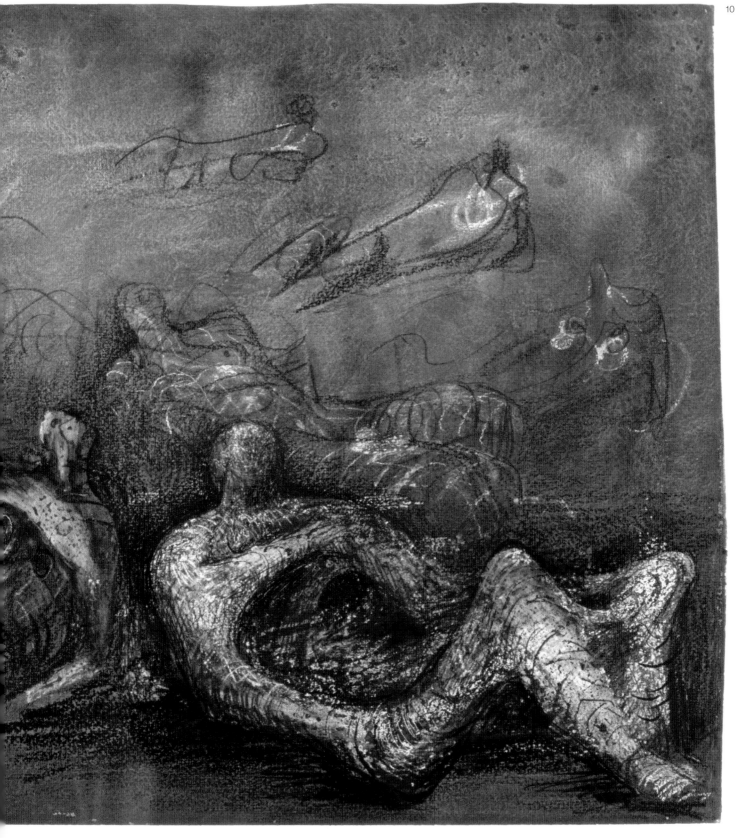

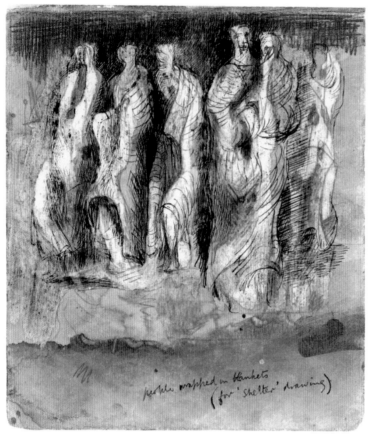

11

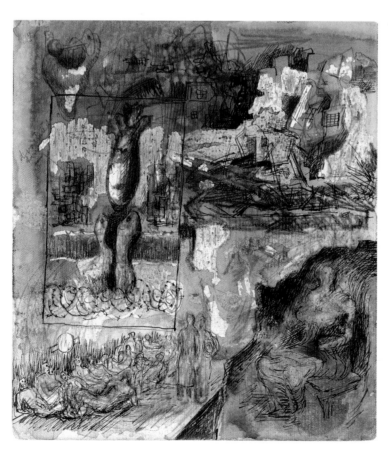

12

11
People Wrapped in Blankets
1940–41

HMF 1559
First Shelter Sketchbook p.1
Pencil, pen and ink, wax crayon, coloured
crayon, crayon, watercolour wash on cream
lightweight wove
186 × 162mm
Inscription: pen and ink l.c.r. *people wrapped in
blankets / (for 'Shelter' drawing)*

The British Museum, London: bequest of Jane Clark 1977

12
Devastated Buildings and Underground
Platform Scene
1940–41

HMF 1562
First Shelter Sketchbook p.4
Pencil, wax crayon, coloured crayon, watercolour
wash, pen and ink on cream lightweight wove
186 × 162mm
Inscription: pencil c.l. *devastated / house*

The British Museum, London: bequest of Jane Clark 1977

13
Eighteen Ideas for War Drawings
1940

HMF 1553
Pencil, wax crayon, coloured crayon,
watercolour wash, pen and ink
on cream medium-weight wove
274 × 376mm
Inscription: pencil u.l. *searchlights*; u.c. *Flashes
from ground*; *gunshells bursting like stars*; u.r.
Night & day – contrast; u.c.l. *devastated
houses*; *bomb crater*; u.c.r. *contrast of
opposites*; *contrast of peaceful normal with
sudden devastation*; c.l. *disintegration of farm
machine*; *fire at night*; c. *Haystack & airplane*;
Nightmare; c.r. *contrast of opposites*; *Burning
cows*; l.c.l. *spotters on buildings*; *barbed wire*;
l.c.r. *Cows & Bombers*; *Bombs bursting at sea*
Signature: pen and ink l.r. *Moore / 40*

The Henry Moore Foundation: gift of the artist 1977

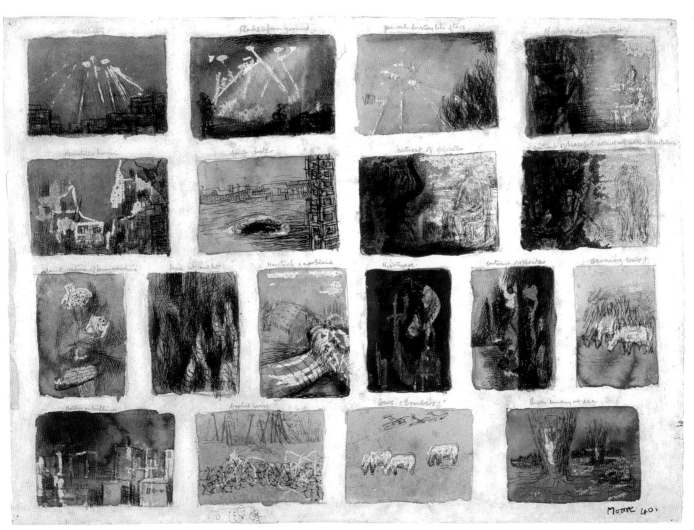

13

Catalogue of Drawings 55

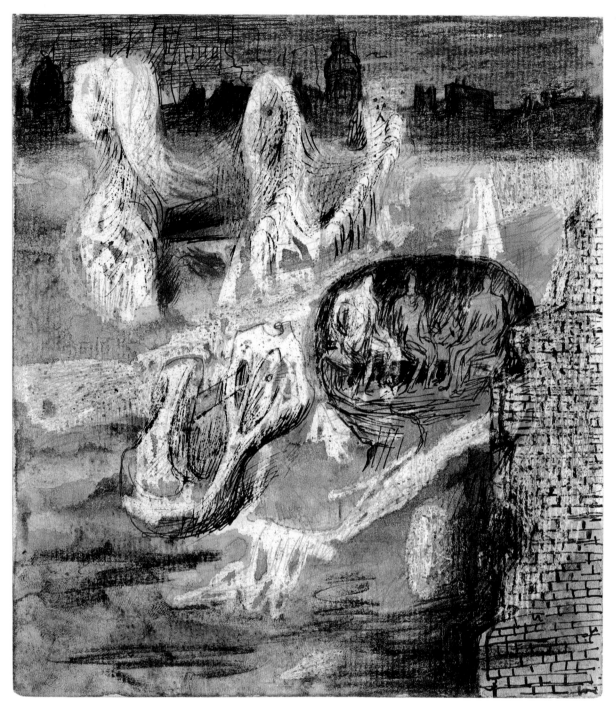

14
London Skyline
1940–41

HMF 1574
First Shelter Sketchbook p.16
Pencil, wax crayon, coloured crayon,
watercolour, wash, pen and ink
on cream lightweight wove
186 × 162mm

The British Museum, London: bequest of Jane Clark 1977

15
Crashed Aeroplane and Urban Skyline,
1940–41

HMF 1575
First Shelter Sketchbook p.17
Pencil, wax crayon, coloured crayon,
watercolour, wash, pen and ink
on cream lightweight wove
186 × 162mm
Inscription: pencil top of page *Material for a*
[…]; c.l. *devastated buildings*; c.r. *[…]/Cows*
grazing; l.r. *[…] here*

The British Museum, London: bequest of Jane Clark 1977

16
Head Made up of Devastated House
1940–41

HMF 1611
First Shelter Sketchbook p.53
Pencil, wax crayon, coloured crayon,
watercolour, wash, pen and ink
on cream lightweight wove
186 × 162mm
Inscription: pencil u.c. *Head made up of*
devastated house

The British Museum, London: bequest of Jane Clark 1977

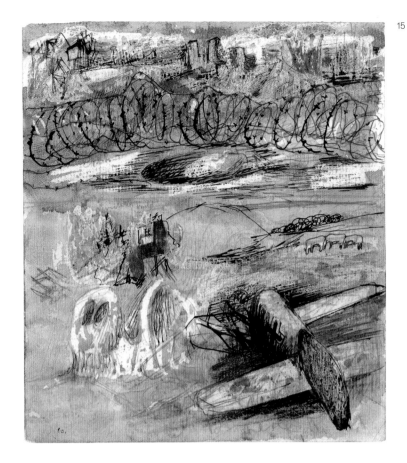

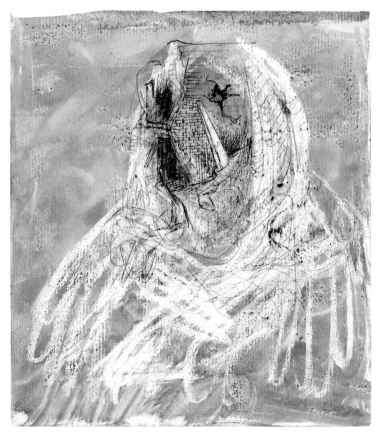

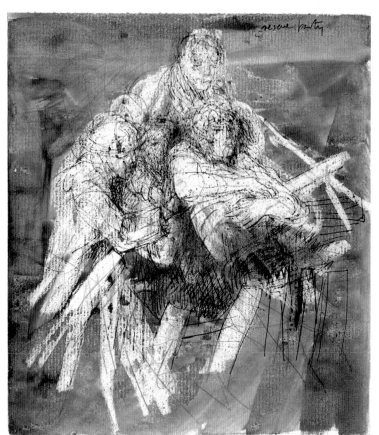

17
Rescue Party
1940–41

HMF 1612
First Shelter Sketchbook p.54
Pencil, wax crayon, coloured crayon, watercolour,
wash, pen and ink on cream lightweight wove
186×162mm
Inscription: pen and ink over pencil u.c.
rescue party

The British Museum, London: bequest of Jane Clark 1977

18
Figures in Bombed Streets
1940–41

HMF 1620
First Shelter Sketchbook p.62
Pencil, wax crayon, coloured crayon, watercolour,
wash, pen and ink on cream lightweight wove
186×162mm
Inscription: pen and ink u.l. *Blanketed figure in
bombed street*; pencil u.r. *Seated woman with
[overwritten &] child*; l.c. *Figure lying down*

The British Museum, London: bequest of Jane Clark 1977

19
Two Seated Figures in Shelter
1940–41

HMF 1625
First Shelter Sketchbook p.67
Pencil, wax crayon, coloured crayon, watercolour,
wash, pen and ink on cream lightweight wove
186×162mm
Inscription: pen and ink over pencil c.r.
Two seated figures in shelter

The British Museum, London: bequest of Jane Clark 1977

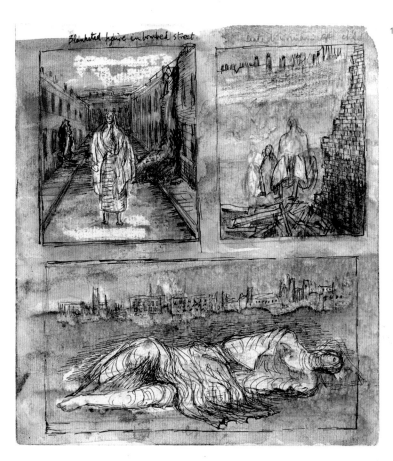

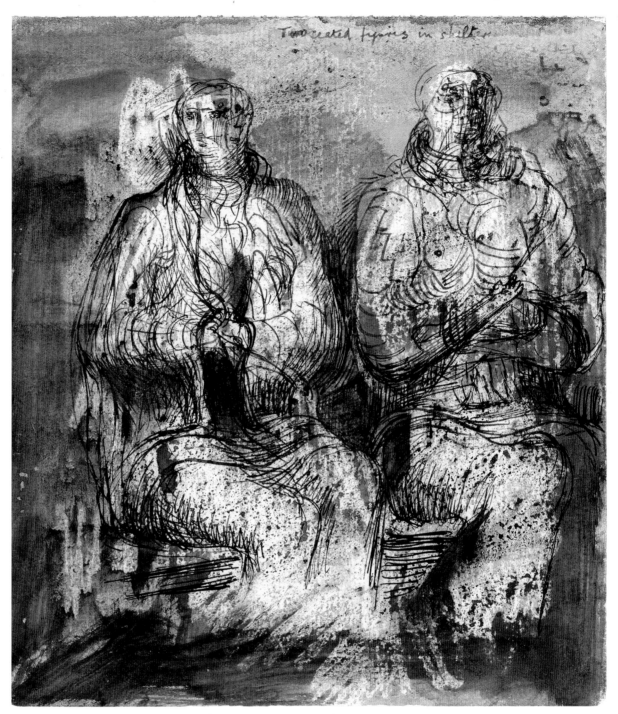

Two seated figures in shelter

20
Sleeping Figure and Figure Pinned
under Debris
1940–41

HMF 1627
Second Shelter Sketchbook p.2
Pencil, wax crayon, watercolour, wash, pen
and ink on off-white lightweight wove
204 × 165mm
Inscription: pen and ink c.r. *Figure sleeping / in
shelter*; c.l. *Figure pinned / under debris*

The Henry Moore Foundation: gift of Irina Moore 1977

21
Woman Wearing Hat, Woman and Child
with Bundle, Seated Mother and Child
1940–41

HMF 1628
Second Shelter Sketchbook p.3
Pencil, wax crayon, watercolour, wash, pen
and ink on off-white lightweight wove
204 × 165mm
Inscription: pencil u.l. *woman / wearing hat / &
feather fur*; c.r. *Shelter drawings / Women &
children with bundles / Think of different
scenes in the / Liverpool Street* [*Tube* added]
extension / bundles of [crossed out] *& blankets
laid out / & two or three seated women / &
children / Shortsighted man reading in
Underground / Views in Liverpool St.
Underground / Children keeping shop in / a
shelter*

The Henry Moore Foundation: gift of Irina Moore 1977

22
Tube Shelter Scenes
1940–41

HMF 1629
Second Shelter Sketchbook p.4
pencil, wax crayon, watercolour, wash, pen and
ink, gouache on off-white lightweight wove
204 × 165mm

The Henry Moore Foundation: gift of Irina Moore 1977

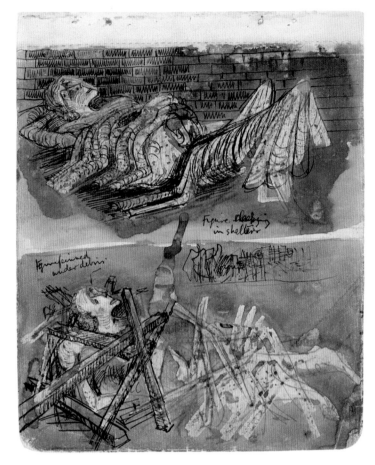

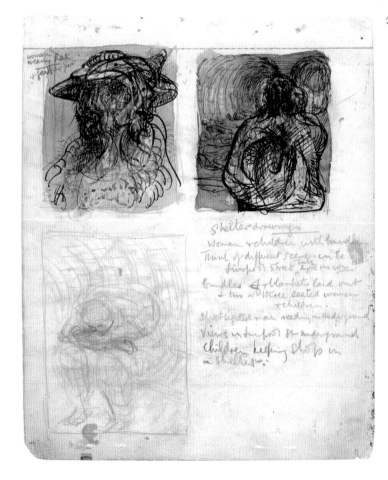

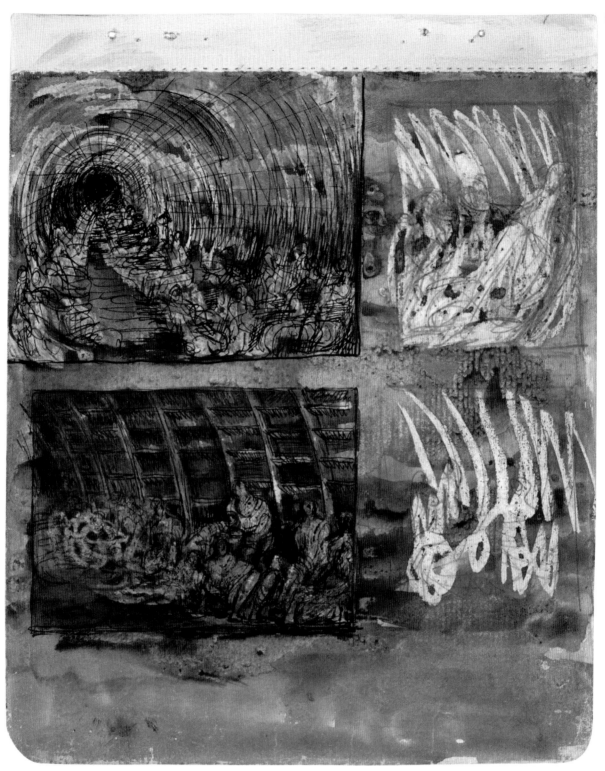

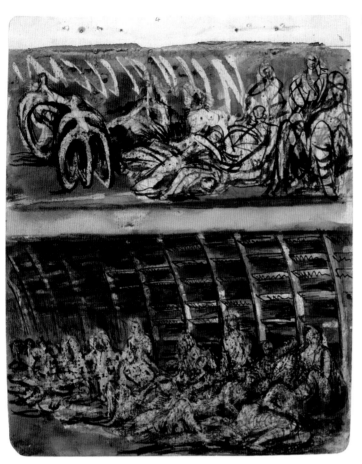

23

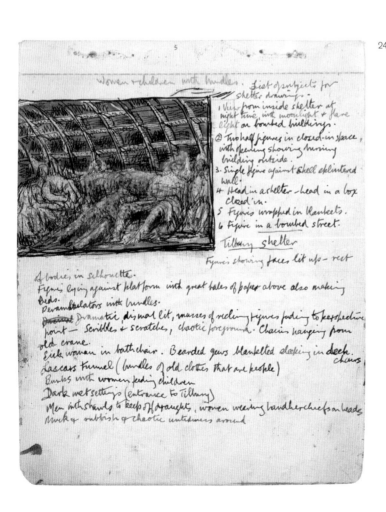

24

23
Study for 'Shelterers in the Tube'
1940–41

HMF 1630
Second Shelter Sketchbook p.5
Pencil, wax crayon, coloured crayon,
watercolour, wash, pen and ink, gouache
on off-white lightweight wove
204 × 165mm
Inscription: pencil u.c. *Bundles & blankets* […]
& two or three women

The Henry Moore Foundation: gift of Irina Moore 1977

24
Women and Children with Bundles
1940–41

HMF 1631
Second Shelter Sketchbook p.6
Pencil, wax crayon, watercolour, wash, pen and
ink, gouache on off-white lightweight wove
204 × 165mm
Inscription: pencil u.c. *Women & children with
bundles; pen and ink u.r. List of subjects
for / shelter drawings / 1 View from inside shelter
at / night time, with moonlight & flare / light on
bombed buildings / (2) Two half figures in
closed-in space / with opening showing burning /
building outside / 3. Single figure against shell
splintered / wall / 4. Head in a shelter – head in
a box / closed in / 5 Figures wrapped in
blankets / 6 Figure in a bombed street / Tilbury
Shelter / Figures showing faces lit up – rest / of
bodies in silhouette / Figures lying against
platform with great bales of paper above also
making / beds / Perambulators with bundles /
[Dismal crossed through] Dramatic, dismal
lit, masses of reclining figures fading to
perspective / point – Scribbles and scratches,
chaotic foreground. Chains hanging from / old
crane / Sick woman in bathchair. Bearded Jews
blanketed sleeping in deck / chairs / Lascars
tunnel (bundles of old clothes that are people) /
Bunks with women feeding children / Dark
wet settings (entrance to Tilbury) / Men with
shawls to keep off draughts, women wearing
handkerchiefs on heads / Muck & rubbish &
chaotic untidiness around*

The Henry Moore Foundation: gift of Irina Moore 1977

25
Studies for 'Figures in a Shelter'
1940–41

HMF 1634
Second Shelter Sketchbook p.9
Pencil, wax crayon, coloured crayon,
watercolour, wash, pen and ink on
off-white lightweight wove
204 × 165mm
Inscription: pencil u.c. *Muck & masses, dismal,
dramatic lit. scribbles & scratches. chaotic
foreground; pen and ink l.c. Subjects for shelter
drawings / Sleeping figures, arms in angles with
heads. Heads in perspective from below /
relaxed, innocent – abandoned – beatific
abandon. Old men old women / Flood gates,
Angular thin figure covered with old coat –
Head to feet / sleepers – Aproned women –
black bracered [sic] men. Sleeping heads / &
round eyeballs*

The Henry Moore Foundation: gift of Irina Moore 1977

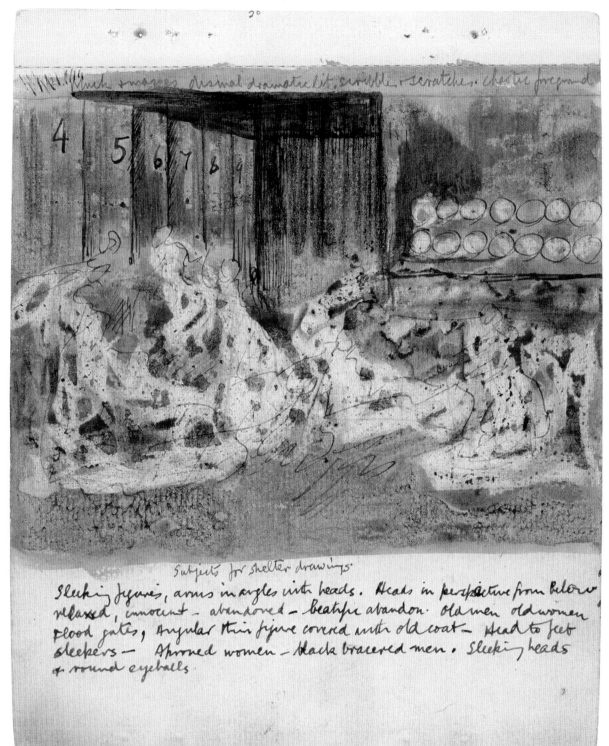

Subjects for shelter drawings.

Sleeping figures, arms in angles with heads. Heads in perspective from below relaxed, innocent - abandoned - beatific abandon. Old men old women flood gates, Angular thin figure covered with old coat — Head to feet sleepers — Aproned women — black bracered men. Sleeping heads & round eyeballs.

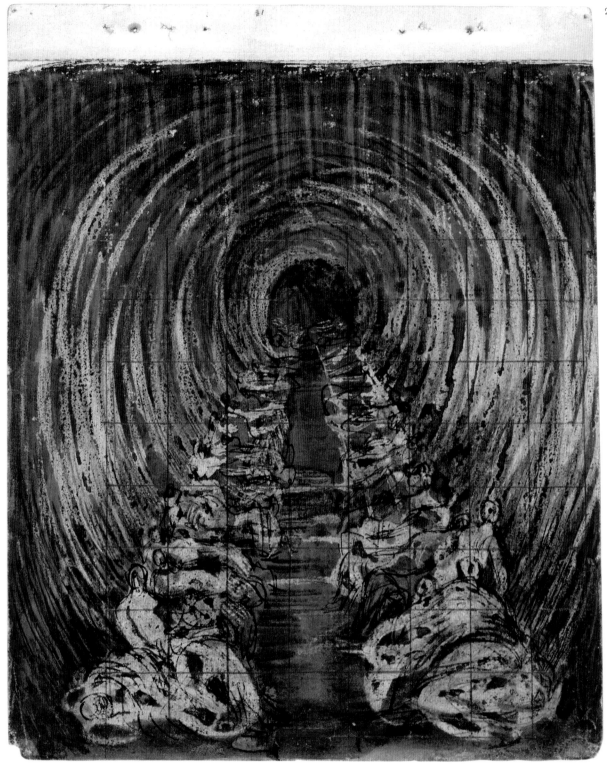

26
Study for 'Tube Shelter Perspective'
1940–41

HMF 1635
Second Shelter Sketchbook p.10
Pencil, wax crayon, coloured crayon,
watercolour, wash, pen and ink on off-white
lightweight wove
204×165mm

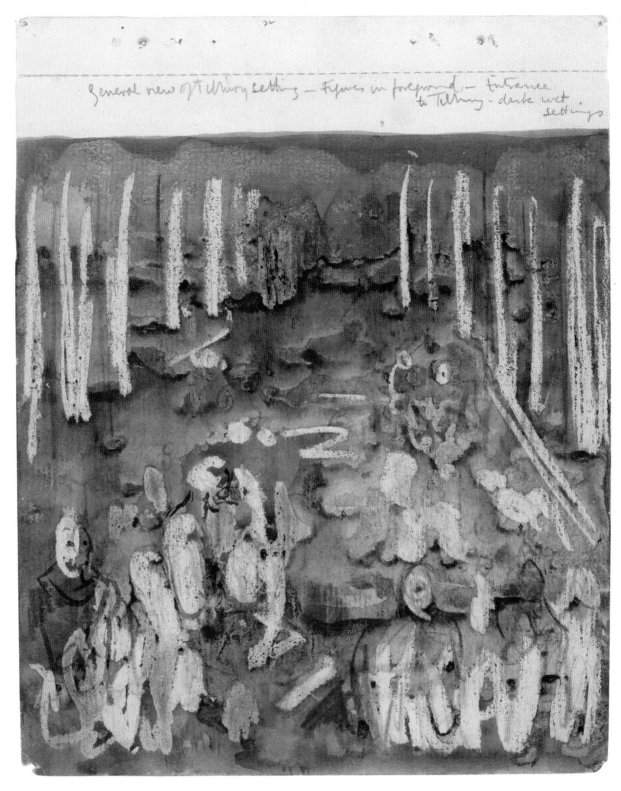

General view of Tilbury setting – Figures in foreground, – Entrance to Tilbury – dark wet settings

27
Study for 'Shelter Drawing'
1940–41

HMF 1636
Second Shelter Sketchbook p.11
Pencil, wax crayon, coloured crayon,
watercolour, wash on off-white lightweight wove
204 × 165 mm
Inscription: pencil u.c. *General view of Tilbury
setting – Figures in foreground –
Entrance/to Tilbury – dark wet/settings*

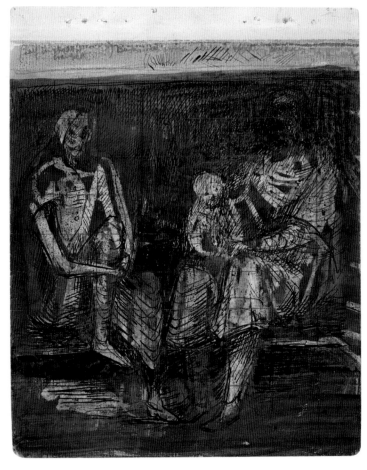

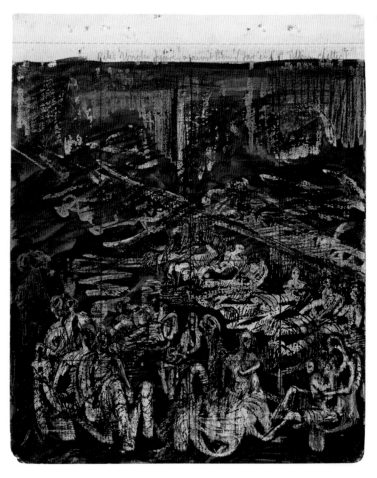

28
Study for 'Shelter Drawing'
1940–41

HMF 1637
Second Shelter Sketchbook p.12
Pencil, wax crayon, watercolour, wash, pen and
ink on off-white lightweight wove
204 × 165mm
Inscription: pencil u.l. *(half in shadow / cramped)*;
u.c. *Bunks with women sleeping & feeding
children –*

The Henry Moore Foundation: gift of Irina Moore 1977

29
Study for 'Tilbury Shelter Scene'
1940–41

HMF 1638
Second Shelter Sketchbook p.13
Pencil, wax crayon, watercolour, wash, pen and
ink on off-white lightweight wove
204 × 165mm
Inscription: pencil u.c. *Piles of bricks figures
against them (far end of Tilbury shelter)*

The Henry Moore Foundation: gift of Irina Moore 1977

30
Tilbury Shelter Scenes
1940–41

HMF 1639
Second Shelter Sketchbook p.14
Pencil, wax crayon, coloured crayon,
watercolour, wash, pen and ink
on off-white lightweight wove
204 × 165mm
Inscription: pencil u.c. *Dark wet settings,
entrance to Tilbury*

The Henry Moore Foundation: gift of Irina Moore 1977

31
Tilbury Shelter Platform
1940–41

HMF 1640
Second Shelter Sketchbook p.15
Pencil, wax crayon, coloured crayon, water-
colour, wash on off-white lightweight wove
204 × 165mm
Inscription: pencil u.c. *Far end of Tilbury Shelter,
platforms with people in dark corners, coats
hung up, / figures making beds etc.*

The Henry Moore Foundation: gift of Irina Moore 1977

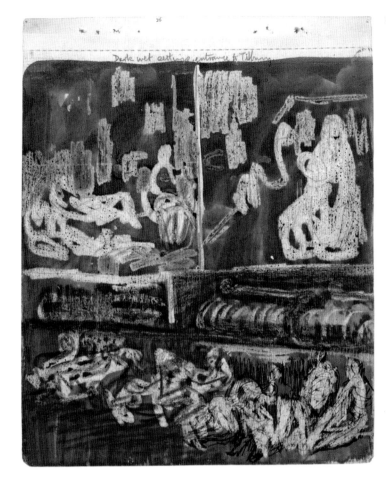

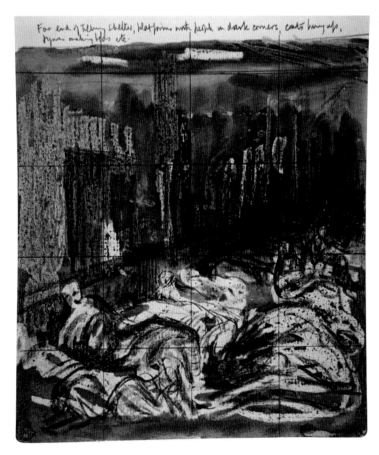

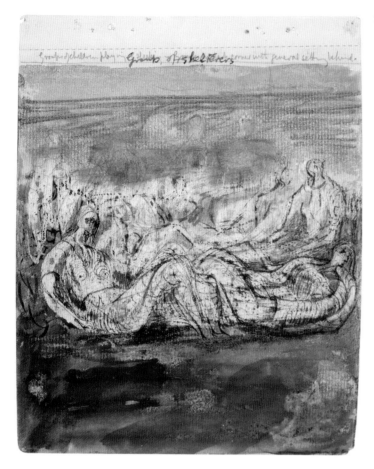

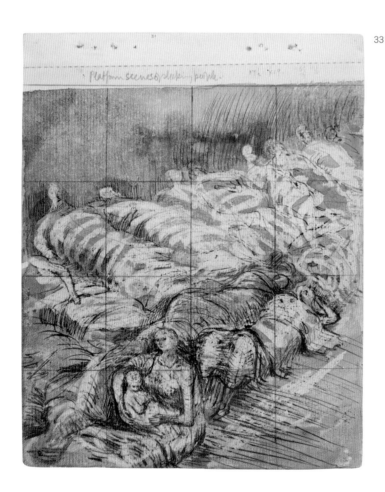

32
Group of Shelterers
1940–41

HMF 1644
Second Shelter Sketchbook p.19
Pencil, wax crayon, coloured crayon,
watercolour, wash, pen and ink
on off-white lightweight wove
204 × 165mm
Inscription: pencil u.c. *Groups of children
playing or sleeping – Group in dark corner with
general setting behind*; pen and ink over pencil
Group of shelterers

The Henry Moore Foundation: gift of Irina Moore 1977

33
Study for 'Mother and Child among
Underground Sleepers'
1940–41

HMF 1645
Second Shelter Sketchbook p.20
Pencil, wax crayon, coloured crayon,
watercolour, wash, pen and ink, conté
crayon on off-white lightweight wove
204 × 165mm
Inscription: pencil u.c. *Platform scenes of
sleeping people*

The Henry Moore Foundation: gift of Irina Moore 1977

34
Study for 'Tube Shelter Perspective:
The Liverpool Street Extension'
1940–41

HMF 1649
Second Shelter Sketchbook p.24
Pencil, wax crayon, coloured crayon,
watercolour, wash, pen and ink
on off-white lightweight wove
204 × 165mm
Inscription: pencil u.c. *Rows* […]; pen and ink
over pencil *Tunnel shelterers*

The Henry Moore Foundation: gift of Irina Moore 1977

35
Study for 'Row of Sleepers'
1940–41

HMF 1657
Second Shelter Sketchbook p.32
Pencil, wax crayon, coloured crayon,
watercolour, wash on off-white lightweight wove
204 × 165mm

The Henry Moore Foundation: gift of Irina Moore 1977

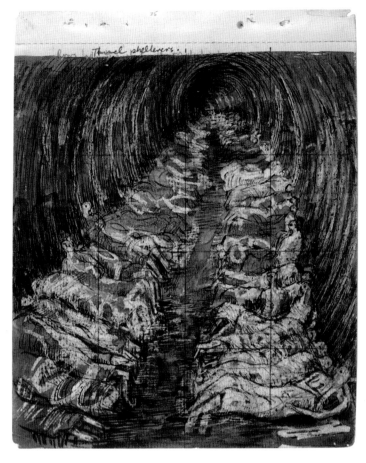

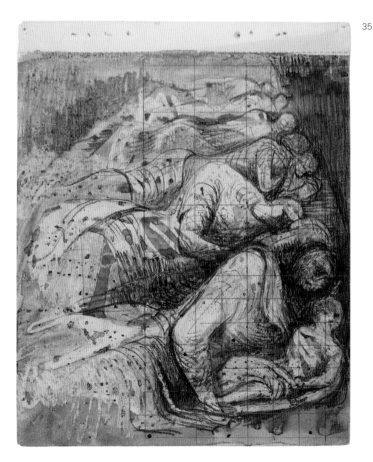

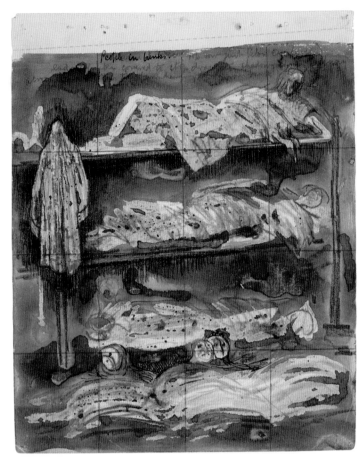

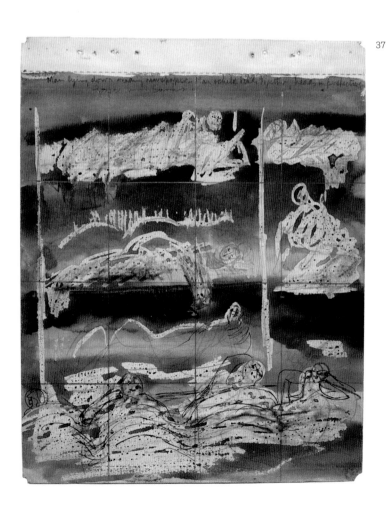

36
Study for 'Shelter Scene: Bunks and Sleepers'
1940–41

HMF 1658
Second Shelter Sketchbook p.33
Pencil, wax crayon, coloured crayon, wash,
pen and ink on off-white lightweight wove
204 × 165mm
Inscription: pencil u.c. *(Top row just below eye
level) / end of bunks covered to stop draughts
– shadows come halfway / across second &
bottom tier (arm hanging down from bunk)*; pen
and ink u.c. *People in bunks*

The Henry Moore Foundation: gift of Irina Moore 1977

37
Study for 'Shelter Scene: Bunks and Sleepers'
1940–41

HMF 1663
Second Shelter Sketchbook p.38
Pencil, wax crayon, coloured crayon,
watercolour, wash, pen and ink
on off-white lightweight wove
204 × 165mm
Inscription: pencil u.c *Man lying down reading
newspaper – Man & child heads together,
heads in perspective / Figures in Bunks*

The Henry Moore Foundation: gift of Irina Moore 1977

38
Two Studies of Sleeping Shelterers
1940–41

HMF 1665
Second Shelter Sketchbook p.40
Pencil, wax crayon, coloured crayon,
watercolour, wash, pen and ink
on off-white lightweight wove
204 × 165mm
Inscription: pencil u.c. *Try doing figures, of all
sorts of coloured blankets & coats & odd black
boots near head*

The Henry Moore Foundation: gift of Irina Moore 1977

39
Study for 'Sleeping Figures'
1940–41

HMF 1666
Second Shelter Sketchbook p.41
Pencil, wax crayon, wash
on off-white lightweight wove
204 × 165mm
Inscription: pen and ink over pencil u.c. *people
under Different coloured coats & blankets –
one or two sat up*

The Henry Moore Foundation: gift of Irina Moore 1977

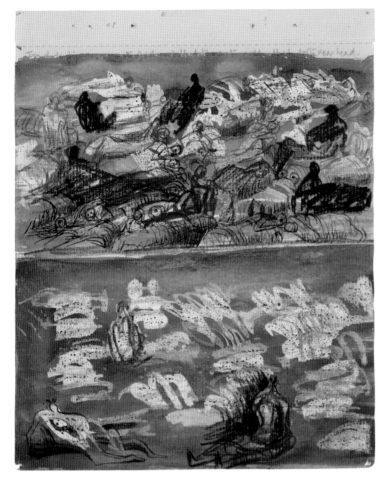

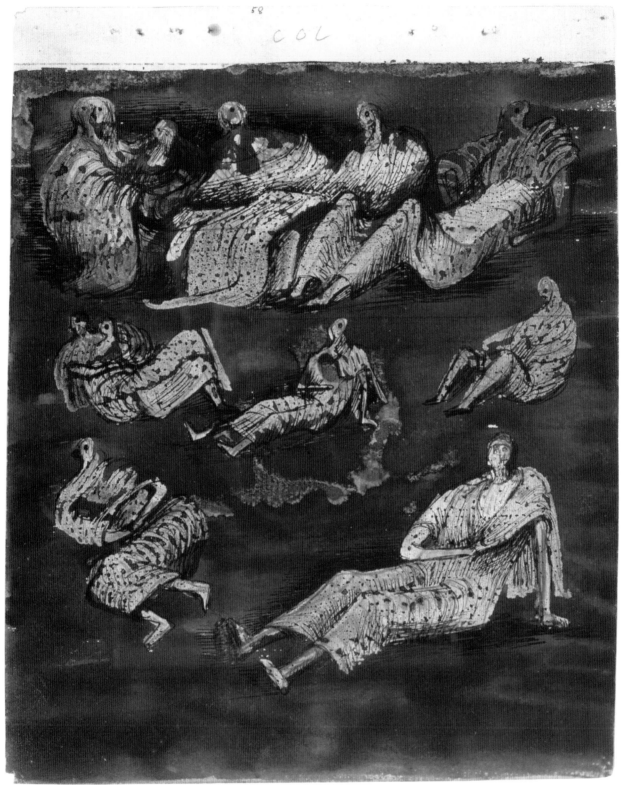

40
Study for 'Group of Draped Figures in a Shelter'
1940–41

HMF 1672
Second Shelter Sketchbook p.47
Pencil, wax crayon, coloured crayon,
chalk, wash, pen and ink
on off-white lightweight wove
204 × 165mm

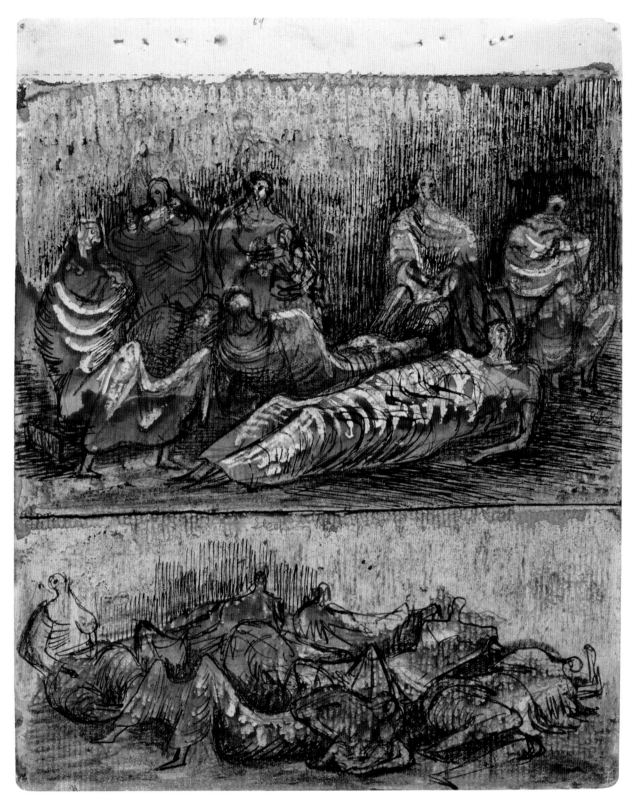

41
Group of Shelterers
1940–41

HMF 1673
Second Shelter Sketchbook p.48
Pencil, wax crayon, coloured crayon,
watercolour, wash, pen and ink
on off-white lightweight wove
204 × 165mm
Inscription: pencil l.c. *Sleeping figures*

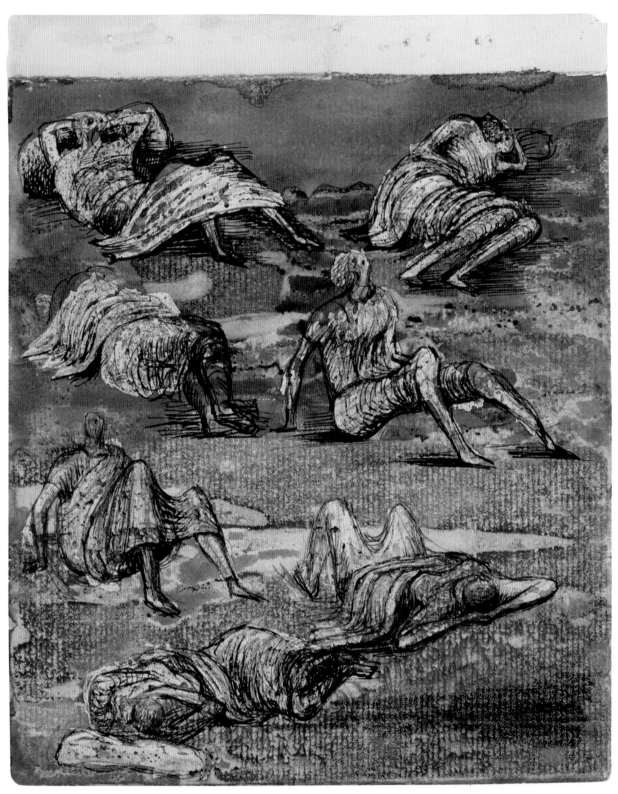

42
Figure Studies
1940–41

HMF 1674
Second Shelter Sketchbook p. 49
Pencil, wax crayon, coloured crayon,
watercolour, wash, pen and ink
on off-white lightweight wove
204 × 165mm

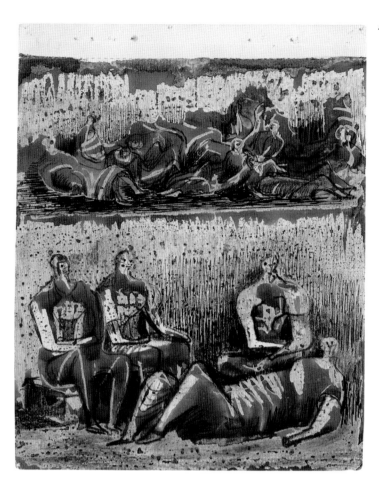

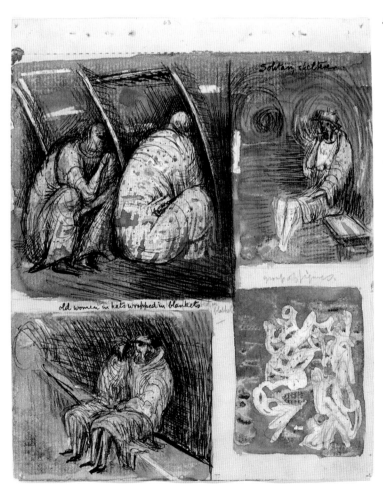

43
Group of Shelterers
1940–41

HMF 1675
Second Shelter Sketchbook p.50
Pencil, wax crayon, watercolour, wash, pen
and ink on off-white lightweight wove
204 × 165mm

The Henry Moore Foundation: gift of Irina Moore 1977

44
Shelter Figures
1940–41

HMF 1677
Second Shelter Sketchbook p.52
Pencil, wax crayon, chalk, watercolour, wash,
pen and ink on off-white lightweight wove
204 × 165mm
Inscription: pen and ink u.r. *Solitary shelterer*;
pencil c.r. *group of figures*; pen and ink over
pencil l.c.l. *old women in hats wrapped in
blankets*

The Henry Moore Foundation: gift of Irina Moore 1977

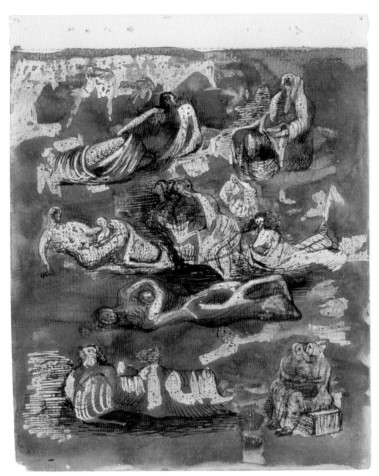

45
Figure Studies
1940–41

HMF 1678
Second Shelter Sketchbook p.53
Pencil, wax crayon, watercolour, pen and ink
on off-white lightweight wove
204 × 165mm

The Henry Moore Foundation: gift of Irina Moore 1977

46
Tube Shelter Scenes
1940–41

HMF 1679
Second Shelter Sketchbook p.54
Pencil, wax crayon, coloured crayon,
watercolour, wash, pen and ink
on off-white lightweight wove
204 × 165mm
Inscription: pencil u.c. *Do abstract drawing […]
of scene […] / draw these in pen before
colouring*

The Henry Moore Foundation: gift of Irina Moore 1977

47
Study for 'Shelter Drawing'
1940–41

HMF 1684
Second Shelter Sketchbook p.59
Pencil, wax crayon, watercolour, pen
and ink on off-white lightweight wove
204 × 165mm

The Henry Moore Foundation: gift of Irina Moore 1977

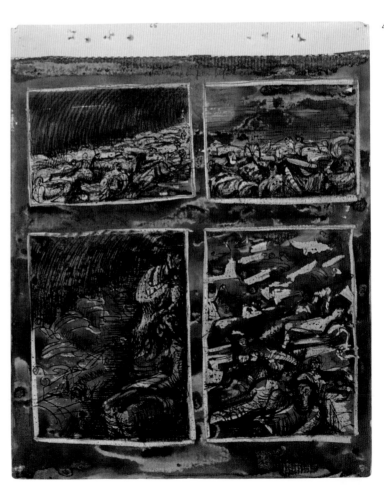

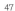
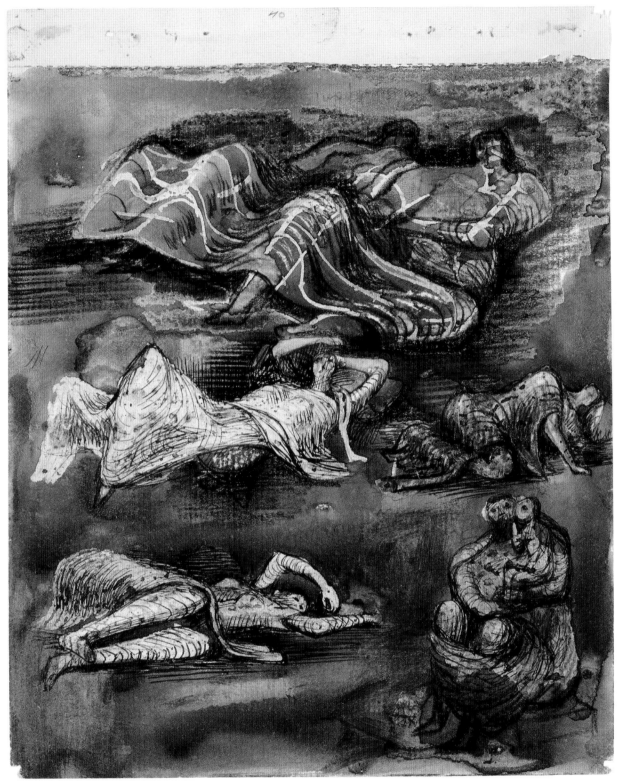



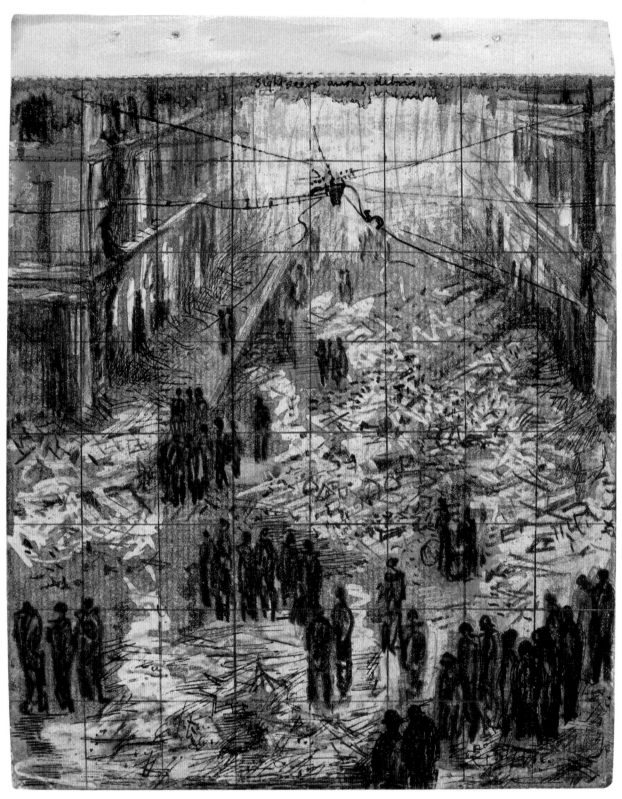

48
Study for 'Morning after the Blitz'
1940–41

HMF 1685
Second Shelter Sketchbook p.60
Pencil, wax crayon, coloured crayon, watercolour,
wash, pen and ink on off-white lightweight wove
204 × 165mm
Inscription: pen and ink u.c. *Sightseers among
debris*

The Henry Moore Foundation: gift of Irina Moore 1977

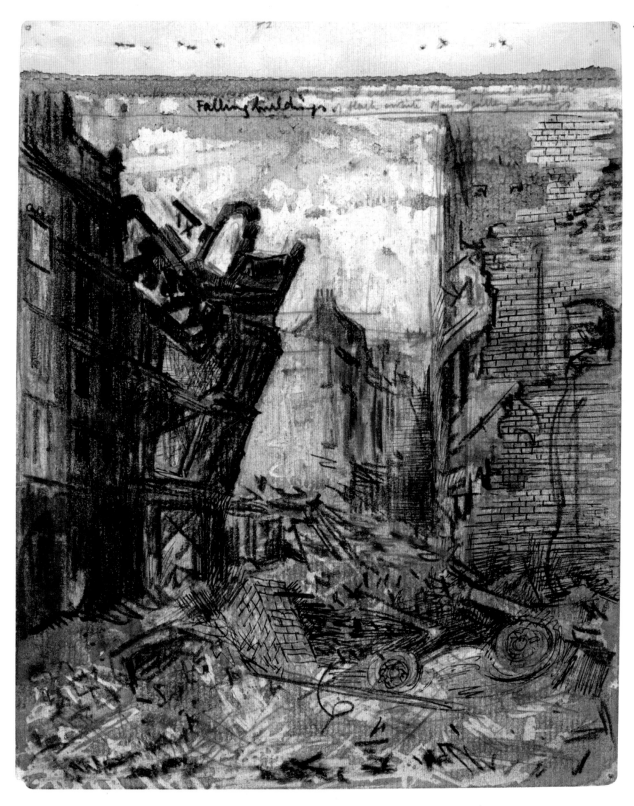

49
Falling Buildings: The City 30 December 1940
1940–41

HMF 1686
Second Shelter Sketchbook p.61
Pencil, wax crayon, coloured crayon, watercolour,
wash, pen and ink on off-white lightweight wove
204 × 165mm
Inscription: wax crayon u.c. *Falling buildings;* pencil
[…] *drawings & enclosed drawings against walls
etc /* […] *of black & white Mayor Gallery drawings*

The Henry Moore Foundation: gift of Irina Moore 1977

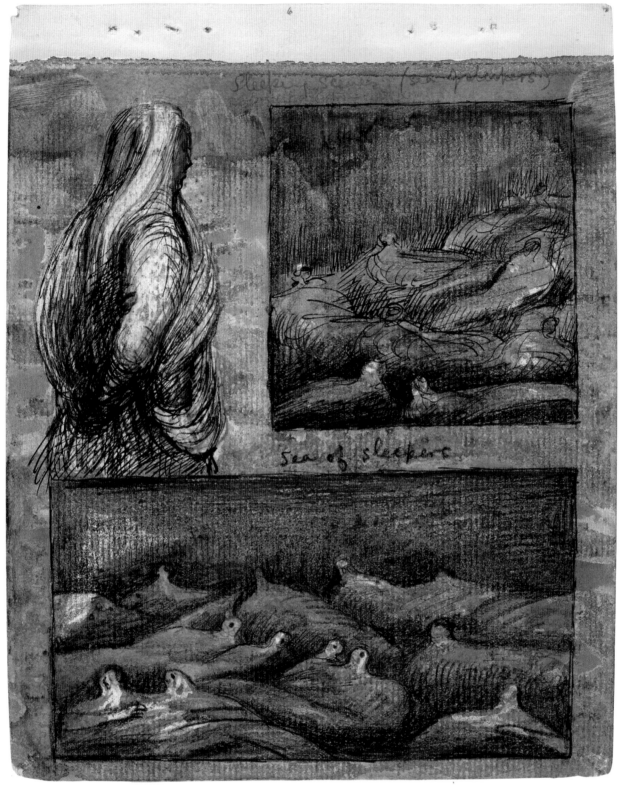

50
Sea of Sleepers
1940–41

HMF 1687
Second Shelter Sketchbook p.62
Wax crayon, watercolour, wash, pen and ink
on off-white lightweight wove
204 × 165mm
Inscription: pencil u.c. *Sleeping scenes (sea of
sleepers)*; wax crayon c.r. *Sea of sleepers*

The Henry Moore Foundation: gift of Irina Moore 1977

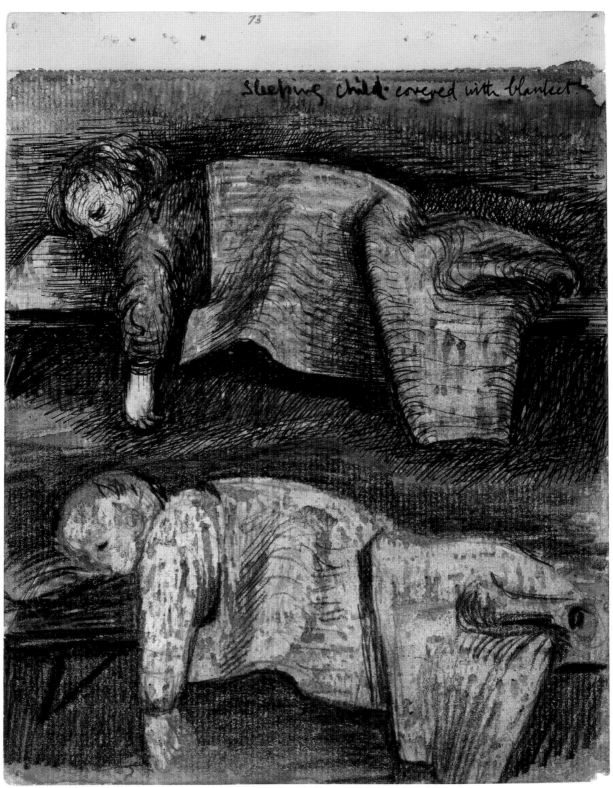

51
Sleeping Child Covered with Blanket
1940–41

HMF 1688
Second Shelter Sketchbook p.63
Pencil, wax crayon, coloured crayon, watercolour
wash, pen and ink on off-white lightweight wove
204 × 165mm
Inscription: wax crayon u.c. *Sleeping child*;
pen and ink *covered with blanket*

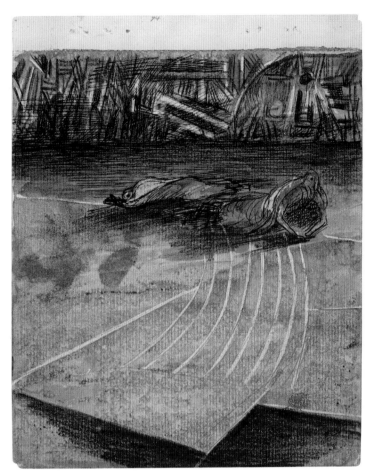

52
Sleeping Figures on Shelter Platform
1940–41

HMF 1689
Second Shelter Sketchbook p.64
Pencil, wax crayon, coloured crayon,
watercolour, wash, pen and ink
on off-white lightweight wove
204 × 165mm

The Henry Moore Foundation: gift of Irina Moore 1977

53
Study for 'Pink and Green Sleepers'
1940–41

HMF 1692
Second Shelter Sketchbook p.67
Pencil, wax crayon, watercolour, wash, pen and
ink, gouache on off-white lightweight wove
204 × 165mm
Inscription: pencil u.c. *blanket / heads v.
foreshortened / Child's crayon background &
pencil instead of tube colour*; pen and ink (over
inscription in pencil) l.c. *Sleeping Mother & child*

The Henry Moore Foundation: gift of Irina Moore 1977

54
Sleeping Shelterer
1940–41

HMF 1694
Second Shelter Sketchbook p.69
Pencil, wax crayon, coloured crayon,
watercolour, wash, gouache
on off-white lightweight wove
204 × 165mm

The Henry Moore Foundation: gift of Irina Moore 1977

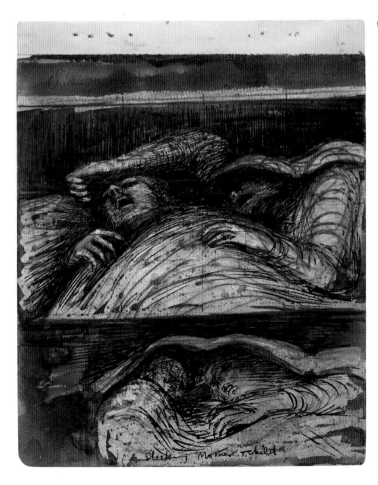

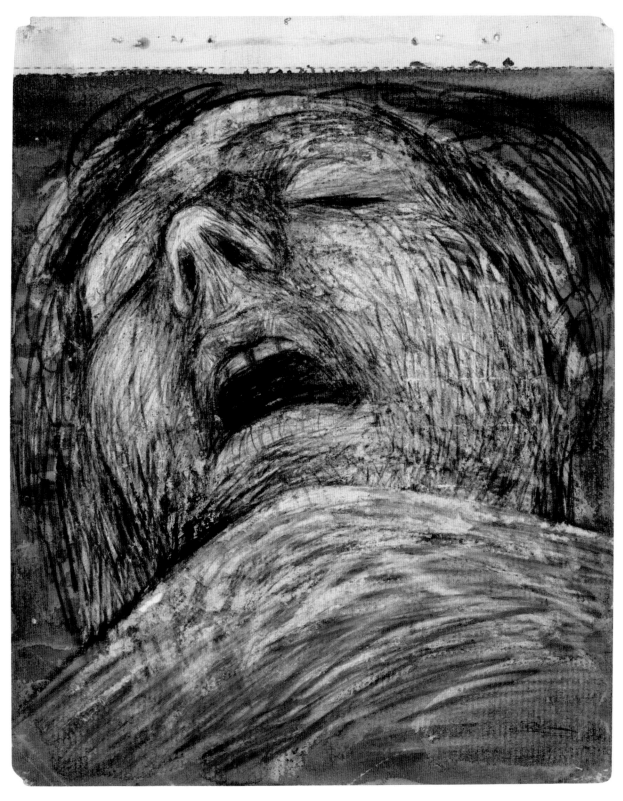

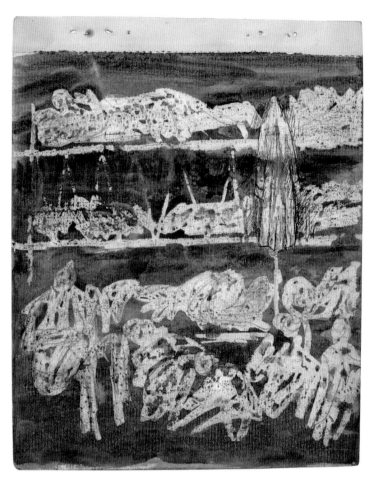

55
Bunks and Sleepers
1940–41

HMF 1697
Second Shelter Sketchbook p.72
Pencil, wax crayon, coloured crayon, watercolour,
wash, pen and ink on off-white lightweight wove
204 × 165mm
Inscription: pencil u.c. *(Try pastel colours)* […]
Bunk […] *figures over page*

The Henry Moore Foundation: gift of Irina Moore 1977

56
Bunks and Sleepers
1940–41

HMF 1698
Second Shelter Sketchbook p.73
Pencil, wax crayon, coloured crayon, watercolour,
wash, pen and ink, gouache on off-white
lightweight wove
204 × 165mm

The Henry Moore Foundation: gift of Irina Moore 1977

57
Bunks and Sleepers
1940–41

HMF 1700
Second Shelter Sketchbook p.75
Pencil, wax crayon, wash, pen and ink
on off-white lightweight wove
204 × 165mm
Inscription: pencil u.r. [E]*arth shades*

The Henry Moore Foundation: gift of Irina Moore 1977

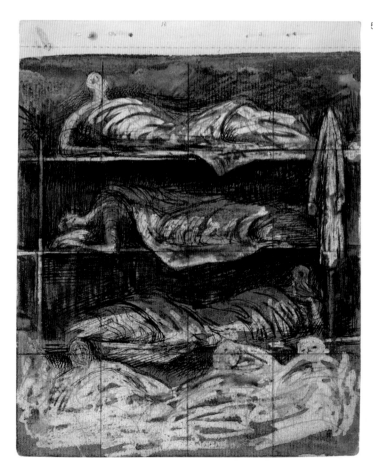

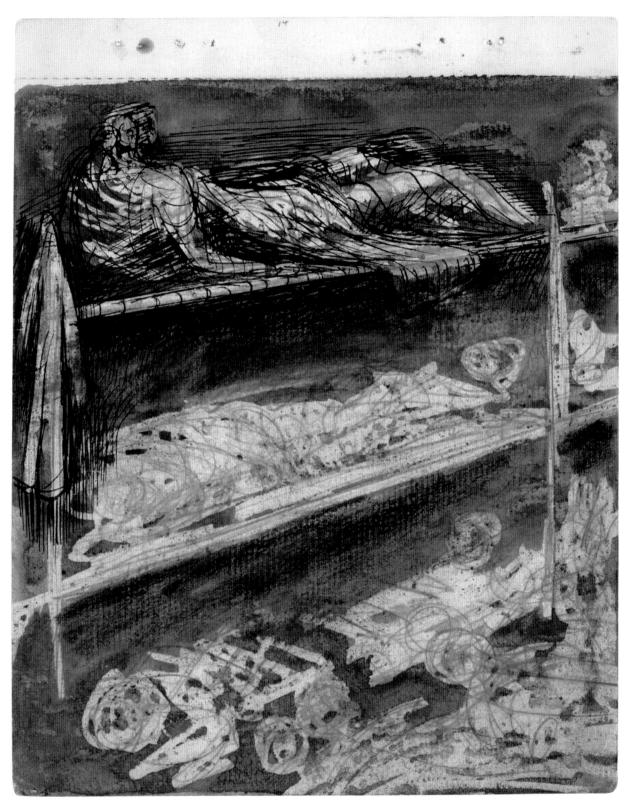

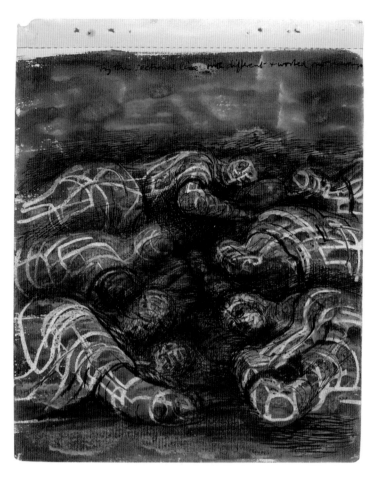

58

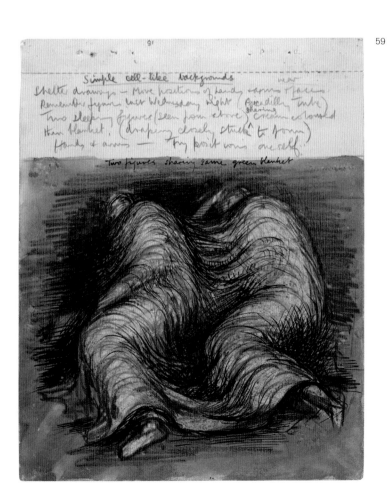

59

58
Study for 'Shelter Drawing'
1940–41

HMF 1702
Second Shelter Sketchbook p.77
Pencil, wax crayon, coloured crayon,
watercolour, wash, pen and ink
on off-white lightweight wove
204 × 165mm
Inscription: pen and ink u.c. *Try this sectional
line with different & worked out drawings*

The Henry Moore Foundation: gift of Irina Moore 1977

59
Two Figures Sharing Same Green Blanket
1940–41

HMF 1705
Second Shelter Sketchbook p.80
Pencil, wax crayon, watercolour, pen
and ink on off-white lightweight wove
204 × 165mm
Inscription: pencil u.c. *Simple cell-like
backgrounds / Shelter drawings – More positions
of heads & arms &* [near added] *faces /Remember
figures last Wednesday night (Piccadilly Tube) /
Two sleeping figures (seen from above)* [sharing
added] *cream coloured /thin blanket (drapery
closely stuck to form) /Hands & arms – Try
positions oneself*; pen and ink *Two figures
sharing same green blanket*

The Henry Moore Foundation: gift of Irina Moore 1977

60
Sleeping Positions
1940–41

HMF 1707
Second Shelter Sketchbook p.82
Pencil, wax crayon, coloured crayon,
watercolour, wash, pen and ink
on off-white lightweight wove
204 × 165mm
Inscription: pen and ink u.c. *Try position
oneself / Sleeping positions*

The Henry Moore Foundation: gift of Irina Moore 1977

61
Study for 'Shelter Sleepers'
1940–41

HMF 1709
Second Shelter Sketchbook p.84
Pencil, wax crayon, coloured crayon,
pastel, watercolour, wash, pen and ink
on off-white lightweight wove
204 × 165mm
Inscription: pencil u.r. *mother & child /
sleeping /* [child crossed out]

The Henry Moore Foundation: gift of Irina Moore 1977

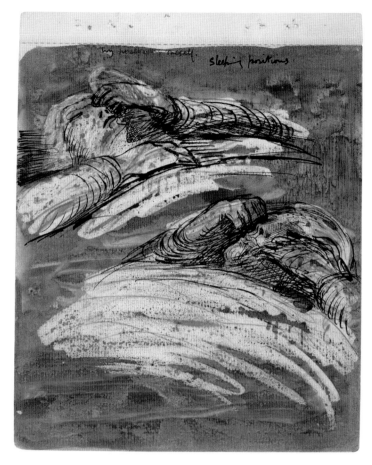

sleeping positions

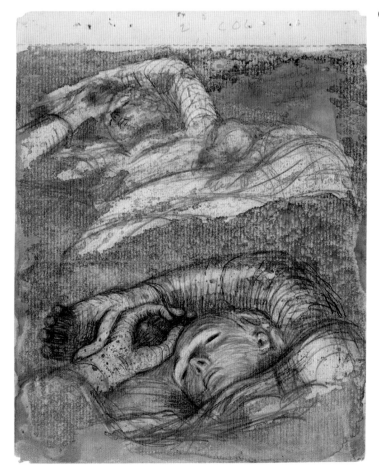

62
Sleeping Figures
1940–41

HMF 1711
Second Shelter Sketchbook p.86
Pencil, wax crayon, pastel, watercolour, wash,
pen and ink on off-white lightweight wove
204 × 165mm

The Henry Moore Foundation: gift of Irina Moore 1977

63
Woman with Plaster in Her Hair
1940–41

HMF 1714
Second Shelter Sketchbook p.89
Pencil, wax crayon, coloured crayon, pen
and ink on off-white lightweight wove
204 × 165mm

The Henry Moore Foundation: gift of Irina Moore 1977

64
Shelter Figure Studies
1940–41

HMF 1717
Second Shelter Sketchbook p.92
Pencil, wax crayon, coloured crayon,
pastel, watercolour, wash, pen and ink
on off-white lightweight wove
204 × 165mm

The Henry Moore Foundation: gift of Irina Moore 1977

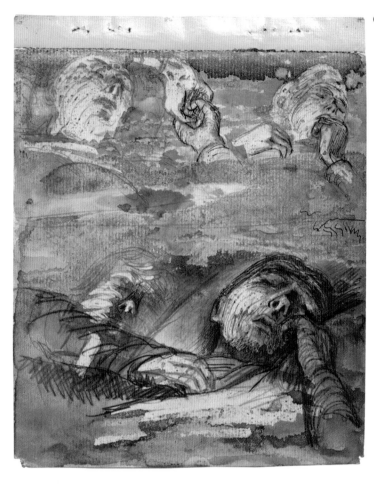

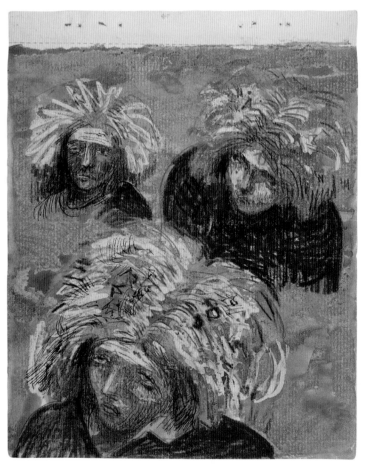

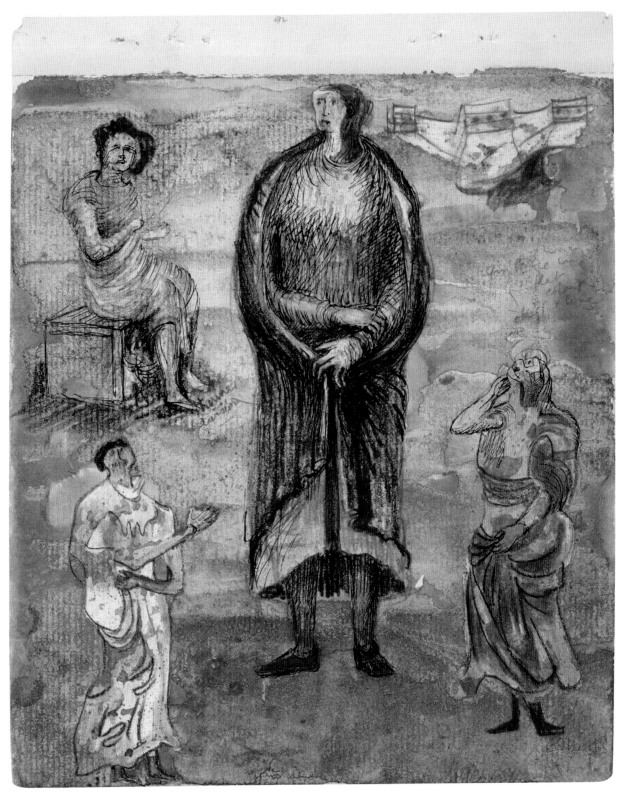

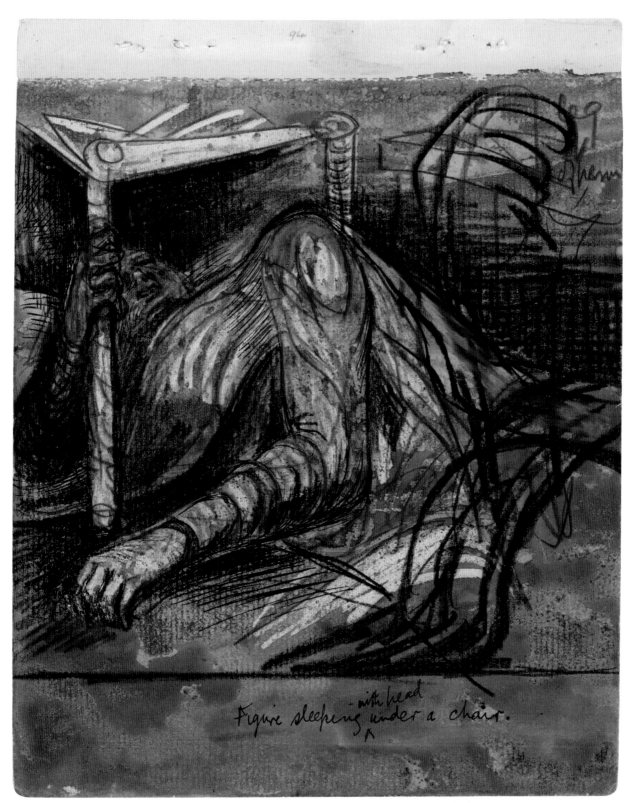

65
Figure Sleeping with Head under a Chair
1940–41

HMF 1719
Second Shelter Sketchbook p.94
Pencil, wax crayon, coloured crayon, watercolour,
wash, pen and ink on off-white lightweight wove
204 × 165mm
Inscription: pencil u.c. *figure sleeping under a
chair or bench / leg /* […]; pen and ink l.c.
Figure sleeping [*with head* added] *under a chair*

The Henry Moore Foundation: gift of Irina Moore 1977

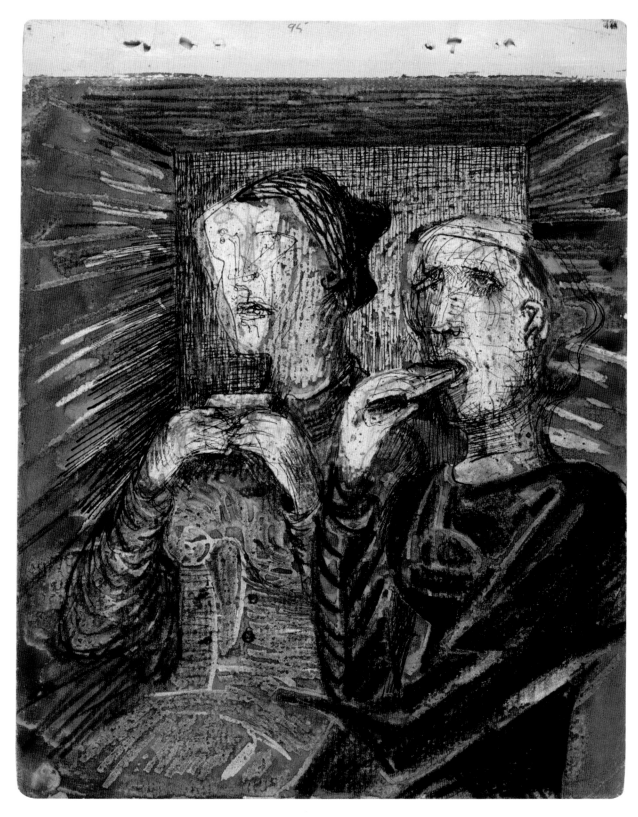

66
Two Figures Taking a Snack in a Shelter
1940−41

HMF 1720
Second Shelter Sketchbook p.95
Pencil, wax crayon, coloured crayon, watercolour,
wash, pen and ink on off-white lightweight wove
204 × 165mm

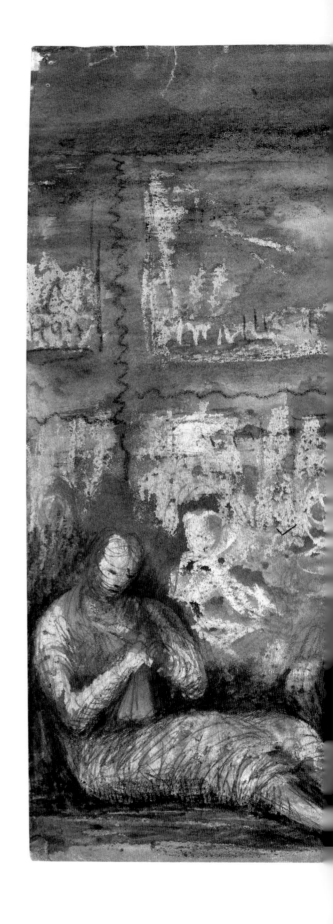

67
Study for 'Grey Tube Shelter'
1940

HMF 1723
Pencil, wax crayon, chalk, watercolour
279 × 381mm
Signature: pen and ink l.r. *Moore / 40*

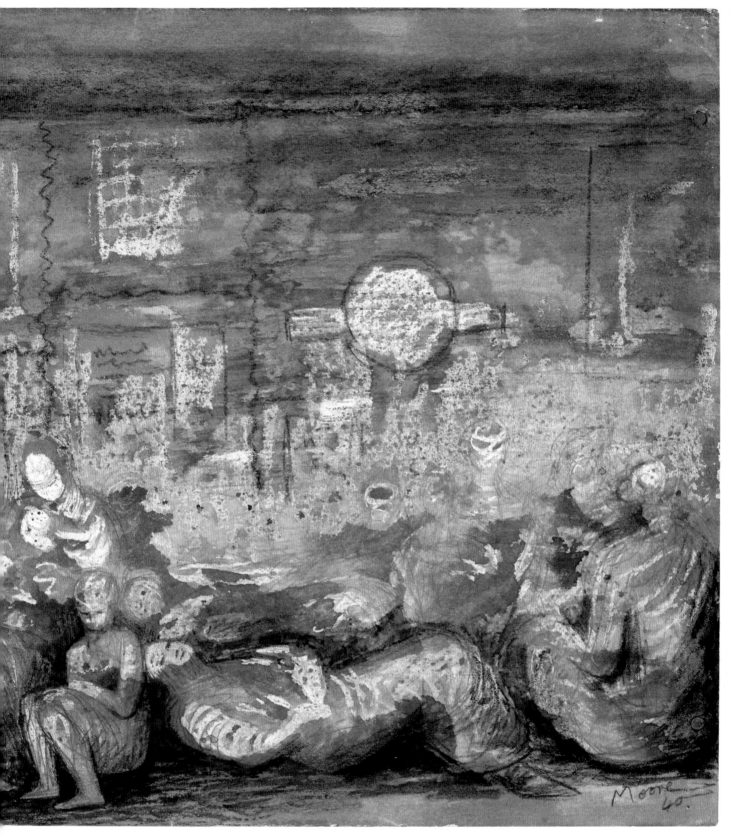

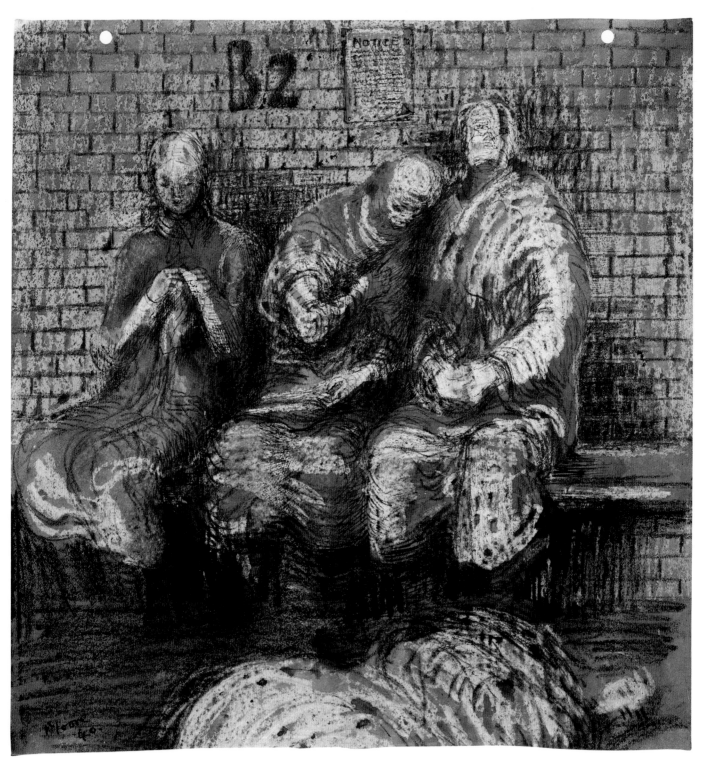

68
Shelter Drawing
1940

HMF 1731
Pencil, wax crayon, coloured crayon, watercolour,
pen and ink on cream lightweight wove
289 × 273mm
Signature: pen and ink l.l. *Moore / 40*

The Henry Moore Family Collection

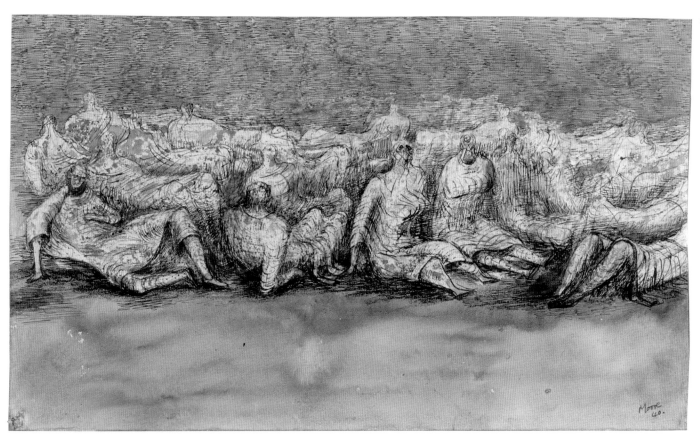

69
Group of Shelterers
1940

HMF 1736
Pencil, wax crayon, watercolour,
wash, pen and ink
254 × 432mm
Signature: pen and ink l.r. *Moore / 40*

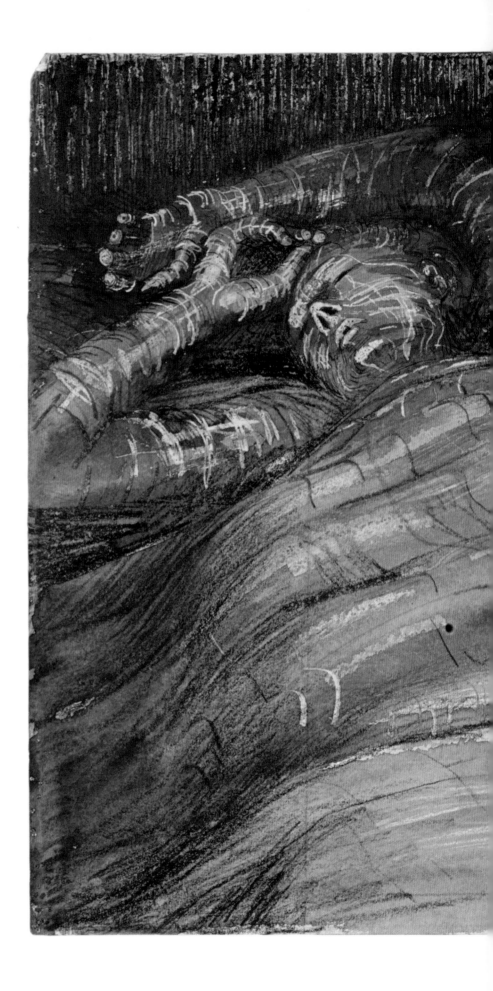

70
Shelter Sleepers
1940

HMF 1738
Pencil, wax crayon, chalk, watercolour,
wash, pen and ink
333 × 524mm
Signature: l.r. *Moore / 40*

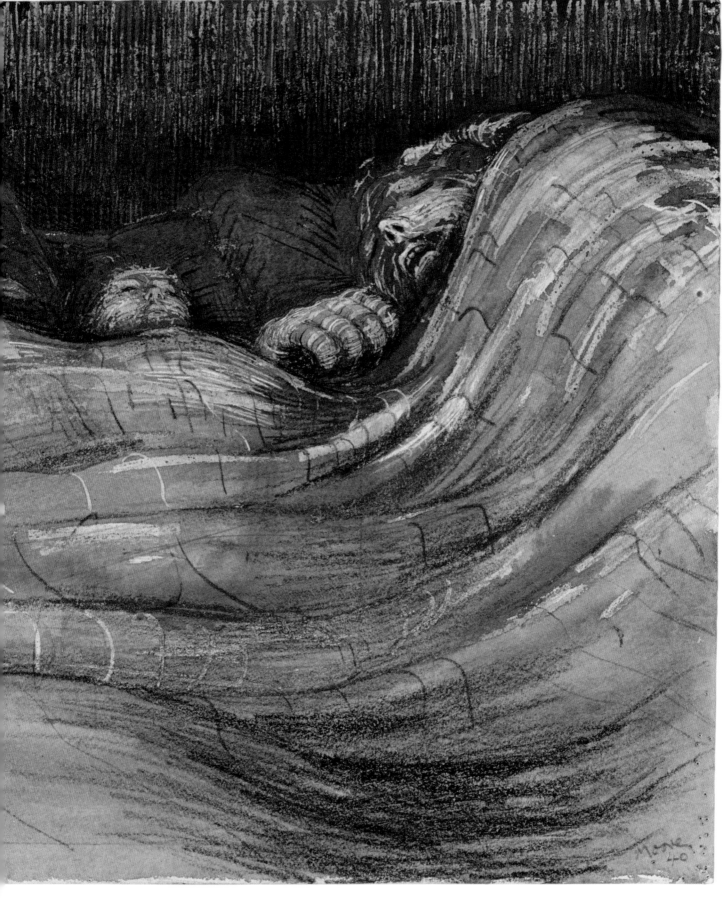

70

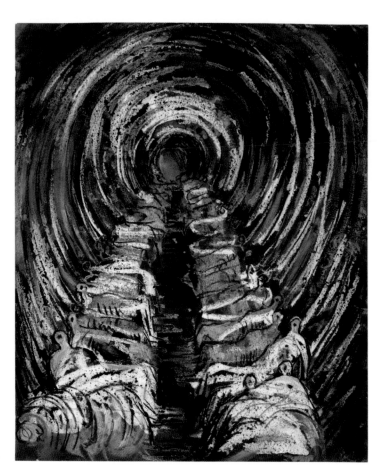

71
Tube Shelter Perspective
1941

HMF 1773
Page from Large Shelter Sketchbook 1941
Pencil, wax crayon, coloured crayon, watercolour
wash, gouache on off-white lightweight wove
292 × 242mm

The Henry Moore Foundation: gift of the artist 1977

72
Sleeping Figures
1941

HMF 1782
Page from Large Shelter Sketchbook 1941
Pencil, wax crayon, coloured crayon, watercolour,
wash on off-white lightweight wove
290 × 238mm

The Henry Moore Foundation: gift of the artist 1977

73
Shelter Scene: Bunks and Sleepers
1941

HMF 1789
Pencil, wax crayon, watercolour,
wash, pen and ink
482 × 432mm

The Trustees of the Tate Gallery, London: presented
by the War Artists' Advisory Committee 1946

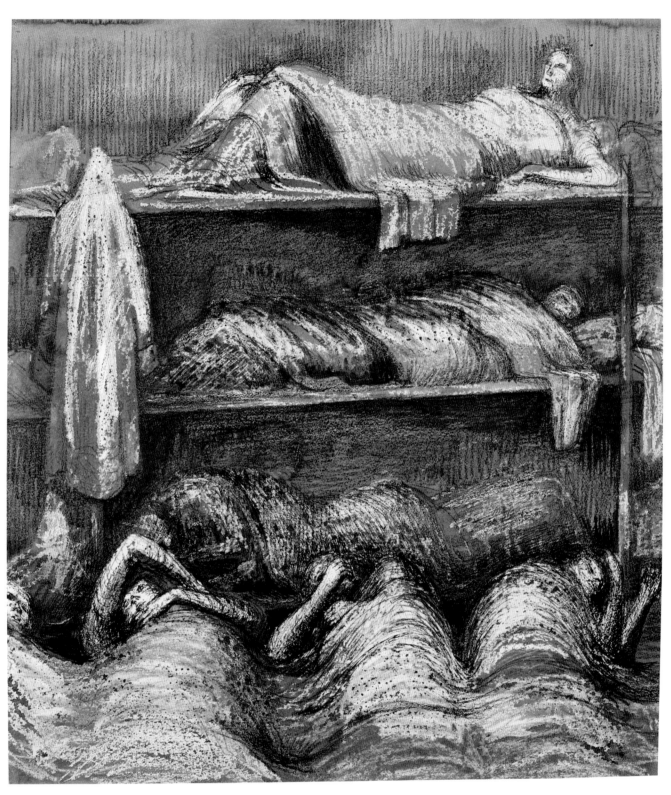

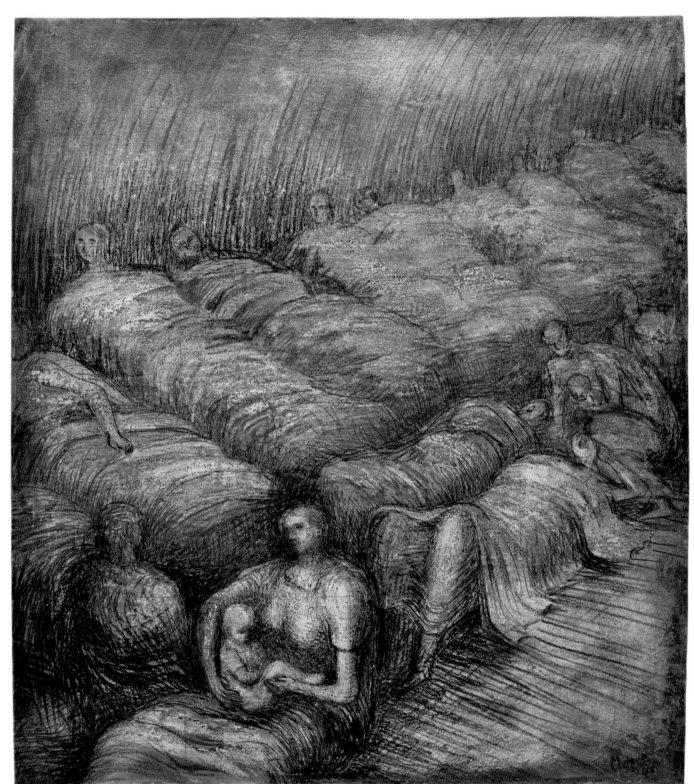

74
Mother and Child among Underground Sleepers
1941

HMF 1798
Pencil, wax crayon, watercolour wash, pen and
ink, gouache on cream medium-weight wove
485 × 439mm
Signature: l.r. pen and ink *Moore / 41*

The Henry Moore Foundation: acquired 1977

75
Shelter Drawing: Sleeping Figures
1941

HMF 1816
Pencil, wax crayon, watercolour, wash, pen
and ink on off-white medium-weight wove
303 × 308mm
Signature: pen and ink l.r. *Moore / 41*

The Henry Moore Foundation: acquired 1983

76
Group of Draped Figures in a Shelter
1941

HMF 1807
Chalk, wax crayon, coloured crayon,
watercolour, pen and ink, gouache
on cream medium-weight wove
324 × 565mm
Signature: pen and ink l.r. *Moore / 41*

The Henry Moore Foundation: acquired 1982

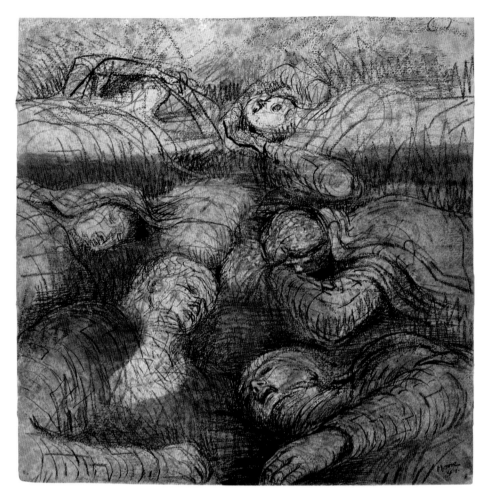

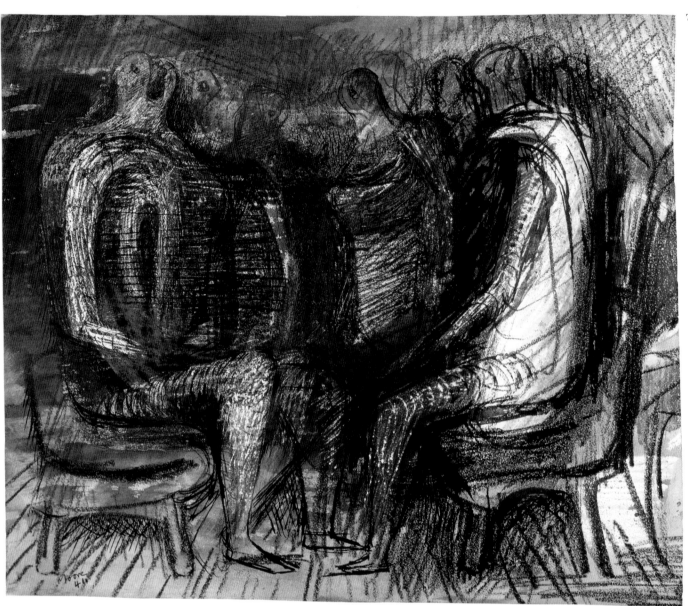

77
Group of Seated Figures
1941

HMF 1835
Pencil, wax crayon, coloured crayon,
watercolour wash, gouache, pen and ink
on medium-weight wove
359 × 432mm
Signature: pen and ink l.l. *Moore / 41*

The Henry Moore Foundation: acquired
in memory of Joanna Drew CBE 2005

78
Shelter Drawing: Woman Eating Sandwich
1940–41

HMF 1838
Pencil, wax crayon, coloured crayon,
watercolour wash
177 × 125mm
Inscription: pen and ink l.l. *woman eating
sandwich*
Signature (added later): ballpoint pen l.l.
Moore / 41

The Henry Moore Family Collection

79
Two Figures Taking a Snack in a Shelter
1941

HMF 1839
Pencil, wax crayon, coloured crayon,
watercolour wash, pen and ink
156 × 165mm
Signature: pen and ink l.r. *Moore / 41*

Robert and Lisa Sainsbury Collection,
University of East Anglia, Norwich

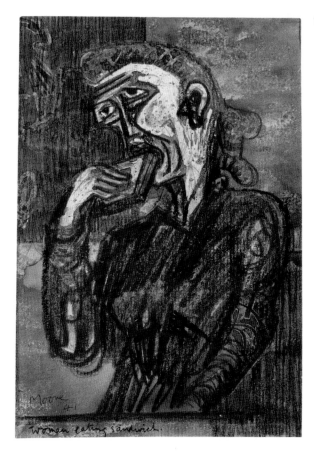

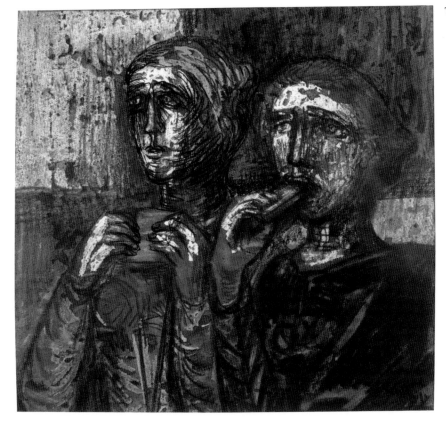

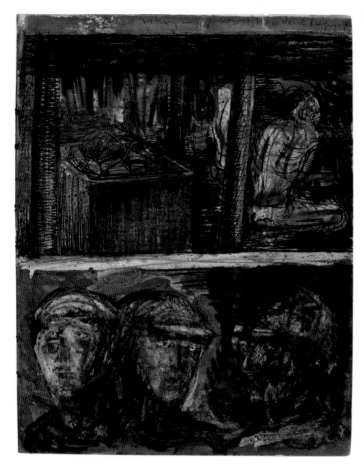

80

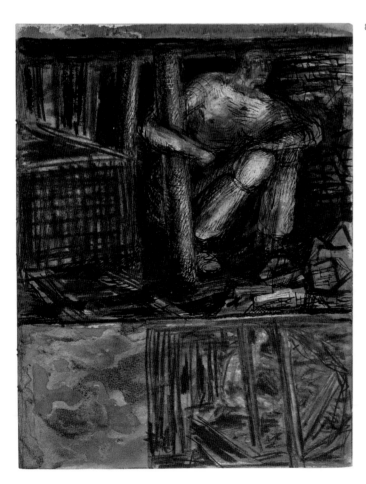

81

80
Miners' Heads
1942

HMF 1927
Coalmining Subjects Sketchbook p.[7]
Pencil, wax crayon, coloured crayon,
watercolour wash, pen and ink
on cream lightweight wove
203 × 162mm
Inscription: pencil u.c. *Collier working –
waistcoat, [...] in sleeve hanging*

The Henry Moore Foundation: gift of the artist 1977

81
Miner with Truck
1942

HMF 1928
Coalmining Subjects Sketchbook p.[9]
Pencil, wax crayon, coloured crayon,
watercolour wash, pen and ink
on cream lightweight wove
203 × 162mm
Inscription: pencil u.c. *old man with white eyes –
when conveyor belt stopped)*

The Henry Moore Foundation: gift of the artist 1977

82
Miner with Pit Pony
1942

HMF 1929
Coalmining Subjects Sketchbook p.[11]
Pencil, wax crayon, coloured crayon,
watercolour, wash, pen and ink
on cream lightweight wove
203 × 162mm
Inscription: pencil u.c. [illegible]

The Henry Moore Foundation: gift of the artist 1977

83
Miners Walking into Tunnel
1942

HMF 1943
Coalmining Subjects Sketchbook p.[39]
Pencil, wax crayon, coloured crayon,
watercolour, wash, pen and ink
on cream lightweight wove
203 × 162mm
Inscription: pencil u.l. [illegible]

The Henry Moore Foundation: gift of the artist 1977

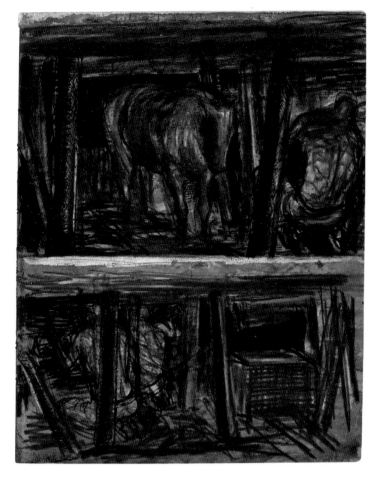

82

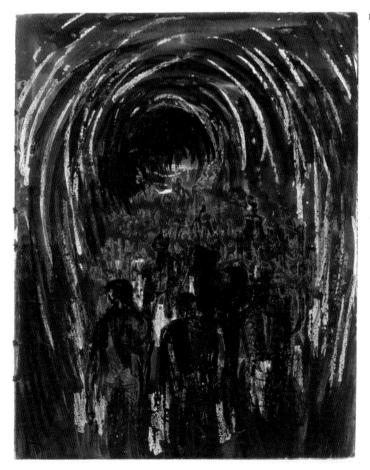

83

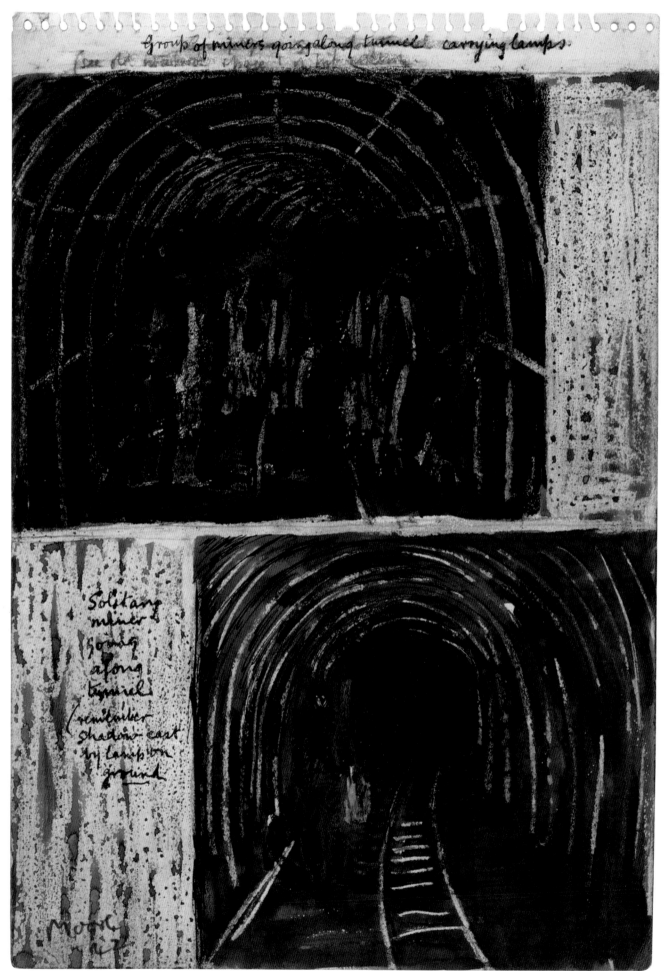

Group of miners going along tunnel carrying lamps.

Solitary miner going along tunnel

(remember shadow cast by lamp on ground

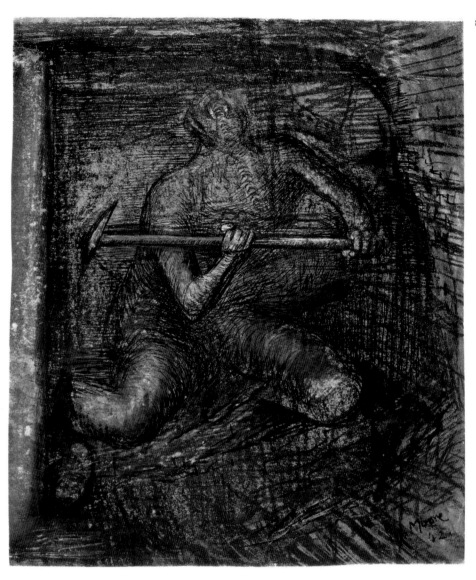

84
Miners Going along Tunnel
1942

HMF 1947
Page from Coalmine Sketchbook 1942
Pencil, wax crayon, coloured crayon,
watercolour, wash, pen and ink
on white medium-weight wove
251 × 178mm
Inscription: pen and ink u.c. *Group of miners
going along tunnel carrying lamps*; pencil
(see old notebook & page 1 of pit notebook;
pen and ink l.l. *Solitary / miner / going /
along / tunnel / (remember / shadow cast /
by lamp on / ground*
Signature (added later): pencil l.l. *Moore / 42*

The Henry Moore Foundation: gift of the artist 1977

85
Miner at Work
1942

HMF 1999
Pencil, wax crayon, coloured crayon,
watercolour, wash, pen and ink
on cream medium-weight wove
311 × 267mm
Signature: pen and ink l.r. *Moore / 42*

The Henry Moore Foundation: gift of the artist 1977

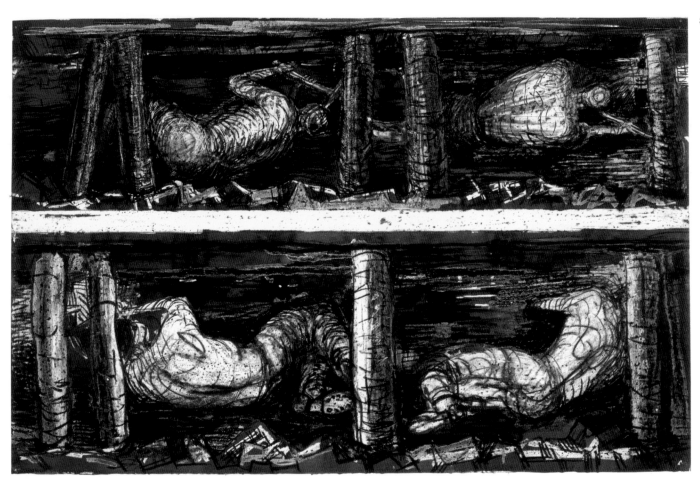

86
Four Studies of Miners at the Coalface
1942

HMF 2000a
Pencil, wax crayon, coloured crayon,
watercolour, wash, pen and ink, gouache
on cream medium-weight wove
365 × 562mm
Signature: pen and ink l.r. *Moore / 42*

The Henry Moore Foundation: acquired 1984

87
Miner Drilling in Drift
1942

HMF 2005
Pencil, wax crayon, coloured crayon,
watercolour, wash, pen and ink
292 × 216mm
Signature: pen and ink l.r. *Moore / 42*

Robert and Lisa Sainsbury Collection,
University of East Anglia, Norwich

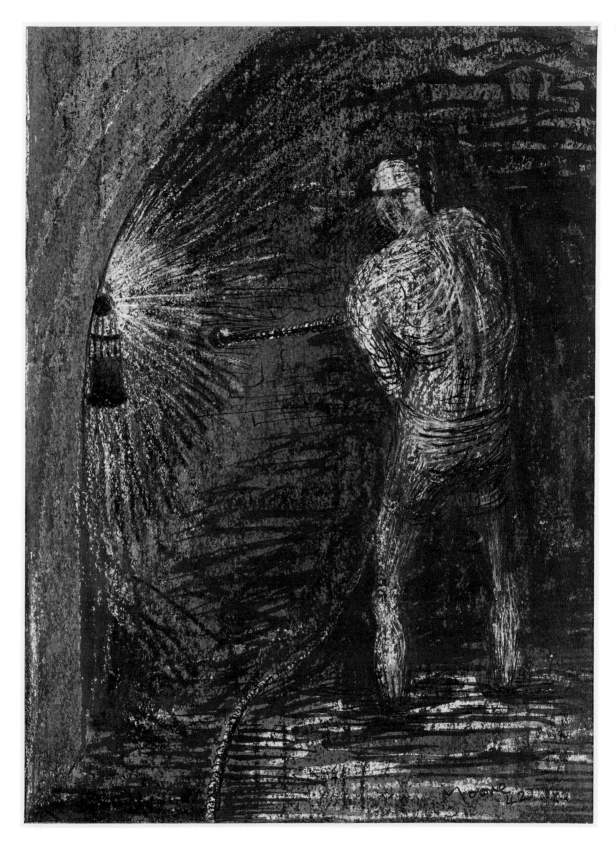

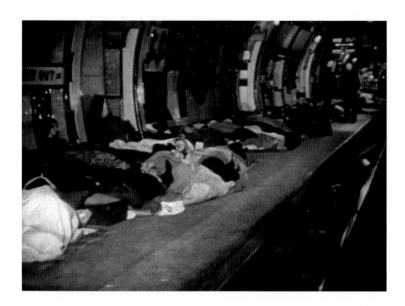

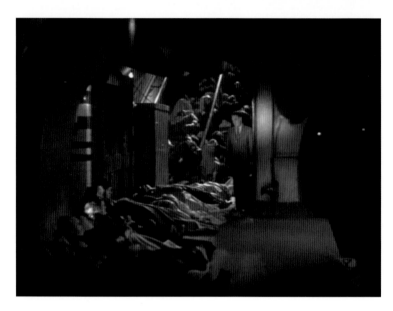

Fig. 37–43 (pp. 110–113). Stills from *Out of Chaos* (directed by Jill Craigie, London, 1944)

Thierry Morel Out of Chaos

The film *Out of Chaos*, made in 1944, started out as an attempt by the British Government to show official war artists at work as they documented the effect of the war on Britain and its population. At the same time it was intended to give the public a didactic introduction to modern art.

This pioneering enterprise became one of the first semi-documentary films to be distributed to mainstream cinemas. The film featured interviews with prominent British artists, among them Paul Nash, Graham Sutherland and Henry Moore, and offered them a rare opportunity to describe and explain their works on camera to the general public.

The film-maker Jill Craigie (1911–99), of English and Russian parentage, was one of the first prominent female film directors; her work was acclaimed by public and critics alike. *Out of Chaos* and her subsequent film *The Way We Live*, released in 1946, which told of the adjustment to post-war life by a typical British family in war-devastated Plymouth, demonstrated her remarkable ability to capture her subjects' inner thoughts and emotions. Such are the humility and subtlety of the film-maker's approach that she withdraws almost entirely before her subject.

In the characteristic fashion of news-reel and propaganda films of the war era, an articulate voice-over dramatically sets the scene, as Henry Moore suddenly appears on screen in the dark tunnels of the London underground, while extras adopt the poses

that the artist observed when sketching during the Blitz: 'One of the most moving scenes of the Blitz was the sight of the tube shelters. On almost any night during a raid, this figure might have been seen wandering about: Henry Moore, the sculptor. Here perhaps was the one artist most capable of immortalising the stoic endurance and suffering of these people.' This bold claim reminds us of the powerful impact of the drawings on the public so soon after the worst days of the Blitz.

The following description of Moore's artistic practice underlines the immediacy and sensitivity of his approach, as well as the three-dimensional nature of his works on paper: 'As a sculptor in stone and wood, Henry Moore is interested in the sitting and reclining figures, and he was keen to emphasize this strange, vault-like atmosphere. Not wishing to intrude on their privacy, he'd wander off, and away from the crowds make notes of what he'd seen. After working out various ideas in a sketchbook, he'd pick out the best for making a larger drawing, and he'd work on this for quite a long time. Being a sculptor, all his drawings are made with the feeling that they may finally take shape in stone; but what really matters in his mind is that they should be timeless and elemental.'

The highlight of Moore's participation in this unique documentary is contained in a piece to camera where the artist, like an inspiring art teacher, sets out to draw while commenting on his every step. Nothing before nor afterwards was to give the public such intimate and immediate access to Moore's artistic process.

'Having roughed out the general placing and spacing in pencil, I draw on the paper with wax crayon the part of the figure which is going to catch the light. It doesn't show at this stage, I merely know where I put the crayon. It's more or less feeling the form without seeing it. I can use on this drawing other crayons besides white. For instance, this form, being a green blanket, I draw green. The form is now in a state of suggestion. Next comes filling in the background. In this case, being a tube, I decide on a grey as a colour of the background. I just paint with a grey watercolour, over the whole sheet of paper. Now I can begin to see the drawing as a pictorial whole, and can decide whether, in some parts, the background must be lighter or darker. In this stage, before the watercolour is dry, it can be blotted and made darker where I need deeper shadow, or lighter if necessary. This is just the first blot-in stage, and only the first stage of the drawing.' Mesmerizingly, within minutes, the film manages to encapsulate the miracle of artistic creation. The viewer becomes the sorcerer's apprentice, and watches with awe as the image appears before his eyes.

The voice-over is remarkable for its lyricism and lack of artifice, as it echoes the essence and effect of Moore's delicate yet powerful figures: 'This isn't just a drawing of two people sleeping. Henry Moore has discovered the very rhythm of sleep, a great rolling movement around the course of the drawing, like a broad Atlantic swell or like the rocking lilt of a lullaby. And the rhythm is just, but only just, broken by the lines of the tired, listless sleepers. Deep shadows brood over the picture and out of the shadows emerge two heads, sunk in an uneasy sleep. There is no sharp detail to discern them, only the mouths and nostrils of the sleepers stand out in relief, like symbols of the deep slow breathing of exhaustion. Yet it's an unnatural sleep, troubled by memories of fear. It's an oasis of tranquillity in the heart of a nightmare.'

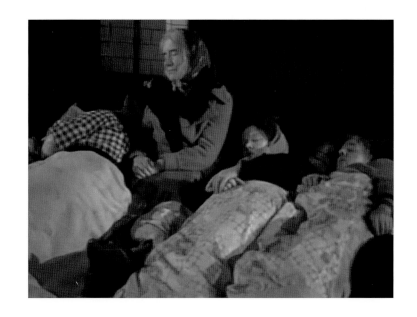

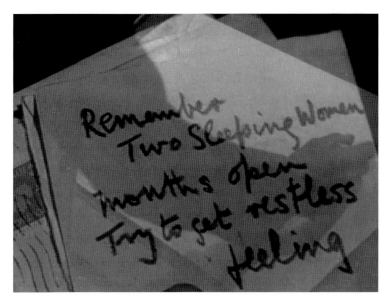

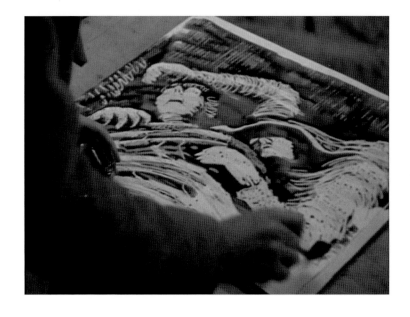

Alexander Nikolsky and
the Blockade of Leningrad

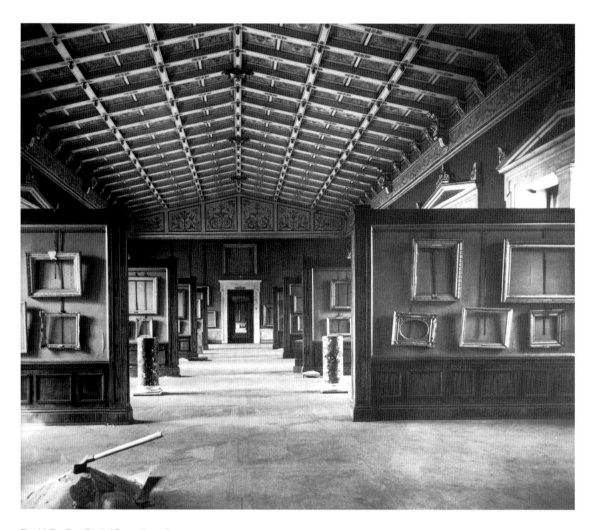

Fig. 44. The Tent-Roofed Room, the gallery
of seventeenth-century Dutch painting, after
evacuation of the paintings in 1941

Thierry Morel The Hermitage under Siege

Although they echo the familiar images of fire, death and devastation of the London Blitz, representations of the Blockade of Leningrad are little known in the West, and even less well understood. For Russians, the Blockade of Leningrad is a resonant and painful symbol of their participation in the Second World War. The sacrifices endured by the inhabitants of the former imperial capital in a campaign that lasted from September 1941 to January 1944 make the blockade one of the most heroic chapters of European history.[1]

The resilience, courage and determination of the besieged citizens of Leningrad affected the morale of the Russian troops in ways that are difficult to grasp seventy years later. The comparison between London and Leningrad is justified because the fear and suffering of both cities galvanized each nation's spirit of resistance, and also inspired some of their most valiant and creative behaviour.

The persistent German bombing and shelling of Leningrad made existence there almost intolerable, as supplies of water, food, utilities, oil and coal were frequently disrupted. The infamously cold winters intensified the difficulties, and the besieged were sometimes left with no option but to burn furniture and floorboards in order to provide meagre heat for their lodgings. Food shortages forced starving souls to boil leather soles, to eat birds, rats and even domestic pets. It was common for family members sharing the same flat to die one after the other. In winter, human corpses were sometimes kept frozen on a balcony or in a room so that the rest of the family could use the ration cards to obtain a tiny extra ration of food.[2]

All of the inhabitants of Leningrad suffered these atrocious conditions, and the curators and helpers of the Hermitage Museum were no exception. The primary role of the curators and staff was to look after the museum's remaining treasures and to protect what could be salvaged from the bombed fabric of the palace.

Since Stalin had signed a non-aggression pact with Hitler two years earlier, the first German attack on the USSR at dawn on Sunday 22 June 1941 took the Soviets by surprise. The news only reached Leningrad at lunch-time and in a matter of hours the staff of the Hermitage was warned that the entire contents of the museum would have to be packed as a preventive measure against potential German air raids from nearby Finland. By the early hours of the following morning, everybody in the museum, from the top curators to the attendants and cleaners, was involved in packing away artworks. It was intended that the Red Army should evacuate the bulk of the treasures to the Urals.

The speed of the German invasion did not allow much time for the Russian museum authorities to organise a systematic national campaign for the protection of buildings and the evacuation of objects of artistic and historical significance. They therefore concentrated their efforts upon one of the most vulnerable and splendid cities in the Union, Leningrad.

To begin with, forty of the most precious Old Masters were taken down from the picture gallery and brought to the darkness of the Gold Room, the Museum's special vault.[3] The staff was given six days to pack the hundreds of paintings and hundreds of thousands of other artefacts. In addition, a handful of curators supervised the entire operation, keeping a precise written record that today provides a vivid and accurate account of the undertaking. In 1942 Vasily Kuchumov, a volunteer curator, produced atmospheric drawings depicting the palatial rooms of the Hermitage hung with empty frames and littered with all the decorative elements that could not be evacuated. These valuable records demonstrate that, despite the terrible rush, every possible ingenious effort was deployed to keep these treasures safe during the turmoil of war.

Small and medium-sized pictures were neatly fitted in crates lined with cloth-padded parallel dividers, and were held in place by wooden blocks. One such crate could hold between twenty and sixty paintings. Larger pictures were removed from their stretchers and rolled up on rollers, with each roller taking from ten to fifteen canvases, each separated by layers of tissue paper. The rollers were then placed in oilcloth casings, deposited in long, flat boxes and tightly lashed.[4]

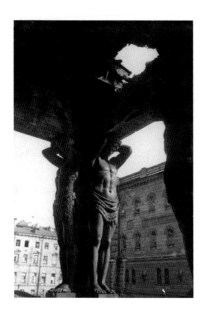

Fig. 45. Wartime photograph showing damage to the Atlantes portico of the New Hermitage

Sometimes, however, other solutions had to be found for particularly fragile items, such as Old-Master pastels and exceptionally large canvases. One of the Hermitage's greatest treasures, Rembrandt's late masterpiece *The Return of the Prodigal Son*, was among those works the curators were determined to save. The canvas, which depicts a very old man bending and embracing his kneeling son, measures 262 by 205 cm, and is particularly significant as it was completed shortly before the artist's death. The curators and restorers decided against the rolling procedure and a three-centimetre-thick wooden crate was created to transport it.

Along with the majority of pictures by Raphael, Leonardo and Titian, Watteau and Caravaggio, the curators also transported archaeological treasures such as the silver and gold vessels from the Scythian royal burials of Southern Russia. The youngest members of staff present in the Gold Room remember to this day the extraordinary sight of these glittering treasures reflecting and magnifying the feeble electric light of the bulb above. In six days, ten thousand items dating from Ancient Greece to Imperial Russia, including watches, necklaces, rings, intaglios, rubies and diamonds, were hand-wrapped in tissue paper. Meanwhile, the numismatic collection, which was initiated by Peter the Great and enlarged over the centuries, left the Twelve-Column Hall in wooden drawers wrapped in cotton wool. In all, an astonishing total of 300,000 coins of all ages were transported.

In December 1941, the museum's director Iosif Orbeli received the famous submarine commander Alexander Tripolsky, whose portrait had been exhibited on the walls of the museum alongside other 'Heroes of the Soviet Union'. Tripolsky was appalled by the working conditions of the staff, who were struggling inside these gigantic edifices, deprived of heating and light. Through the flickering light of a candle, the commander could not help but notice the director's crippling rheumatic pain, whilst the latter, oblivious, was passionately describing the intricate ornamen-tation of a medieval candlestick. Returning to the quay, the navy officer boarded the *Polyarnaya Zvezda* (*Polar Star*), the imperial family's former yacht which he now commanded as an auxiliary vessel of his submarine squadron, and gave a few orders.[5] The following morning, the sailors laid a cable across the road from the ship's engine rooms to the Hermitage. The architect Alexander Nikolsky (see pp.120–30), who kept an illustrated diary of the Hermitage throughout the siege, noted 'The ship fed electricity to several of the Hermitage rooms. It was now light where it had been dark before and this was priceless.'[6]

Fig. 46. The effects of a 70mm shell exploding in the coaches store in 1942

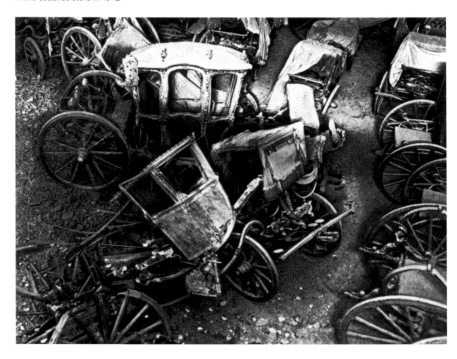

1 The pressure of the siege was slightly alleviated in January 1943 when a small strip of land was re-conquered by the Soviet armies which allowed much needed supplies to be delivered.

2 I thank Larissa Haskell, née Salmina, former curator of Italian Drawings in the Department of Prints and Drawings at the Hermitage, who survived the Siege, for sharing her precious testimony and painful memories.

3 Boris Piotrovsky (ed.), Sergei Varshavsky and Boris Rest, *Saved for Humanity, The Hermitage During the Siege of Leningrad 1941–1944* (Leningrad, 1985), pp.21–35.

4 Ibid., p.23.

5 Ibid., p.127.

6 Ibid., p.130.

7 Ibid., pp.131–32.

8 Christopher Morgan & Irina Orlova, *Saving the Tsars' Palaces* (Clifton-upon-Teme: Polperro Heritage Press, 2005), pp.70–71.

The stronger and more skilled members of the museum staff were recruited to form a 'crash rescue team' in order to undertake 'speedily and with surprising dexterity and skill the repair of the breakdowns and damage caused to the buildings by the shelling and bombardment'.[7] To give but one example of the intensity, on 6 September 1941 German planes bombed the besieged Leningrad, as they would continue to do for the next 900 days, causing 178 city fires with no fewer than 6,327 incendiary bombs. Museum researchers quickly adapted to these extraordinary circumstances, becoming impromptu fire-fighters.

Boris Piotrovsky recalled that 'during the autumn and winter of 1941–42, there were as many as ten to twelve air-raid alerts daily'. These brigades, therefore, were absolutely essential to the preservation of the buildings. The shelling did hit the palace in many locations and damaged not only the buildings and its interiors but also some of the remaining artefacts. The exposure of these objects to the humidity of the air and temperatures of minus thirty degrees centigrade was sometimes even more dangerous than the impact itself. Some items were either corroded or mouldy beyond recognition by the time they were excavated from the debris. The imperial country palaces outside Leningrad such as Pavlosk, the Catherine Palace and Peterhof met an equally devastating fate, for they fell into German hands and were ransacked and almost destroyed.

On 9 August 1942 the mere fifteen surviving members of the Leningrad Radio Orchestra emerged from the debris of the besieged city, defying the blasts of explosions outside. Accompanied by emaciated army musicians and other volunteers, they came together to play for the first time Shostakovich's Seventh ('Leningrad') Symphony.[8] This composition, encompassing both grief and hope, was broadcast across the city. Not unlike the drawings of Alexander Nikolsky, it offered vibrant testimony that art and humanity could prevail over the chaos of war.

Fig. 47. Wartime photograph showing the damage caused by a direct hit to the Winter Palace

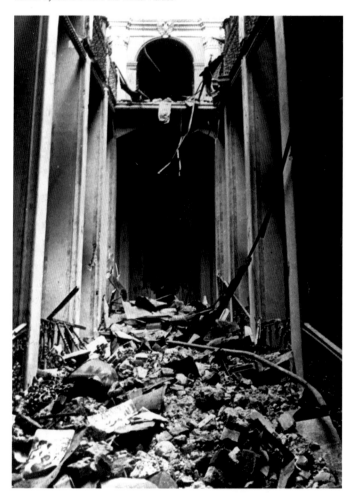

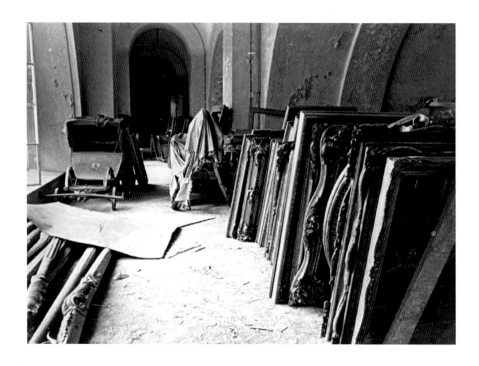

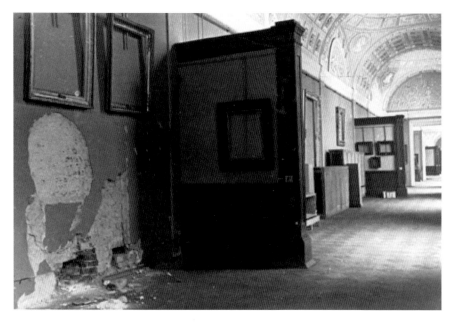

Fig. 48 and 49. Wartime photograph showing
empty picture frames following the evacuation
of paintings from the museum

Memories of the Blockade

The Blockade Book (1977–81), edited by Ales Adamovich and Daniil Granin, is a compilation of interviews and conversations with citizens of Leningrad who lived through the blockade, as well as other documentary material, such as letters and memoirs. The following first-hand accounts by senior Hermitage curator Pavel Gubchevsky, mathematician and academic Evgeny Lyapin, and Hermitage employee Zoya Bernikovich provide an extraordinary record of the courage and resourcefulness shown by those facing a daily struggle for survival in the besieged city. The passages are linked by the two editors' questions and commentary.

Pavel Gubchevsky:

Thirty-two shells fell. The damage was unpredictable: in the Armorial Hall a shell fell about two metres from the Small Throne Room. I don't know by what law of ballistics, but the fragments ricocheted through to here, to the Small Throne Room. In the Armorial Hall there was a hole in the floor down to the Rastrelli Gallery, and that was it, but the Small Throne Room was riddled with fragments. The chandelier was broken and was never able to be restored – the bronze was too fragile … What's more, the fragments literally peppered the walls and ceiling. Although there was nothing on the walls (these wonderful period Lyonese velvets embroidered with silver were rolled up and taken away, evacuated), the decorative painting was phenomenally hard to restore. The whole place looked terrible. Or the staircase that now brings you up into the museum – the Ambassadors', the Jordan, the Main Entrance, whatever you want to call it – that too looked dreadful. A shell made a hole in the ceiling above the staircase. While the decorated ceiling only went black because of three years of constantly changing temperatures, all the painting around the ceiling and all the other parts of the ceiling were iron (after the fire of 1837 they put in iron ceilings). The iron rusted through, gave way and perished. So the decorative painting which you're looking at now fluttered down in flakes only a little bigger than this booklet. Everyone, the museum workers, were walking about on those flakes. A wretched sight, of course.

Were all the paintings taken out?

Well, you see overall the Hermitage removed one million, one hundred and seventeen thousand objects, but this is just a statistic – essentially boring and uninteresting. There were practically no paintings left in the galleries. But there was no way of evacuating Fra Angelico's fresco or the enormous cartoon by Giulio Romano – even rolled up it would have fallen to pieces. Nor of course could the painting in the Raphael Loggias be evacuated. What was also left was anything that could survive by itself, frames for example.

What did the galleries look like?

Just empty frames! This was a very wise decision by Orbeli: to leave all the frames in place. Thanks to this the Hermitage managed to restore everything to its rightful place within seventeen days of the paintings' return from evacuation! But during the war they just hung there, empty eyesockets on the walls. I led several guided tours around them.

Around empty frames?

Around empty frames.

Which year was this?

This was the spring, around the end of April 1942. These tours were part of a course for young lieutenants. The students helped us drag out the wonderful, very valuable furniture which was under water. We were never able to evacuate this furniture. It was carried out to the stables (on the ground floor, beneath the Hanging Garden). In 1942 water poured through from above and the superb collection of furniture – medieval and French classicist – all ended up waterlogged. It had to be urgently dragged out and saved, but how, and who would do it? Certainly not the forty old women under me,

a third of whom were in hospital or the clinic! All the others were either disabled or over seventy. So they brought students over from Siberia – they were still more or less fit – and they were trained here to be young lieutenants. And they dragged the furniture through to that room where it was relatively safe, and there it stayed until the end of the war. Well, they had to be thanked of course. So they were formed up in the hall (here between these columns), and given a few words of thanks. And then I took those lads from Siberia and led them round the Hermitage, around those empty frames. It was the most extraordinary tour I've ever given. Even empty frames, it seems, can make quite an impression.

You can imagine what it was like. The walls of the Hermitage completely frost-bound during the winter, covered in hoar-frost from top to bottom, footsteps echoing down empty galleries … The rectangles of frames – gilt, oak, some small, some huge, some smooth, some ornately carved and decorated with ornament; frames that had never previously been noticed and which now hung there on their own terms – some attempting to fill up the emptiness, others emphasising the empty space which they now embraced. For Gubchevsky these frames that had contained the works of Poussin, Rembrandt, Cranach, the Dutch, French and Italian masters, represented real paintings. There was no distinction: he saw within the frames the canvases that had inhabited them in all their detail, in all the subtlety of light and colour, of figure and face, the fold of a garment, the individual brushstrokes. For him the pictures' absence now made them more vivid than ever. The power of imagination and the sharpness of memory, of the inner vision, became stronger and filled the emptiness. He 'redeemed' their absence through words, gestures, intonations, through all possible means of his imagination, language and knowledge. People would stare intently, with total concentration, at the space within the frame. Word turned into line, colour, stroke; the play of shadow and air somehow emerged. It is said that a painting cannot be conveyed in words, and that is true. However, in that blockade life words did recreate the pictures, returning them to their rightful place, and making them resonate in all their colour – indeed, so brightly and with such graphic intensity that they became forever burnt into the memory. Never subsequently did Pavel Filippovich Gubchevsky manage to conduct a tour where people saw and felt so much.

Evgeny Lyapin:
How does the face of someone who looks the way we looked change? This cannot be described in words. Perhaps it could be drawn. It is utterly terrifying. It is not so terrifying when someone is just ill and dying, or dying in an unusual way (however cynical that sounds) – killed by shrapnel or a bomb. But the look of someone dying from hunger is particularly terrible. The change in the face, the look, the way they turn into shuffling corpses; even a lifeless corpse, after all, is not a pleasant sight. Those yellow faces were dreadful, that frozen look. It is completely different to when someone is in agony from an injured arm or leg. No, here the whole organism is affected, the mental processes often disturbed. The yellow face, the frozen look, the feeble voice that makes it impossible to tell whether the person is male or female, that rasping voice of an ageless, sexless being.

The enemy was waiting for Leningrad to 'cannibalise itself'. And the shelling, the bombs, the leaflets were all constant reminders that the time was approaching, that it was waiting.

Zoya Bernikovich:
When I was in the trenches, do you know what little ditties they sent us? The Germans dropped leaflets that read, 'Eat up your beans – prepare your coffins!' These were what they dropped from aeroplanes. Or 'Eat lentils, surrender Leningrad!' And our response was 'We will never surrender!'

Death became a daily commonplace in the city. Soviet soldiers and sailors, themselves half-starved, fought and died on the Nevsky *piatachok* [*the small piece of land where some of the most bloody battles took place*], and broke through to the railway which would provide Leningrad with a lifeline and give strength back to the starving, emaciated people – and save their lives. The Ice Road across Lake Ladoga, which was opened up at the end of November, meant that some food started to get through in December, and with it some hope. Here was a renewed chance to evacuate citizens, although for people so emaciated and ill the journey was extremely arduous, and many died on the way to new life, even after breaking through the ring. Right up to the summer of 1942 hunger decimated people, even when things got easier: for many, the dystrophia was just too advanced.

Bread, it seemed, was all that mattered, and water and heat! It was all anyone could talk or think about, all desires were concentrated entirely on this daily need. Nothing else. Well, not entirely. When the body is desiccated, the soul, suffering and diminished by hunger, also looks for sustenance. The life of the spirit continues. At times people surprised themselves by their sensibility to the word, to music, to theatre. Poetry became necessary. Poems and songs that helped people believe that their endless torment was not without purpose, not futile. And there was much more that the Leningrader needed, that was essential for survival. The living voice of someone who shared the same fate – under siege in Sevastopol. And the conviction that Moscow would resist and despatch [*the German commander*] Guderian's tanks. And the most essential thing of all, more even than bread, water and heat: hope, the light of victory at the end of the icy tunnel…

People did move along this tunnel, stifling within themselves anything that might seem superfluous, not essential. But they had only to receive a tiny bit more heat or light and they would start to perceive, with extraordinary acuteness, the most simple of pleasures – the sun, sky, colours. Nothing was more delicious than a potato-cake made of peelings. The electric light bulb had never shone so brightly. People learned to appreciate the simplest things, and the things that truly mattered.

Extracts from *Blokadnaya kniga*, edited by Ales Adamovich and Daniil Granin.

Fig. 50. Wartime photograph showing the
Hermitage storerooms

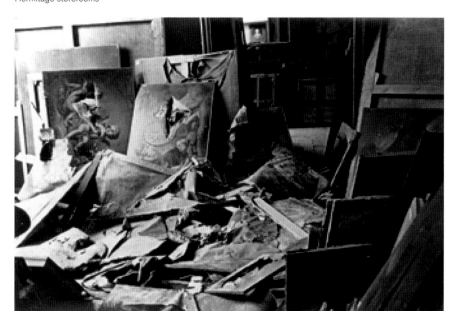

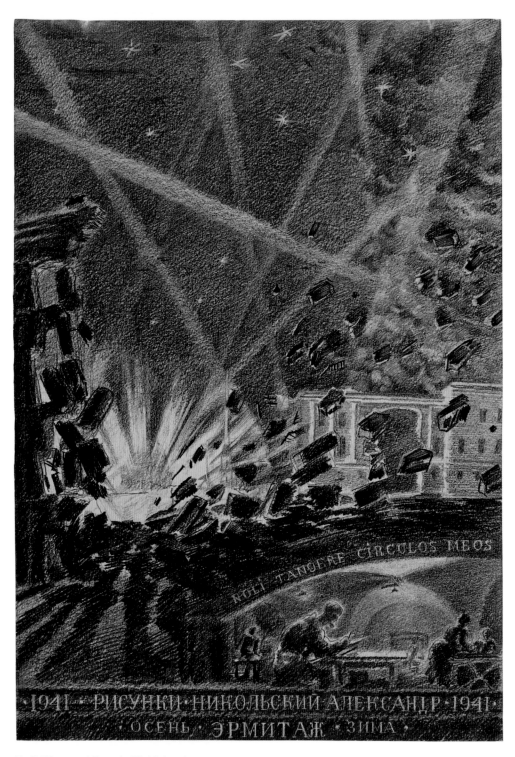

Fig. 51. Title page of Alexander Nikolsky's series
The Hermitage during the Blockade, 1941
(OR 44542)

Alexei Mitin The Drawings of Alexander Nikolsky

In the winter of 1941–42, the Soviet architect Alexander Nikolsky (1884–1953) created a series of drawings of the Blockade of Leningrad which are of lasting historical and artistic significance.

In the 1920s and 1930s Nikolsky was a prolific architect, responsible for numerous projects in Leningrad, including residential buildings on Traktornaya Street and in the Serafimov district on Stachek Prospect, the Tenth Anniversary of the October Revolution School, the *Krasny Putilovets* club, and the public baths in Lesnoi. But Nikolsky was also a wonderful draughtsman, and his vividly rendered drawings harmoniously combine the two sides of his nature: the rational and calculated approach of the structural engineer, and the epic story-telling qualities of the artist. In Soviet architectural drawing, Nikolsky's work was unsurpassed.

In the first days of the war Nikolsky led one of the teams delegated to camouflage the city's most important industrial sites. When the bombardments started, he kept watch on one of the anti-aircraft positions, where, between alerts, he continued to draw and make notes in his diary.

The city was finally encircled on 8 September 1941. Many thought that the ring would quickly be breached, and that Stalin would soon be informed that the German forces had been successfully repelled. However, the Germans closed the circle with catastrophic speed, before Leningrad's citizens had even started properly to think of evacuation.

In the autumn of 1941 Nikolsky and his wife Vera, like most of the artists who remained in Leningrad, were resettled; along with many others they were given refuge in the bomb shelters beneath the Hermitage. Nikolsky noted in his diary: 'Being accustomed to work in any conditions, I began working in the bomb shelter. The reality of what we were going through put all thoughts of the stadium to the back of my mind.[1] A new and more relevant theme took hold, with new drawings that filled an entire album – about 30 or 40 in all.' Nikolsky wrote extensive commentaries in the margins of many of the drawings, such as 'Bomb Shelter no. 3, allocated to Hermitage staff – this is the cellar beneath the Italian "Skylight" rooms. Our beds are in the far corner on the left. The Vereiskys live in the near left-hand corner' (fig. 61).

The Hermitage shelters were in the vaulted basement areas, where heating pipes crossed the ceilings. They were lit by naked bulbs; people would sit at a table in the middle, and bunk-beds were crammed along the walls. They were put together using whatever could be found, but with a sense of communal endeavour and great emotional

Fig. 52. *Twenty-Column Hall of the Hermitage at Night*, 1941

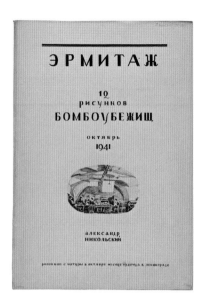

Fig. 53. Title page of Alexander Nikolsky's
Second Bomb Shelter Drawings Sketchbook,
1941 (OR 44552)

effort. Nikolsky wrote in his diary: 'The entrance to Bomb Shelters 2 and 3 was through the Twenty-Column Hall. At night this route was fantastically eerie. There were no blackout curtains on the large windows of the museum so we weren't allowed any light. As a result, at the far end of the Twenty-Column Hall a few storage batteries were set up on the floor with small electric lamps. Everywhere else was dark as coal-dust. Far ahead, in the pitch black, you could see the flicker of a small guiding light. If you lost your way you ended up bumping into a column, a display cabinet or a door jamb.'

Nikolsky did more than twenty drawings of the Hermitage bomb shelters and rooms during the Siege, as well as a whole series showing the besieged city. *Roller-coaster on Fire* shows the Neva through the arch over the Winter Canal, with a boat in silhouette against the sky lit up by the fire (fig. 64). Another drawing, *The Badaev Warehouses on Fire* (fig. 65) – a distant view of Chernigovskaya Street showing an enormous cloud of black smoke rising up above the three-storey residential houses – documents the first major catastrophe of the Siege: the destruction of the city's entire grain reserves. Several drawings show cityscapes of Leningrad in the winter of 1941–42, such as *The End of Gorokhovaya Street* (fig. 66), *Monument to Nicholas I* and *View of Palace Embankment from the House of Scientists* (fig. 57). Alongside the evident signs of wartime life in a besieged city, the artist also manages to evoke those sunny, unusually cold days of December 1941.

One of Nikolsky's drawings of the Hermitage Bomb Shelter no. 3 shows a Christmas tree beneath the low basement arches, revealing how the Leningraders saw in the new year of 1942 (fig. 69). The artist noted in his diary on 22 January 1942: 'I firmly believe that the siege will be broken soon and I have begun to think about the design of triumphal arches to greet our heroic soldiers when they liberate Leningrad. A specialist must always be ready, and I shall make preparations even without being urged to do so … I think the arches should be designed on the assumption that there will be a lack of everything: materials, the workers' physical strength, and, most importantly, time.' So Nikolsky designed temporary arches made from plywood and material decorated as banners, which can also be seen in his siege drawings. In one, showing a distant view of Stachek Prospect, a narrow lancet arch is drawn in the middle, crowned with the figure of a soldier with a rifle; in front of the arch in the left foreground is a KV-86 tank, with three more tanks to the right, while crowds of people line the street (fig. 54). In another the arch is made from a sheet tied together in the middle with a tasselled cord, the inscription 'Glory to the heroes' at the top and lowered flags along the edges (fig. 55).

Nikolsky's album of drawings was presented as documentary evidence at the Nuremberg war trials. On the 22 February 1946, the director of the State Hermitage, Iosif Orbeli, was cross-examined as a witness in the trials. Lawyers of the accused tried to downplay his testimony by saying that Orbeli was no military expert and his claims that this treasure-house of world culture had been deliberately targeted were unfounded: 'I was never a gunner', parried Orbeli, in a retort that became legendary, 'but thirty shells fell on the Hermitage, while the bridge just alongside was hit by only one. I can say with total certainty what the Fascists were aiming at. So in this respect, I am indeed a gunner!'

Nikolsky's drawings were his own testimony to this extraordinary period in the history of Leningrad. They recreate the atmosphere of the besieged city with remarkable skill and emotional intensity.

1 In 1932 Nikolsky had started work on designing a
 new stadium on Krestovsky Island; the Kirov Stadium
 was finally completed after the war, and opened on
 30 July 1950.

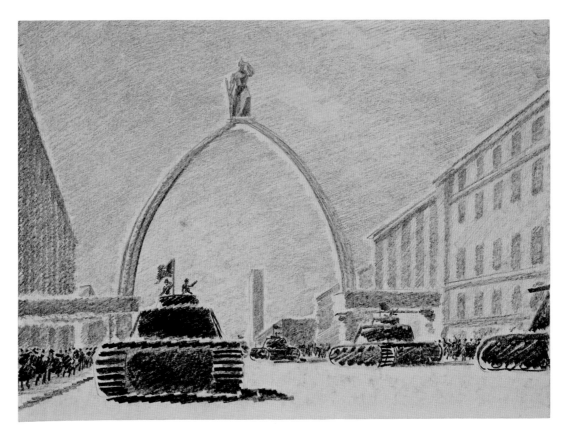

Fig. 54. *Design for a Temporary Triumphal Arch to Greet the Troops*, 1942 (OR 44594). The drawing shows the view down Stachek Prospect

Fig. 55. *Design for a Temporary Triumphal Arch to Greet the Troops*, 1942 (OR 44595)

Fig. 56. *The Neva from the Hermitage*, 1941
(OR 44572). View of the Spit of Vasilievsky island
from the Maly entrance of the Hermitage

Fig. 57. *View of Palace Embankment from the
House of Scientists*, 1941 (OR 44573)

Fig. 58. *The Neva from the Windows of the Hermitage*, 1941 (OR 44571). The drawing shows the view from the windows of Hermitage director Iosif Orbeli's office, with the frigate *Polar Star* anchored on the embankment

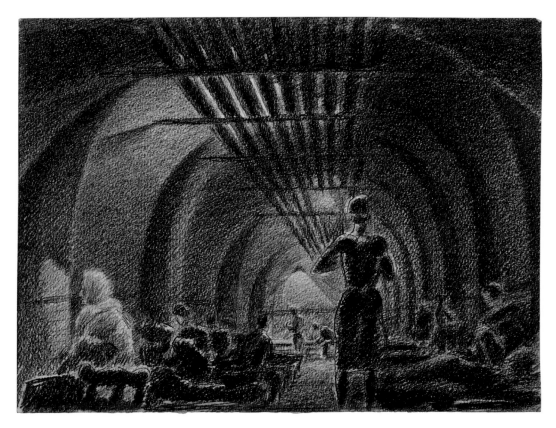

Fig. 59. *Hermitage Bomb Shelter No. 7*, 1941 (OR 44563). On the lower right of the mount, Nikolsky has written: 'View from our beds to the table used for working and eating'

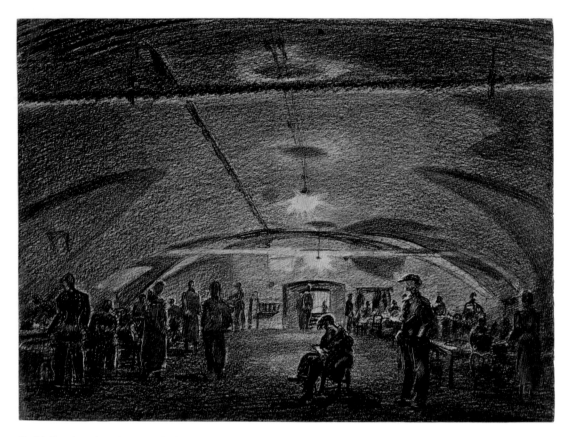

Fig. 60. *Hermitage Bomb Shelter No. 3*, 1941
(OR 44560)

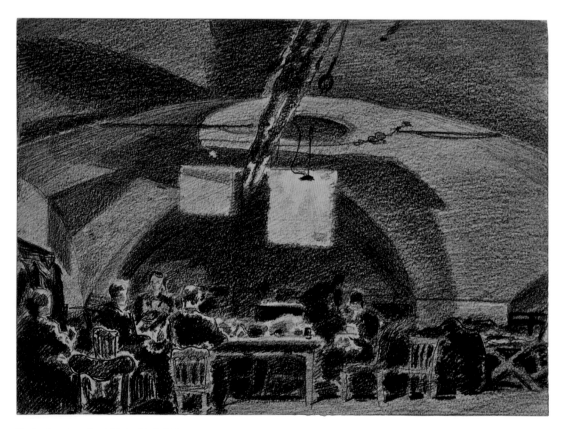

Fig. 61. *Hermitage Bomb Shelter No. 3*, 1941
(OR 44559). On the lower right of the mount
Nikolsky has written: 'Bomb Shelter No. 3,
where we and the Vereiskys lived'

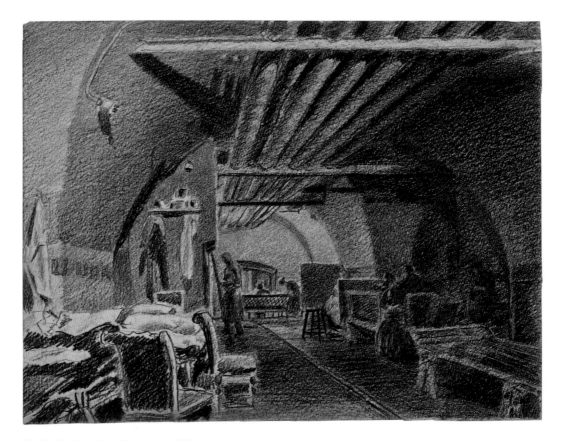

Fig. 62. *Hermitage Bomb Shelter No. 3*, 1941
(OR 44557)

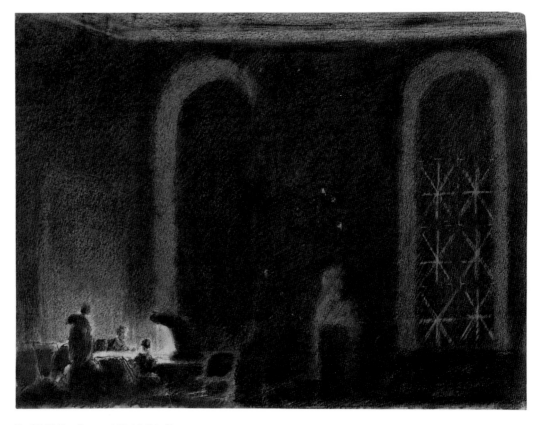

Fig. 63. *Waiting Room outside I.A. Orbeli's
Office in the Hermitage at Night*, 1941
(OR 44546)

Fig. 64. *Rollercoaster on Fire*, 1941 (OR 44551).
The drawing shows the Felten Gallery over the
Winter Canal against the backdrop of the fire

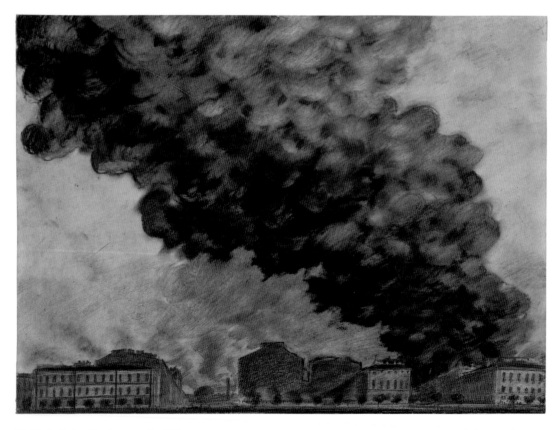

Fig. 65. *The Badaev Warehouses on Fire*, 1941
(OR 44585). The view shows a stretch of
Moskovsky Prospect, looking down Smolenskaya
and Chernigovskaya Streets

Fig. 66. *The End of Gorokhovaya Street*, 1941
(OR 44578). The drawing shows the Admiralty
in the distance with a broken-down tram in
the foreground

Fig. 67. *Monument to Catherine II*, 1942
(OR 44583). On the mount Nikolsky has noted:
'The statue of Catherine wasn't boarded up'

Fig. 68. *Crossing the Neva from the Academy
of Arts to the Monument to Peter I*, 1942
(OR 44582). The boarded-up monument to
Peter the Great is shown with St Isaac's
Cathedral in the background

Fig. 69. *New Year's Eve*, 1942 (OR 44588). In
the Hermitage cellar beneath the Small Italian
Skylight Hall Nikolsky made a Christmas tree
from paper

Henry Moore: a chronology

Moore (front row, far right) at an evening pottery class run by Alice Gostick in December 1919

Moore's *Head and Shoulders* (1933; LH 130)(centre) at the *International Surrealist Exhibition* in London, 1936

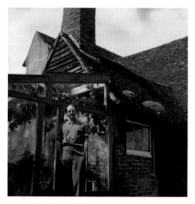

Moore in September 1946 outside the greenhouse at Hoglands

Left to right: René d'Harnoncourt, Anton Zwemmer and William Hayter standing in front of Moore's *Reclining Figure* (1932; LH 122) during the *Henry Moore: Retrospective* exhibition at the Museum of Modern Art, New York, 1946

1898
30 July, Henry Spencer Moore is born, the seventh of eight children, in Castleford, Yorkshire, where his father is a miner.

1910
Wins a scholarship to Castleford Secondary (later Grammar) School. His first artistic influence is the art teacher Alice Gostick, who introduces him to contemporary European art.

1917
Enlists in the Civil Service Rifles, 15th London Regiment; is gassed at the Battle of Cambrai and returns to England to convalesce.

1919–20
Enrols at Leeds School of Art, where a sculpture department is set up with Moore as the sole student.

1921
Wins a scholarship to the Royal College of Art, London, to study sculpture. Begins frequent visits to the British Museum, where he makes copious notes and sketches.

1922
Develops his interest in direct carving and in the work of Henri Gaudier-Brzeska and Constantin Brancusi. Visits Paris, where he is deeply impressed by Paul Cézanne's paintings in the Auguste Pellerin collection. His family moves to Norfolk, where, during vacations, Moore makes his first carvings.

1924
Takes part in his first group exhibition at the Redfern Gallery, London. Is awarded a Royal College of Art travelling scholarship to Italy, which he postpones to take up a seven-year appointment as instructor in the sculpture department at the Royal College of Art.

1928
His first one-man exhibition is held at the Warren Gallery, London; drawings bought by Jacob Epstein and Augustus John. Meets Irina Radetzky, a painting student at the Royal College of Art.

1929
Moore and Irina are married; they move to Hampstead, a centre for artists and writers in the 1930s. Carves the important *Reclining Figure* (LH 59), now in Leeds City Art Gallery; influenced by carved figures of Chacmool, the Mexican rain god; completes *West Wind* (LH 58), a relief sculpture on the north wall of the London Underground headquarters overlooking St James's Park.

1930
Exhibits with the Young Painters' Society and the London Group; chosen (with Jacob Epstein and John Skeaping) to represent Britain at the Venice Biennale.

1931
Resigns from his teaching post at the Royal College of Art. Following a one-man exhibition at the Leicester Galleries, London, his first work is sold abroad, to a museum in Hamburg. Becomes first Head of Sculpture in new department at Chelsea School of Art. Buys a holiday cottage in Kent.

1933
Second exhibition at the Leicester Galleries, London. Chosen to become a member of Unit One, a group of avant-garde artists. In Paris he meets Alberto Giacometti, Ossip Zadkine and Jacques Lipchitz.

1934
Goes, with Irina and friends, to see prehistoric cave paintings in Altamira (Spain) and Les Eyzies de Tayac (France). The first monograph on his work, by Herbert Read, is published.

1935
Buys a larger cottage with land near Canterbury, Kent, where he makes many carvings in the open air. As the size of his carvings increases he makes use of small preliminary models known as maquettes.

1936
Finishes his first major elmwood carving, *Reclining Figure* (LH 175), now in Wakefield City Art Gallery. Serves on the Organizing Committee of the *International Surrealist Exhibition* at the New Burlington Galleries, London, in which he also takes part.

1937
Begins a series of stringed figures inspired by mathematical models in the Science Museum, London. Visits Picasso in Paris to see *Guernica* in progress.

1939
On the outbreak of war he is forced to give up his post at Chelsea School of Art, as well as the cottage in Kent; produces his first lithograph, *Spanish Prisoner* (CGM 3), intended to be sold in aid of Spanish prisoners of war.

1940
Begins Shelter Drawings of figures in the London Underground; he and Irina move to Perry Green, Hertfordshire, when their London home and studio are damaged by bombs.

1941
His first retrospective exhibition, with Graham Sutherland and John Piper, is held at Temple Newsam House, Leeds. Moore is appointed a Trustee of the Tate Gallery, a position he holds intermittently until 1956.

1942
Commissioned by the War Artists' Advisory Committee to make a series of drawings of miners at Wheldale Colliery near Castleford, the mine in which his father had worked. Appointed to the Art Panel of the Council for the Encouragement of Music and the Arts (later the Arts Council of Great Britain).

1943
His first one-man exhibition abroad opens at the Buchholz Gallery, New York.

1944
Madonna and Child (LH 226) is installed in St Matthew's Church, Northampton. The first volume of *Henry Moore: Sculpture and Drawings* (later *Complete Sculpture*) is published.

1946
Birth of the Moores' only child, Mary. Georges Braque visits Perry Green. Moore makes his first trip to New York on the occasion of a travelling retrospective exhibition at the Museum of Modern Art.

1948
Goes to Venice for his one-man exhibition in the British Pavilion at the 24th Biennale, where he is awarded the International Prize for Sculpture.

1950
Makes series of Rocking Chair and Helmet Head sculptures and the *Standing Figure* (LH 290), later sited on a hillside at Glenkiln, Scotland. Refuses the offer of a knighthood.

1951
Moore's first retrospective at the Tate Gallery; *Reclining Figure: Festival* (LH 293) is exhibited on the South Bank during the Festival of Britain. He tours Greece on the occasion of his exhibition in Athens.

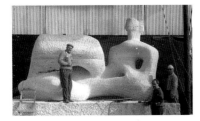

Moore with local artisans working on *UNESCO Reclining Figure* (1958; LH 416) at Querceta, Italy

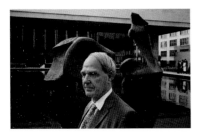

Moore with *Reclining Figure* (1963–65; LH 519) in situ outside the Lincoln Center for Performing Arts, New York

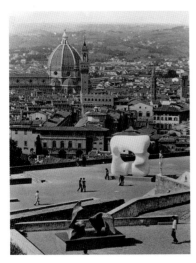

Large Square Form with Cut (1972; LH 599) at the Forte di Belvedere in Florence, Italy

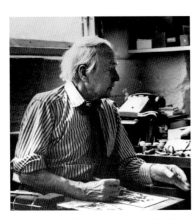

Moore drawing in Gildmore Graphic studio at Perry Green c.1980

1952
A period of intense sculptural activity includes a series of standing figures, internal/external forms and reliefs. Work begins on *King and Queen* (LH 350) and two sculptures for the Time-Life Building in London's Bond Street; all three are completed the following year.

1953
Moore attends the 2nd São Paulo Bienal, where he is awarded the International Sculpture Prize; afterwards he tours Brazil and Mexico.

1955
Makes a series of *Upright Motives* (LH 376–392a). Appointed Member of the Order of the Companions of Honour; made a Trustee of the National Gallery, London (1955–74).

1957
Develops several large figures of Seated and Reclining Women (LH 428, 431, 435, 439). Awarded a prize at the Carnegie International, Pittsburg, and the Stefan Lochner Medal by the City of Cologne.

1958
Unveiling of the *UNESCO Reclining Figure* (LH 416) in Paris. Moore is appointed Chairman of the Auschwitz Memorial Committee.

1959
Travelling exhibitions in Japan, Eastern Europe, Spain and Portugal. Moore is awarded the Foreign Minister's prize at the 5th International Art Exhibition of Japan, Tokyo. Begins large elmwood *Reclining Figure* (LH 452) and completes the bronze *Two-Piece Reclining Figure No. 1* (LH 457).

1964
Appointed a member of the Arts Council of Great Britain; awarded a special medal by the Institute of Architects in America. *Locking Piece* (LH 515) completed; work begins on *Nuclear Energy* (LH 526) for the University of Chicago.

1965
Completes *Knife Edge Two Piece* (LH 516), a cast of which is sited outside the Houses of Parliament in Westminster. Visits New York for the installation of *Reclining Figure* (LH 519) at the Lincoln Center. Buys a house in Forte dei Marmi, where he and his family spend subsequent summer holidays.

1966
Installation of *Three Way Piece No. 2: Archer* (LH 535) in Nathan Phillips Square, Toronto.

1968
A retrospective at the Tate Gallery, London, marks Moore's seventieth birthday; at an exhibition at the Rijksmuseum Kröller-Müller, Otterlo, he receives the Erasmus Prize. Awarded the Order of Merit by the Federal Republic of Germany and the Einstein Prize by Yeshiva University, New York.

1969
Begins the monumental bronze version of *Large Torso: Arch* (LH 503b) and several Reclining Figures. The gift of an elephant skull inspires a prolonged series of etchings.

1971
Oval with Points (LH 596) is installed at the University of Princeton; work begins on *Sheep Piece* (LH 627). Moore travels to Toronto to oversee plans for the Henry Moore Sculpture Centre at the Art Gallery of Ontario. Elected Honorary Fellow of the Royal Institute of British Architects.

1972
A spectacular retrospective exhibition is held at the Forte di Belvedere, Florence; Moore attends the opening by HRH The Princess Margaret, and later presents a cast of *Warrior with Shield* (LH 360) to the city of Florence; he is created Cavaliere di Gran Croce dell'Ordine al Merito della Repubblica Italiana, and wins the Florentine international prize 'Le Muse'. Begins drawing the Sheep Sketchbook, which in turn leads to an album of sheep etchings.

1973
Makes *Hill Arches* (LH 636) and begins *Goslar Warrior* (LH 641). Exhibition at Los Angeles County Museum of Art. Receives the prestigious French award of Commandeur de l'Ordre des Arts et des Lettres, Paris.

1974
Travels to Canada for the inauguration of the Henry Moore Sculpture Centre at the Art Gallery of Ontario, Toronto, to which he donates 101 sculptures and 57 drawings.

1977
Inauguration of the Henry Moore Foundation.

1978
Moore's eightieth birthday is marked by exhibitions at the Tate Gallery and Serpentine Gallery in London, and the City Art Gallery, Bradford. He makes a gift of 36 sculptures to the Tate Gallery. *Mirror: Knife Edge* (LH 714) installed at the National Gallery of Art, Washington, DC.

1979
Now suffering from arthritis in his hands, Moore devotes more time to drawing and graphic work; makes series of etchings and lithographs of trees and hands.

1980
Tapestries made from his drawings are exhibited at the Victoria and Albert Museum, London. A large marble version of *The Arch* (LH 503c) is donated to the Department of the Environment for permanent position in Kensington Gardens, London. Moore is awarded the Grand Cross of the Order of Merit of the Federal Republic of Germany. Despite declining health, he completes 350 drawings.

1981
A large retrospective exhibition opens in Madrid, then travels to Lisbon and Barcelona.

1982
The Henry Moore Sculpture Gallery and Centre for the Study of Sculpture is opened by HM The Queen as an extension to Leeds City Art Gallery.

1983
Major exhibition at the Metropolitan Museum of Art, New York.

1984
Created Commandeur de l'Ordre National de la Légion d'Honneur when President Mitterrand visits him at Perry Green. A touring exhibition of war drawings opens at the Nationalgalerie in East Berlin.

1986
31 August, Moore dies at Perry Green, Hertfordshire, aged 88. A Service of Thanksgiving for his life and work is held on 18 November in Westminster Abbey.

Selected Publications

Bibliography

Davis, Alexander (ed.), *Henry Moore Bibliography 1898–1991*, 5 vols, The Henry Moore Foundation, London and Much Hadham 1992–94

Catalogues raisonnés

Henry Moore: Complete Sculpture, vol. 1, 1921–48 (entitled *Sculpture and Drawings*), ed. Herbert Read 1944, 4th rev. edn ed. David Sylvester 1957; vol. 2, 1949–54, ed. David Sylvester 1955, 3rd rev. edn ed. Alan Bowness 1986; vol. 3, 1955–64, ed. Alan Bowness 1965, 2nd rev. edn 1986; vol. 4, 1964–73, ed. Alan Bowness 1977; vol. 5, 1974–80, ed. Alan Bowness 1983, 2nd rev. edn 1994; vol. 6, 1981–86, ed. Alan Bowness 1988, rev. edn 1999; Lund Humphries, London

Henry Moore: Catalogue of Graphic Work, [vol. I], 1931–72, eds. Gérald Cramer, Alistair Grant and David Mitchinson 1973; vol. II, 1973–75, eds. Gérald Cramer, Alistair Grant and David Mitchinson 1976; vol. III, 1976–79, eds. Patrick Cramer, Alistair Grant and David Mitchinson 1980; vol. IV, 1980–84, eds. Patrick Cramer, Alistair Grant and David Mitchinson 1988; Cramer, Geneva

Henry Moore: Complete Drawings, ed. Ann Garrould, vol. 1, 1916–29, 1996; vol. 2, 1930–39, 1998; vol. 3, 1940–49, 2001; vol. 4, 1950–76, 2003; vol. 5, 1977–81, 1994; vol. 6, 1982–83, 1994; vol. 7, 1985–86, 2003; The Henry Moore Foundation in association with Lund Humphries, London

Books

Andrews, Julian, *London's War: The Shelter Drawings of Henry Moore* 1st published 2002; Lund Humphries, Aldershot 2010

Berthoud, Roger, *The Life of Henry Moore*, 1st published Faber & Faber 1987; rev. edn Giles de la Mare, London 2003

Causey, Andrew, *The Drawings of Henry Moore*, Lund Humphries, Aldershot 2010

Feldman, Anita, *Henry Moore Textiles*, intro. by Sue Prichard, 1st published 2008; Lund Humphries, London 2009

Feldman, Anita, *Henry Moore: The Plasters*, essays by Malcolm Woodward, Royal Academy of Arts, London 2011

Lewison, Jeremy, *Moore*, Taschen, Cologne 2007

Lichtenstern, Christa, *Henry Moore: Work-Theory-Impact*, Royal Academy of Arts, London 2008

Mitchinson, David (ed.), *Celebrating Moore: Works from the Collection of The Henry Moore Foundation*, Lund Humphries, London 1998

Mitchinson, David, *Hoglands: The Home of Henry and Irina Moore*, Lund Humphries, London 2007

Mitchinson, David, *Henry Moore: Prints and Portfolios*, Patrick Cramer, Geneva 2010

Wilkinson, Alan (ed.), *Henry Moore: Writings and Conversations*, Lund Humphries, London 2002

Exhibition catalogues (in chronological order)

Henry Moore Shelter Sketch Book, Editions Poetry London, London 1945

Darracott, Joseph, *Henry Moore War Drawings*, Imperial War Museum, London 1976

Henry Moore, Royal Academy of Arts, London 1988

Henry Moore: A Shelter Sketchbook, commentary by Frances Carey, British Museum Publications Ltd, 1988

Genri Mur: chelovecheskoye izmereniye (Henry Moore: The Human Dimension), British Council, London 1991

Henry Moore: War and Utility, David Mitchinson, HMF, Much Hadham 2001

Henry Moore Retrospective, Anita Feldman Bennet, Caroline Edde, Jean-Louis Prat and Margaret Reid, Galerie Maeght, Saint Paul de Vence 2002

Henry Moore, Anita Feldman Bennet, Ian Dejardin and Ann Garrould, Dulwich Picture Gallery, London 2004

Henry Moore: Human Landscapes/Menschliche Landschaften, Christa Lichtenstern and Sabine Maria Schmidt, Städtische Galerie, Wolfsburg 2004

Henry Moore: Uma Retrospectiva, Aracy Amaral, Anita Feldman Bennett, Rafael Cardoso, David Mitchinson and Margaret Reid, Pinacoteca do Estado de São Paulo, São Paulo; Paço Imperial, Rio de Janeiro; Centro Cultural Banco do Brasil, Brasília 2005

Henry Moore: Epoche und Echo/Englische Bildhauerei im 20. Jahrhundert, Ian Barker and Christa Lichtenstern, Kunsthalle, Würth, Schwäbisch Hall 2005

Henry Moore: War and Utility, David Mitchinson and Roger Tolson, Imperial War Museum, London 2006

Henry Moore: Master Printmaker, Suzanne Eustace, British Council, London 2006

Henry Moore, Anita Feldman Bennet, Maria Lluïsa Borràs and Toby Treves, Fundació 'la Caixa', Barcelona 2006

Henry Moore et la Mythologie, David Mitchinson, Anita Feldman and Thierry Dufrêne, Musée Bourdelle, Paris 2007

Henry Moore und die Landschaft, Anita Feldman Bennet, Katja Blomberg, Beate Kemfert, Helmut Schmidt and Irene Tobbin, Haus am Waldsee, Berlin; Opelvillen, Rüsselsheim 2007–8

Henry Moore, Chris Stephens (ed.), Richard Calvocoressi, David Alan Mellor, Jennifer Mundy, Lyndsey Stonebridge and Jonathan Wood, Tate Britain, London 2010

Henry Moore: L'atelier, Anita Feldman, David Mitchinson, Patrick Le Nouëne, Paul-Louis Rinuy, Hélène Pinet, Véronique Mattiussi and Michael Phipps, Musée Rodin, Paris 2010

Index

Page numbers in *italic* refer to the illustrations

Credits

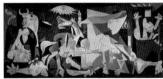

Full listing of essay illustrations

Fig. 1, 17
Two Sleeping Figures, 1941 (HMF 1755), pencil; Art Gallery of Ontario, Toronto: purchased 1977

Fig. 2
Constantine Fitz Gibbon, *The Blitz*; Allan Wingate (publishers) Ltd., London, 1957

Fig. 3, 7
Photographs by Lee Miller from *Grim Glory: Pictures of Britain Under Fire*, Lund Humphries, London, 1941

Fig. 4
Lilliput, Vol. II, No. 6 (66), Pocket Publications Ltd., London, December 1942

Fig. 5
Bill Brandt's photograph of a family sheltering in the Underground during the Blitz and Moore's drawing *Four Grey Sleepers*, 1941 (HMF 1847); Lilliput, December 1942

Fig. 6
Bill Brandt's photograph of a shelterer near Victoria Station and Moore's drawing *Woman Seated in the Underground*, 1941 (HMF 1828); *Lilliput*, December 1942

Fig. 8
Grim Glory: Pictures of Britain Under Fire, Lund Humphries, London 1941, with photograph of St Paul's Cathedral during the Blitz by Herbert Mason

Fig. 9
Spanish Prisoner, 1939 (HMF 1464); charcoal, wax crayon, chalk, watercolour wash on medium to heavyweight wove; The Henry Moore Family Collection

Fig. 10
Henry and Irina Moore at their home and studio in Hampstead, London, *c.* 1930

Fig. 11
Reclining Figure, 1931 (LH 101); lead

Fig. 12
Bird Basket, 1939 (LH 205); lignum vitae and string; accepted by HM Government in lieu of Inheritance Tax and allocated to the Henry Moore Foundation, 2002

Fig. 13
Pablo Picasso, *Guernica*, 1937 (detail); oil on canvas; Museo Nacional Centro de Arte Reina Sofía, Madrid

Fig. 14
Pointed Forms, 1940 (HMF 1496); page from *Ideas for Sculpture Drawing Book*; pencil, chalk, crayon, watercolour, pen and ink; Graphische Sammlung Albertina, Vienna

Fig. 15
We Ask Your Attention 1938; broadsheet of the Surrealist declaration designed by Henry Moore

Fig. 16
Sheet of Heads Showing Sections, 1940 (HMF 1508); wax crayon, coloured crayon, watercolour wash, pen and ink on cream medium-weight wove; The Henry Moore Foundation

Fig. 18
Woman Seated in the Underground, 1941 (HMF 1828); pencil, wax crayon, coloured crayon, watercolour, pen and ink; Tate: presented by the War Artists' Advisory Committee, 1946

Fig. 19
Moore sketching miners at Wheldale Colliery, Castleford, Yorkshire, January 1942

Fig. 20
Coalminers, 1942 (HMF 1996a); pencil, wax crayon, coloured crayon, watercolour, wash, pen and ink

Fig. 21
Barbed Wire fabric design, *c.* 1946 (TEX 4.13); serigraphy in five colours, spun rayon; printed by ascher

Fig. 22
Moore with Double Standing Figure (LH 291) in Hoglands garden, Perry Green, 1950

Fig. 23
September 3rd, 1939, 1939 (HMF 1551); pencil, wax crayon, chalk, watercolour, pen and ink on heavyweight wove; The Henry Moore Family Collection

Fig. 24
Group of Shelterers during an Air Raid, 1941 (HMF 1808); pencil, wax crayon, coloured crayon, watercolour wash, pen and ink; 380 × 555mm; Art Gallery of Ontario, Toronto: presented by the Contemporary Art Society 1951

Fig. 25
War Drawing: Aeroplanes 1940 (HMF 1552); pencil, wax crayon, charcoal (rubbed), watercolour wash on cream medium-weight wove; 277 × 190mm; The Henry Moore Foundation

Fig. 26
Shelter Drawing: Seated Mother and Child, c. 1942 (HMF 1861a); pencil, wax crayon, coloured crayon, watercolour, pastel, pen and ink, gouache on cream medium-weight wove; 360 × 277mm; private collection, UK

Fig. 27
In a Large Public Shelter, 1940–41 (HMF 1592); page from First Shelter Sketchbook; pencil, wax crayon, coloured crayon, watercolour, wash, pen and ink on cream lightweight; 181 × 160mm; The British Museum, London, bequeathed by Lady Clark

Fig. 28
Woman with Dog, 1940–41 (HMF 1743); page from Shelter Sketchbook 1940–41; pencil, wax crayon, coloured crayon, wash on cream lightweight; 200 × 159mm; private collection, USA

Fig. 29
War: Possible Subjects, 1940–41 (HMF 1603); page from First Shelter Sketchbook; pencil, wax crayon, watercolour, wash, pen and ink on cream lightweight; 188 × 160mm; The British Museum, London, bequeathed by Lady Clark

Fig. 30
Henry Moore in his studio, Hampstead, London, *c.* 1930

Fig. 31
Reclining Figure, 1930 (LH 85); bronze; The Henry Moore Foundation

Fig. 32
Reclining Figure: Festival, 1951 (LH 293), at the Hayward Gallery, London, 1969; bronze; Scottish National Gallery of Modern Art

Fig. 33
Madonna and Child, 1943–44 (LH 226), St Matthew's Church, Northampton

Fig. 34
King and Queen, 1952 (LH 350), in the grounds at Perry Green; bronze; The Henry Moore Foundation

Fig. 35
Draped Reclining Mother and Baby, 1983 (LH 822); bronze; The Henry Moore Foundation

Fig. 36
Moore in his studio at Perry Green with *Helmet Head No. 2*, 1950 (LH 281)

Fig. 37–43
Stills from *Out of Chaos*, directed by Jill Craigie, London, 1944

143

Cover image:

London Skyline (detail)
1940–41
HMF 1574

The British Museum, London:
bequest of Jane Clark 1977

cat. 14, p. 56